The Way of Tea

Health, Harmony and Inner Calm

AARON FISHER

無 為 海
(Wu Wei Hai)

TUTTLE Publishing

Tokyo | Rutland, Vermont | Singapore

"Books To Span The East And West"

Tuttle Publishing was founded in 1832 in the small New England town of Rutland, Vermont [USA]. Our core values remain as strong today as they were then—to publish best-in-class books which bring people together one page at a time. In 1948, we established a publishing office in Japan—and Tuttle is now a leader in publishing English-language books about the arts, languages and cultures of Asia. The world has become a much smaller place today and Asia's economic and cultural influence has grown. Yet the need for meaningful dialogue and information about this diverse region has never been greater. Over the past seven decades, Tuttle has published thousands of books on subjects ranging from martial arts and paper crafts to language learning and literature—and our talented authors, illustrators, designers and photographers have won many prestigious awards. We welcome you to explore the wealth of information available on Asia at **www.tuttlepublishing.com**.

Published by Tuttle Publishing, an imprint of Periplus Editions (HK) Ltd.,

www.tuttlepublishing.com

Copyright © 2022 Aaron Fisher

Library of Congress Cataloging-in-Publication Data

Fisher, Aaron.
 The way of tea : reflections on a life with tea / Aaron Fisher. -- 1st ed.
 p. cm.
ISBN 978-0-8048-4032-3 (hardcover)
1. Tea--Asia--History. 2. Cookery (Tea)
3. Drinking customs--Asia. I. Title.
 TX415.F52 2010
 641.3'372095--dc22
 2009022453

ISBN 978-0-8048-5436-8
*(Previously published as
ISBN 978-0-8048-4032-3)*

First edition
26 25 24 23 22 10 9 8 7 6 5 4 3 2 1

Printed in Malaysia 2112VP

Distributed by

**North America,
Latin America & Europe**
Tuttle Publishing
364 Innovation Drive
North Clarendon,
VT 05759-9436 U.S.A.
Tel: 1 (802) 773-8930
Fax: 1 (802) 773-6993
info@tuttlepublishing.com
www.tuttlepublishing.com

Japan
Tuttle Publishing
Yaekari Building, 3rd Floor
5-4-12 Osaki Shinagawa-ku
Tokyo 141 0032
Tel: (81) 3 5437-0171
Fax: (81) 3 5437-0755
tuttle-sales@gol.com

Asia Pacific
Berkeley Books Pte. Ltd.
3 Kallang Sector
#04-01, Singapore 349278
Tel: (65) 6741-2178
Fax: (65) 6741-2179
inquiries@periplus.com.sg
www.tuttlepublishing.com

TUTTLE PUBLISHING® is a registered trademark of Tuttle Publishing, a division of Periplus Editions (HK) Ltd.

This book is for my first teachers, before there were any
masters or teas to learn from, Daniel and Carol Fisher.

"Yet another book on the Tao?"
The old monk asked politely,
Though the stillness in his weathered hands
Seemed in askance of the need for noise in a quiet place.
"Inspired by the Tao,"
Was what I wanted to say;
But "I am moved to write" seemed more true.
"I see" he smiled,
And paused,
"But why the Tao of tea? Why not cabbage soup?"
I couldn't help it,
Glanced briefly down
At his old teapot on the shelf there.
More aware than I,
The wise old man followed my eyes—
"Ahhh" he said,
Reaching for a kettle of water to place on the stove,
"Perhaps it is well after all."

Acknowledgments

Behind every author there is an editor whose gentle touch transforms a manuscript into a book, and with a true unseen virtue to make old Lao Tzu smile. So much of the real quality of this book is due to the patience and wisdom of William Notte. May his cup be filled with Morning Dew.

If I am to be honest, I must say that all the wisdom in this book is really just like a chain letter that I am passing on to you. All of these teachings were handed down to me by teachers greater than I, and with their permission. They, too, hope that the Way of Tea might spread and benefit others.

Let us then bow deeply to teachers Jeffrey McCloud, Master He, Zhou Yu, Master Tsai, Chen Zhi Tong, both the Liangs (father and son, *Lao* and *Xiao*), Gary Cham, Master Takahashi, Henry Yiow and of course my own *Sifu*, Master Lin Ping Xiang.

I also kneel before all the tea sessions I've had, and all those that joined me and taught me so much about tea and myself. Every single day, I always put a cup out on an alter. I place it there for all my tea brothers, sisters, and teachers who aren't with me this day. May you all drink of it in spirit, and find fulfillment.

Contents

茶禅一味

A Brief Introduction

Though there is information flowing through the lines you will read in this story, I write not to add to a growing list of scholarly facts on tea. I instead want to approach my reflections on tea—its history, development and preparation over time—from an intuitive perspective; that is, to inspire the heart not the mind. So much of what tea is about, from ancient to modern, water to leaves to liquor, takes place deep inside us where words can never hope to reach. Therefore, allow me, my friend, to breathe a bit of life—a bit of mythology—back into the story of tea, that it have the transcendent power it once had.

I have tried my best to use what knowledge I have of tea history, art, culture and preparation to paint a more spiritual landscape, based not on the logical, data-oriented criteria that one evaluates a scholarly book, but instead on the values that define art—the rules of the heart, mine to yours. Please don't travel with me in intellect alone. Allow the coming chapters to be what any bit of ink, carefully drawn or flung with artistic abandon, might be: a mere suggestion of the Tao of Tea, not a statement of fact. The best stories are performed in the brewing of tea—sipped stanzas that the minstrel but suggests, leaving us to imagine the rest.

The Tao of Tea

The gently lucent Tao, mysterious and transcendent beyond all words and thoughts—elegant and refined, magical and dreamy; and yet practical, flowing through the earth like the crystal waters of Chinese mountains, dancing down the scroll painting in fluid twists, turns and even leaps. And following the ancient silk scroll, saffroned with age, down past the wash of sky, mythically cyan, past the dancing mountains and waters that seem to fade in and out from the background, merging into misty nothingness—down to the foreground where a tiny bamboo hut sits in a grove, lending shade to the bearded sage there. Though we must squint to find him, being seemingly insignificant compared to the grandeur around him, we can nevertheless tell that there is more to his stillness than he's letting on, and the slight flick of the brush that represents his eyes seems to allude to the emptiness that surrounds the whole composition.

It is very difficult to know where to even begin a discussion on something as elusive as the Tao. We all too often get caught up in the explanation of spiritual ideals, forgetting at once that the words and concepts referring to them are not really the principle itself; and sometimes our intellects can even get in the way of our experience. The first line of the most important book on the Tao is, after all, an admonishment that, "The Tao that can be spoken, is not the Eternal Tao." And if we are to follow in the footsteps of such sages as lived these words in ancient times, all much greater than I, we will of course have to begin our understanding of the Tao by similarly paying homage to the fact that these words are but stones thrown at the stars—never actually coming close to that which they hope to inspire. It is my

understanding that even the sages that are attributed as being the first to stroke these teachings onto paper or carve them into wood and stone were merely offering calligraphic suggestions of the Tao, rather than statements.

The vast and ineffable Tao is the Way all ways travel; the Principal and Virtue all principles and virtues arise from and proceed into, and the Truth that underlies all truths. In a more limited sense, Tao is the Way people may live in harmony with that One; or even more narrowly, the traditional Chinese understanding of Nature and man's place in it.

Due to the basic understanding, since ancient times, that Nature's Way follows the same guidelines no matter what level of understanding or aim one has, the Tao has throughout time been a map for myriad paths. The ancient sages of China believed that it didn't matter how worldly or spiritual one's aspiration, the "Way" to achieve goals was the same. Whether designing and ruling an empire or simply crossing a stream, the most skillful method wouldn't change. It is therefore no surprise to find that even as "Taoism" has found its way into the West, we have books on everything from the Tao of Business to the transcendent Tao of the early mountain mystics, and all the poetry between. Neither the Tao as a philosophy, nor the vast Tao that is the universe, have any objection to this; for the celebration and participation in the particular is also the Universal. Finding the vast Tao in the humming of our kettle, that we perhaps just set aside to pick up this book, is to see that this crossroad of time and space is also a part of Eternity. And as we glide downwards towards the landscape of the winding path that is "Taoism," far beneath thoughts such as these, we shouldn't forget the feeling of open freedom we had while soaring on these loftier currents.

Taoism

Around 100 BCE the combined understanding that we now call "Taoism" began seeking its own roots, attributing its foundation to three great teachers and their texts: Lao Tzu and the *Tao Te Ching*, Lieh

Tzu, and Chuang Tzu, whose books were named after them. At that time, however, these ideas weren't thought of as any kind of "ism." They were allusions of the Way, the Tao, in its ultimate sense and as a path. In none of them do we find any kind of practical beliefs, methods of worship, prayer—nor any priests or clergy. There is no dress, ornamentation or any other kind of organization to the ideas these masters expressed, often so paradoxical and contradictory by nature. The Tao, as such, wasn't an organized religion, or even philosophy. It was but a loose method for interpreting the universe, Nature and the Road man may follow to live in harmony with it; and to these great mystics this was something experiential, beyond words or even the logic that they conceptualize.

Though these three teachers were considered the foundation of "Taoism" in its written, popular sense, the beginnings of the philosophy and practice have much deeper roots, and actually these texts, especially the *Chuang Tzu*, suggest that the Way was already ancient during their time. The earliest teachings are often attributed to the mythical figure of the *Huang Di* or "Yellow Emperor" whose legendary reign lasted a century, from 2697 to 2597 BCE. All such record of his teachings has been lost to the brush strokes of history, and his person submerged in folk religion, deified as a god of the Jade Emperor's Palace. Whether there is an actual, historical figure behind the magnified and exaggerated stories of the Yellow Emperor isn't as important, however, as the suggestion that these beliefs, meditations, and ways of thinking date back to such great antiquity, to the very dawn of civilization itself.

To pay tribute to the two most important figures in early "Taoist" thought, Chinese scholars have often referred to the early Tao teachings, as well as the sages that followed the Way, as *Huang Lao*, honoring the Yellow Emperor and Lao Tzu. For many centuries the *Huang Lao* would be handed down quietly in forest hermitages, escaping the gaze of future generations who, curious as we may be, are forbidden to see beyond the veil of such silent, unutterable truths less we cultivate them in our own breasts. Consequently, for all practical purposes our intellectual understanding of "Taoist" thought must begin with the

three teachers Lao Tzu, Chuang Tzu, and Lieh Tzu and the texts that they have left us.

The modern scholar relies so heavily on their words not because they are really the founders of this thought, though they were attributed to be, but because their texts are all that remains of Taoism's earliest days, other than inconsequential remarks here and there, folklore and art which but corroborate that the "Taoist" way of life dates back much further than we could imagine. Nor should we assume that "Taoist" thought, philosophy, or scholarship ended with them, for there were many equally great masters highlighting each age of antiquity, even into modern times. Similarly, there are a few other, lesser known texts dating from around the same age as these three masterpieces, like the *Huai Nan Tzu* or the *Wen Tzu* for example, though exploring them would take us too far afield.

Some scholars today believe that Lao Tzu and Lieh Tzu weren't historical figures, or at least weren't responsible for writing the texts that bear their names. Most likely, these great books were some kind of collective wisdom passed down from mendicant teachers to their students, and these mythic figures merely the ideal human expression of an enlightened master. In the book *Historical Records*, written by one Hsu Ma Chien sometime in the first century BCE, the author declares that he was unable to find any historical evidence or information about either Lao Tzu or Lieh Tzu, though he apparently did track down some facts about the person of Chuang Tzu. This doesn't prove, however, that they weren't actual people either. In fact, many experts have argued that the consistency of style within the *Tao Te Ching* suggests a single author.

Any kind of scholarly, historical approach to these early works is further complicated by the possibility that material was added to them over the centuries; and like so many other texts of the ancient world, Chinese intellectuals have spent the millennia since arguing about which parts were scribed by these saints themselves, which came later and by who at what time. As such, I think the point of the teachings is lost—in the court of Wisdom, provenance is moot.

Many of these scriptures are also completely anachronistic, often illogical, disorderly and, especially in the *Chuang Tzu*, sometimes

blatantly absurd. To these masters, the world wasn't measurable. It was not to be analyzed—especially in the sense that the sum total of all knowledge (Tao) is by definition "unknowable." They believed that the Ultimate Truth could only be approached experientially, and challenge us to expand our ideas of the world and open our minds to new and greater forms of consciousness. Afraid of speaking in half-truths that would then be upheld by novice disciples, they joined the long list of saints and sages across the world known for acting and speaking like fools, yet somehow ennobling and enlightening their listeners.

In trying to be the good author and start with a more scholarly introduction to the Tao, we fumble around with names and dates, and like so much water, the "Tao" slips through our hands as soon as we try to wrap our minds, our thoughts, words, or our pens around it. The *Tao Te Ching* says (or perhaps "unsays" all we could say):

> *"Silent and endless,*
> *Ever alone and permanent,*
> *Yet pervading all and everything without fail,*
> *It may be regarded as the Mother of the world.*
> *I know not its name,*
> *So I call it 'Tao.'*
> *Other times, in the absence of a better term,*
> *I call it 'The Vast.'"*
>
> —Lao Tzu, Tao Te Ching, Verse 25

In essence, we are being taught to grope out for our understanding of the Tao not with a historical knowledge, like this, but with a kind of pre-logical, absurd intuition—a meditative stillness.

The story of the Tao and the changes it has wrought in Chinese art, culture, literature, society, and even mundane thought would be a library in the telling. Over time, "Taoism" would gather to it all kinds of rights, rituals, practices, and beliefs, changing as it meandered through different regions of China and later Japan and other parts of Asia as well, though none of it would ever stick with enough tenacity to form any kind of cohesive system of thought, practice, or life. Even the idea of

the Tao was too elusive and ephemeral, and as such any practice meant to contain it like trying to catch the wind. Lao Tzu's poetic warning that we hush in its presence wasn't just a witty couplet; he was serious... And yet the shallower and deeper interpretations of the Tao both have brought beauty and an elegant refinement to the aesthetics and art of China, inspiring tremendous growth in painting, calligraphy, poetry, and even the art of living as expressed in the tea ceremony.

From the Naturalist poets to the legends and mythology of the Taoist immortals, the scripture to the morality and society of the times, even the ideas and philosophy of "Taoism"—though not the Way— would guide and move the history of China, beginning in earnest from the Qin Dynasty that united the several "Warring States," and from which we get the name "China" itself. There are no less than 5,400 texts that can be called "Classical" books on "Taoism"—let alone modern commentaries—and it would take a lifetime to sift through even the most important of their teachings. Though exploring such vast halls would be an interesting historical quest, the deeper, experiential aspects of the Tao are more central to the idea of using tea as a "Way." The real answers are in the cup anyway.

Let us then focus on the bamboo hut and tea-drinkers in the foreground of the huge unrolled scroll that is the Tao, perhaps remaining aware that above them is a great and glorious mountain chain that might be thought of as "Taoism" and its influence on the history and evolution of China; while still above and beyond that lays the veiled and thinning wash of blue, slowly cascading off the edge of the scroll to emptiness, which might represent the Tao itself, unspeakable and infinite.

The Grain Flowing Through the Wood

The wind rolled the trees down and up the valleys in broad combers, crashing against the distant beach of snow-clad giants. Like water it flowed—each branch a tiny eddy in the greater ocean of green. And gathering force, one perfect cyan leaf decided to leave its home, breaking free and for a few moments swirling up and down on the wind. At

the climax of one turn, the wind whispered its parting and traveled on, leaving the small leaf to rock back and forth to a soft landing in the river's hands. The current carried the smiling leaf forward, swirling round rocks, over small falls, bobbing below the surface and then coming up again in a loose and fey dance—the river providing the beat. Its edges curled in rapture as it spun around one dizzy turn after another, rolling over and coming to a stop against the old man's leg, who sat twiddling his worn and cracked feet in the mud. He stroked his long beard and reached down to gently pick it up. "What's this?" he said, smiling back at the leaf. "A quite unexpected visit this is, Master."

We often forget that living amongst all our amazing creations, we are still the most marvelous of all: the computer is an astounding tool, capable of so much already and with the potential for more, but does it compare to the brain? Governments and large corporations are all organized in bafflingly complex systems, demonstrating our ability to stratify and cooperate; but can any of it compare to the infinitude of processes working in harmony to sustain each of our living bodies at this very moment? And expanding outward to the Natural laws that govern our Earth, and then the turning of the galaxies, one gets lost in awe, admiring the Way it all unfolds each moment of each day, and without any effort.

This natural course through which all things move—the entirety of all the eddies in this great current we call a Universe—is what the ancients called "the Way (Tao)." As we have done here, they often compared it to a "Watercourse Way," using metaphors of rivers, lakes, and oceans to characterize the great movement of the universe. Like water, all events have a natural, innate predisposition to flow in a particular direction, including the lives of people. The Tao, then, is also the "Way" that a person achieves an accord with that river, for whether we fight the current or not, it carries us forward nonetheless. And yet, the man who turns about and acts in concordance with the river's weight, acts with all its tremendous power surging through whatever he does. Thus, the Tao represents the ineffable, indescribable totality of the river—the movement of the entire cosmos itself—and

also the way that one living being, on one small planet, might find a graceful accord with each step in its dance: as the Tao leads, we follow.

Based on these Taoist principles, the Chinese developed an aesthetic in all their arts that represented a creativity flowing in conjunction with the forces of Nature. This principle is called "Li," originally referring to the grain in wood or jade. *Li* is the fluid motion of the brush that creates unannounced calligraphy, beautiful as much for the graceful dance of the characters themselves as for their meaning; the landscape paintings that predate anything of the kind in the West, often conveying the movement of the mountains and rivers over time; and even the polished stones scholars all have on their writing tables; or perhaps the wonderful array of bamboo, stone and, most importantly, natural wood tea tables. And sipping this cup, I look down at my table and wonder what could be more beautiful than the natural grains within a piece of wood? Such beauty arises out of the natural principles and movements of the growth of the tree, based as much on the sun, rain, soil—Earth and Heaven—as they were on the inner nature of the tree itself. Being in accord with the flowing watercourse of the Tao invariably leads to actions that are *Li*.

The movements of the wind are guided by similarly open and respondent principles, twisting and turning against and with anything it meets, and so refinement and beauty were also often characterized as being "feng liu," literally "flowing with the wind." As the wind responds to the subtlest gesture, so must the follower of the Tao; and as the wind gathers greater forces and currents to it and channels them into its own movements, so must we learn to skillfully harness energy—personally and as a society.

As a force the Tao is the principle field of Nature, the very universe as the sum total of all existence, as well as the void of space in which it rests; but as the Way it is the intentional and skillful following of the current or grain of nature, as we live through it. In that way, humanity is viewed as growing out of the earth, which in turn grew out of the universe, and we are an integral part of its movement, rather than an alien species visiting here from another plane—for even if such a plane existed, it would still be within the universe as seen as the totality of all Reality, and therefore still within the Tao.

Unfortunately, the scientific view of the world has for the last two centuries stressed the idea that the world is foreign to us, and that the best attitude to have towards it is one of detachment, cold and objective. "But as the word itself implies, a universe of mere objects is objectionable," Alan Watts tells us with a Taoist whit beyond my own. And we are coming more and more to realize that the more we view the world in this way, the more it leads to a philosophy of dominance and conversion of Nature, attempting to force her to do our bidding and bend her will to ours. Such a distinction between the subject and object, however, is illusory since we are as much a part of the nature of this world as any mountain, stream, plant, or animal. Whatever we do to it, we also do onto ourselves. And even as our sciences progress into deeper and more elemental studies of the ways the universe operates on a fundamental level, we find ourselves returning to these ancient conclusions: that processes cannot be isolated from each other in actuality, only in the minds of the people observing them; and that all phenomena are deeply and integrally connected to all others.

Unfortunately, it's easy for us to discard such ancient philosophy as outlandish, when actually nothing could be more practical than learning to "go with the flow," cut with the grain, and more importantly find the natural Tao of each thing we use as well as our own natural course in life. Seeing all of Nature as sacred, and searching out the Tao of all the "ten thousand things" might just be the remedy for so many of our personal, and, by extension, greater social and environmental problems.

After all, every particle of every atom in all of us came from the matter of this universe. We grew out of it as naturally as the grains grew in the table on which I brew my tea. Isn't this the very essence of evolution? And as we face more and more environmental and social problems that are founded in our own disavowal of our part in Nature, we come to understand that we need technology and lifeways that flow with the forces of nature, rather than against them, or forcing them to bend in ways they have no propensity to go. Similarly, on a personal level, we cannot live happy, productive lives if we don't find our own inner current and learn to head its wisdom, as well as a way to be in accord with the greater movements of the people and world around

us. To once more quote the Western Taoist who best expressed these sentiments in English, "As human beings have to make a gamble of trusting one another in order to have any kind of workable community, we must also take the risk of trimming our sails to the winds of Nature. For our 'selves' are inseparable from this kind of universe, and there is nowhere else to be."

Harmony and the Way of Tea

While it is intriguing to explore the history, culture, and some of the philosophy of the Tao, however briefly, thousands of books haven't ever grasped it, and the best we can do is apply it to the Leaf we adore. In relation to my personal understandings and interpretations of the Tao—which we all should form individually as we walk the Way—as well as in its relationship to tea, I think that it's important for me to stress repeatedly that the "Tao" doesn't really have anything to do with any kind of "ism," as in "Tao*ism.*" To me drinking tea with Tao is relevant to all spiritual practices, though as you'll soon see, it has shared an especially close bond with the teachings of the Far East. And even for those who practice nothing specific, the quietness and harmony in tea is there regardless of what insights are derived from it. A very famous ancient Taoist poem says there are three-thousand six-hundred gates to the Way, and who are we to say that any method is not the "Mysterious and Shadowy Portal" that leads to the Ultimate?

I have briefly highlighted some of the background of the Tao as it has been captured by ancient Chinese sages only because that is the home of tea. Like most mystics, I believe the experience of Truth and its expression through time to be beyond words; and with poems, songs, scriptures, art, and beauty to be found in every time and place man has sought to understand the meaning of life and our role in it. And yet, it would seem that tea, the goddess of all herbs, would be more at home if we plant her in the garden she was born in and allow her to grow amongst the words and thoughts to be found in her native soil.

Of far greater importance, however, than any study of history, philosophy, or sages and their views, is the Way that we steep our own

tea in Tao. We have more pressing questions, in other words: How do we pour so much truth over our leaves? How do we also come to find the joy and beauty of Nature in a cup? Wherein lays the Tao of Cha?

Chuang Tzu and Lao Tzu, when asked about the Tao, often suggested that it was a part of all things, found in the dust and bricks of the World as much as the trees and forests of the pristine mountains. Since the Ultimate Truth was as much in the low as the lofty, it followed that quotidian life itself was an expression of that eternal stream, and that mindfulness of the ordinary moment was in fact contemplation of the entire thread of life. In celebration or suffering, we weren't to allow our ownmost truths to pass by unnoticed, but rather to find a Way of drinking from a harmony with Existence, as it flows past and through us in each and every steeping life pours.

The Way has always been about harmony, through the streaming moments of life to the stream of Tao itself: and the Way of Tea is no different. Through tea, we learn to listen to the unfolding moment, adapting and flowing in harmony with it, for we quickly realize that the best cups are prepared in such an unaffected way. We learn that even the flavor of tea is as much dependent upon the skill of the one brewing as the quality of the leaf. And beyond skill, we find insight in the very pronounced differences the mind has on the tea liquor.

The best tea sets are in harmony with each other; the best tea is made when the water, tea, and one brewing are in harmony; and the best sessions are created when the host and guests are all in harmony with the environment, tea, water, and teaware. Harmony, more than anything else, is how we steep the Tao, brew the Truth, and pour it for others. It also teaches us how to live, so that through tea we find a guide to lead us through our lives. The tea, rain, and sun, the water and all the teaware have a principle and current guiding them towards the perfect cup, and only when the person becomes but another natural aspect of this creation will the cup of tea that has "Li" be made and drunk, putting the drinker further in tune with the grain of the Tao. The master is a natural part of the tea ceremony in the same way the rain or sun are all natural parts that go into the growth of a tree over time. Rather than manipulating the leaves, water and utensils, he

becomes a part of a single river of experience leading from the Tao to the cloud, the rain to the tree, the leaf to the liquor, which is drunk towards a return to the Tao.

The hardest part of Cha Tao to describe, or achieve, is the **Tao**, not the Cha, which is why this chapter precedes the others. Anyone can learn about the history, farming, production, and preparation of tea. And many such experts will laugh at the idea that tea can be such a deep and central part of living a spiritual life, which to me means nothing more than living from the stillness and love at the center of our beings. To them tea is just a commodity, a hobby, or pastime. Perhaps some will laugh at seeking such depth in so shallow a cup. As such the Tao is Tao. Lao Tzu often said that if one utters a noise that even approximates the true Tao, more worldly-minded people will laugh at it, and hence the histrionics and outwardly foolish behavior of enlightened men like Chuang Tzu.

Using the metaphor of tea brewed or "spoken" as wisdom, the idea is that one speaks/brews plainly from the heart, and those with eyes and wisdom to see and hear will be drawn to such a "tea session" to have a cup, while those without the ears to hear will favor other, less pithy and silent tables—perhaps the more boisterous tea tables in the cluttered, social teahouse. I would go a step further and say that even the worldly-minded tea drinker experiences harmony now and again, and leave them to find such encounters no matter what they think about discussions of "Tao." Tea can and does become "Tao" for many tea drinkers today, whether they call it that or not, just as it has for millennia. And though that aspect of tea, as a living Tao, is extremely difficult to even approximate in words, I think there is inspiration to be found in the attempt, breadth in the cup it may inspire, and fellowship in common understanding of the peace and quiet of tea.

Cha Tao can be realized in the everyday life of any person. When guests come, a cup of tea is offered and conversation flows more smoothly. The culture of tea then becomes an interchange between friends and is often transmitted in this way. Later, one finds a kind of rich simplicity and abundant stillness through the ritual of drinking fine tea daily. The profundity found just beyond the silence that tea

inspires is deep, giving rise to joy and reflection, contemplation and meditation. Without such introversion a life is incomplete. As we discussed earlier, so many of the problems in the modern world are directly related to an ignorance of the dialogue between Nature and Man that can only arise when all external stimuli are removed and tranquility is sought. A healthy life with serenity, equanimity, and wisdom is not a figment of ancient stories, nor just the aged beauty of those hoary scroll paintings. Even in this day one can live in harmony with the Tao.

The Way of Tea is not some somber religious ceremony held in dimly-lit halls by a bunch of solemn tea weirdoes chanting between sips. There is no cult of tea. The "teaists" I know find in tea a Way of sharing their inner peace with each other, of relaxing the ego, allowing us to be free and open with one another. Drinking tea with Tao is about letting go of all our "stuff" and just being ourselves as we really are, in our true nature. And that "original nature" is the Tao, is harmony with Nature itself, and does help us find that dialogue of "Man/Nature" so missing in the modern world.

Whether our nature at that moment is celebratory, jovial and humorous, pensive, or even meditative and transcendent—no matter what expression we find in our calm center, it will be the right one, will be our "true face," and whichever aspect we show, in harmony with the Tao, tea will be right there with us. I have had wonderfully celebratory and social expressions of tea, filled with memorable laughter and kinship that won't ever be forgotten, and also deep and silent sessions with teas that took me into myself, expanding my mind and consciousness.

Despite all these words about the Tao and tea, most of what I know about Cha Tao is ineffable. I couldn't tell you if I tried. I could however share a cup of tea with you in silence, and then maybe you would understand. Maybe you wouldn't. I think the understanding that myself and others have with the Leaf is born from many factors: sensitivity, connection to the sensations of the body, a quiet disposition, a reverence for things aesthetic and natural, maybe even a love of the simple, ordinary joys of life (or perhaps even a certain breed of

insanity). Whatever it is, there is nothing like the smile that curves a face when tea whispers to a person for the first time. And its language isn't of the spoken word. It can't be written here. One has to listen to it, feel it course through the body and soul. Then the stillness and completion, the transcendence of time and self as one is lost in the present moment—all the life-changing stuff I've been talking about— the Tao comes rushing through one. I fall short... There are no words, however poetic, to capture the sensation of being with tea.

Still, I think I can try to capture a sense of what led me to these understandings, and the relationship I have with tea every day. This book won't, and cannot, be a substitute for even one single cup of tea. It can inspire you to find that cup, though. And if you already have found the quiet, present, sensitive completion that the Way of Tea has to offer, this book will just be a testament to that experience.

Na Po Tzu Kuei said, "Master, where did you learn this?"
"I learned it through the medium of the spirit of writing; writing learned it from the offspring of continuous study; continuous study learned it from clarity of vision; clarity of vision heard it from quiet agreement; quiet agreement from being used; being used from great enjoyment; great enjoyment from deepest mystery; deepest mystery from absorption in mystery; absorption in mystery from the ultimate."
—CHUANG TZU, as translated by Martin Palmer

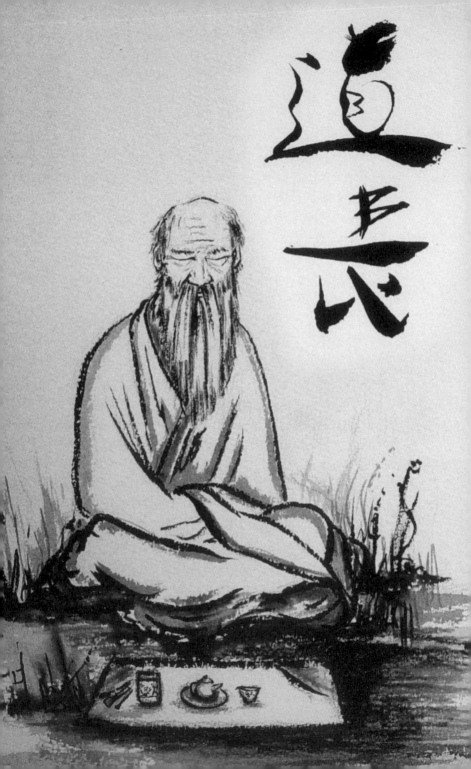

Tea and Health

F ar beneath the ornate dragon, the Son of Heaven lay dying. The old dragon, sculpted, carved and painted so meticulously over and seemingly through the grand ceiling, with scales of true gold and glinting ruby eyes, had witnessed with poised fluidity the procreation and then eventual death of many emperors before this one. Though the dragon seemed unconcerned, the pitter-pattering servants coming and going caused the old wooden floors of the palace to whine, as if the building itself was groaning with anxiety. The world was changing, after all, and destinies beyond count were star-tied to the events unfolding within the Forbidden City. Even the surrounding metropolis felt hushed and heavy, waiting for the news of change to pierce the mists of uncertainty. The kingdom's best doctors, priests, shamans and healers had all failed to restore the emperor, and so most felt it was only a matter of time before they witnessed a new ruler. However, the stars were more aligned than any of the court astrologers could have guessed, for the emperor's son-in-law, husband to his favorite daughter, in a flash of intuition remembered a very special jar he had in his room—the simplest of clay jars, wrapped in the finest of silk...

You see, years earlier, while studying at the great library in the distant mountains of Fujian, he had also fallen gravely ill. The monks there had served him a bowl of the most fragrant draught of Heaven, and amazingly he had recovered fully. He had ever since sworn that these magical leaves could be decocted into the immortal Morning Dew itself, with the healing power to cure all ailments. When he had left Fujian, he'd brought a small jar of the leaves with him to the palace... And then, years later, on the evening his lord lay beneath the dragon

dying, he brought that very same jar to his mother-in-law. Willing to try anything, the queen had the old leaves prepared as her son-in-law suggested. The fragrance alone pierced the old emperor's delusional sweats, and a cool countenance reigned over him as he gently sipped from the royal bowl…

With the dawn of the next day, the thick air surrounding the palace was pierced by sunrays of hope, for the emperor's fever had broken. Not knowing why, the people of the city felt compelled to come outdoors, as if the day had set down the burdens of the night. "Long will your dragon reign," said the warm spring breeze that day…

When he was fully recuperated, the emperor sent envoys to the southern mountains bearing gifts for the monks there. He also had ceremonial, royal red robes wrapped around the four old trees from which his mercy had come, formally declaring these very trees the first-ever non-human dukes and duchesses in all the vast scrolls of history. And though that emperor and his dynasty have long since faded to dust, their reigns reduced to glints in the old dragon's ruby eyes, those very trees still stand in all their regal glory to this day, known far and wide as "The Emperor's Great Red Robe (大红袍)."

Even a casual stroll through the annals of tea surrounds you with a vast library of such legends: of heroes who become tea trees in death, of monks finding the enlightenment of a lifetime in the smallest sip, of great healing and powerful return from death's doorstep through tea liquor and much more… Teas are named for where they grow, the varietal, the fragrance, the appearance of the tree or leaf or for a story like this one concerning their origin. Whenever such an origin story is lent to a tea, it is always one of magic, Heavenly beings or often healing powers like those that saved the Dragon Throne in this legend. This thread of tea lore makes sense, for as you know, they say tea was discovered by the legendary emperor and father of all medicine, Shen Nong (神農, the "Divine Farmer"). In one version of his tale, which also highlights the healing properties of tea, he eats some wicked poison, filling him with "seventy-two toxins." Realizing he will soon die, he reaches up to try one more leaf in order to understand one more herb and thereby share one more medicine with his people. Of

course, that leaf is tea, which they say then flushes the toxins from his old bones and rinses him clean. He then declares this wondrous leaf to be the "Emperor of All Medicinal Herbs." Thus, tea's very beginning is steeped in healing powers.

But what do we make of all these legends? Are these just stories celebrating how great tea is? I think most tea lovers nowadays would never even consider the possibility that tea could save someone who lay dying (under an ornate dragon with ruby eyes or not). And Shen Nong's claim probably seems strange to you. I know it did to me the first time I heard it.

For years, I have wondered about this mystery. I've read many books, articles and other introductions to tea in which the author says something like "tea was medicine to Chinese people for thousands of years," and I always pause at that statement to scratch my head, pondering all the possibilities such an assertion contains. And that curiosity is what has inspired me to leave home with the horizon on my mind. Of course, as Bilbo wisely says, "It's a dangerous business going out of your door. You step into the road, and if you don't keep your feet, there is no knowing where you might be swept off too."

I believe the best journeys always begin with questions. (And I think the best ones end with questions, too.) I've always felt that the "tea was medicine for thousands of years" summary is just way too reductionistic; it cuts too deep, leaves too much out... while I find myself standing in the wake of those "thousands of years" with a whirlwind of falling tea leaves swirling around me, each leaf shining with little gilded invitations to explore: Medicine? What do you mean *medicine*? Thousands of years? That is a long, long time! What happened? How is that different from tea now? Is tea still medicine? I certainly lost my footing as a result of these questions, and the road swept me off to the farthest reaches of my world growing up in small-town Ohio...

Decades later, I sit inside my far away island home, kettle steaming and bowl in hand, wondering about these same things and about all the roads that have led me here. I may not be so young or passionate as I was when I started, and I certainly don't feel like I have found any

answers, but I have found some great tea and made some great friends along the way… This book was the attempt of a much younger man to answer some of these questions and bring the sacred into tea and tea back into the sacred. Here are some more ideas I have discovered since writing this book years ago.

I hope this addition to this old book will inspire a spirit of inquiry and enquiry in you, beginning or deepening your tea journey. The world of tea is vast enough to spend a very pleasant lifetime exploring. (Trust me!) There is much more to learn about this enchanted Leaf and the massive amounts of culture, history, heritage, ritual and ceremony, healing and medicine that have grown up around it, as it crossed oceans of time and space to become a central part of the religion, health, society and hospitality of all the ten thousand peoples of this world.

In the great forest of tea education, I thought we could limit this additional discussion to just the grove of tea trees that relate to health and healing, as introduced by the emperor's story above. Even this arbor is really too big to explore here, so this discussion will hopefully end with more shimmering leaves swirling around inviting you to travel further—well beyond this book! After all, you cannot steep these pages, nor drink their liquor. The truth of tea and its medicinal qualities will only be truly understood by sun-dappled leaf veins, amber liquors with slow-falling drips and aromas that steal the breath from the soul.

Still, I write hoping to inspire the steaming kettles and tinkling pots of true understanding. I want to discuss tea and health from a few perspectives: Firstly, from a modern allopathic/scientific viewpoint, then from a Traditional Chinese Medicine (TCM) standpoint and finally from the perspective of holistic wellbeing, including spiritual cultivation. I will then conclude with some remarks on the quality of tea and its relevance to all these topics.

Hopefully, the white and green moss glistening with morning sun, the sound of the cicadas and the trailing vines that cover these old tea trees will then lead you to explore this majestic forest more deeply on your own. I imagine you surrounded not by these metaphorical tea trees, representing the ideas and questions posed here in this book, but *literally* surrounded by ancient tea trees in some old-growth forest,

wondering how you lost your footing and wound up there. I hold in my bowl your smile as you examine the moss, vines and leaves with great curiosity and awe...

Modern Medicine

Fortunately, research into the health benefits of tea is increasing. However, nutritional science can be a quagmire of conflicting and confusing results. Oftentimes, the researchers know tons about their fields and little about tea. One is therefore left skeptical of the impact "conventional" agriculture using agrochemicals has on their study, not to mention subtler influencing factors like tea tree varietal, soil composition, local water/air pollution levels or even production methods. Beyond that, I am unconvinced by research paid for or supported by tea companies looking to tout health benefits as marketing for their products, which is a common trend in nutritional science. That said, the more research conducted, the better for all of us tea lovers. And while much is open for consideration and discovery, there are some more commonly accepted truths about the health benefits of tea drinking, which I present now with the caveat that I am not a doctor, nor a scientist and am therefore not fully qualified to evaluate such data. Therefore, I would recommend following this introduction up with your own research.

The substances within tea that are commonly agreed upon to have health benefits are: antioxidants, polyphenols, amino acids and polysaccharides. There are other substances that some claim to have benefits, but these are the most mutually agreed upon ones according to my research. As a result of these substances, tea has been found to reduce the risk of cancer and heart disease. It also lowers blood-pressure, relieves stress and can help prevent diabetes. There is further evidence that it contributes to preventing eye diseases and even can help improve dental health. Some studies also claim that tea can increase bone density, helping prevent certain bone diseases like osteoporosis.

Some of the less certain studies I found also talk a lot about how tea prevents cholesterol and contributes to proper digestion. Some studies

claim that tea, or more often certain teas like green tea or puerh, can also contribute to weight loss. There are even some promising studies that suggest regular tea consumption can help improve memory. More research is required in all of these areas, some more than others, but most medical scientists agree that tea is a healthy beverage, and that the consumption of tea can help prevent various diseases.

There are some studies in the other direction, however, suggesting that fluoride in tea can be dangerous or that the microtoxins in puerh tea may also be detrimental to our health. However, as I mentioned, these studies are often conducted using mainstream tea bags and other "low quality" teas. I also wonder if fluoride in tea, for example, is due to irrigation, poor soil, agrochemicals or other modern issues and not to do with tea itself. In some studies, organic tea was found to contain much less fluoride, for example.

I hope to see more research on the influence of agriculture and production on the health benefits or detriments of tea consumption. I suspect that the quality of the tea used in the research will indeed have demonstrable differences. This is certainly true when it comes to Traditional Chinese Medicine and spiritual wellbeing, which is why I plan to devote a whole section of this discussion to understanding the quality of tea, as I think the same characteristics that make a tea "better" in terms of taste (connoisseurship), also influence its potency as a medicinal herb.

Traditional Chinese Medicine

Since tea is originally a Chinese herb, it is worth introducing Traditional Chinese Medicine (TCM) briefly and how tea fits within it. This situates tea as a plant medicine within the culture where it grew up, reaching a wizened maturity of many centuries old before it was shared with the rest of the world. It should be noted that while tea was raised and refined by centuries of Han Chinese appreciation and innovation—both in production and preparation—it was born in the aboriginal cultures of the Southwest of China, Laos, parts of India, Vietnam and Myanmar. Consequently, these peoples and cultures

must also be honored in any worthy discussion of tea's heritage.

The main differences between allopathic medicine and TCM are in approach. In modern medicine, researchers and doctors focus on diseases and treatments for diseases. In TCM, the focus is on the individual patient, not the disease. This is obviously a strength in some cases and a weakness in others, like dealing with viruses for example. The TCM doctor has an aim to help the patient restore and maintain balance. In Western medicine, "disease" is considered to be something isolated from the patient—an independent entity. Thus, the allopathic doctor seeks to diagnose the "cause" of an illness and will determine that seven patients with the same symptoms and "cause" have the "same" disease. However, a TCM doctor would view the patterns of disharmony in these seven patients uniquely. The patterns are similar to the Western understanding of "disease" only in that they will determine a course of treatment, but not as a distinct entity. Rather, the TCM doctor observes patterns and relationships among the symptoms and contextualizes them within all areas of the patient's life. TCM doctors do not seek the cause of symptoms, looking at them as part of a totality of the patient's behavior, biography and even spiritual being.

There is a strong emphasis on preventative medicine in TCM, which is often something that allopathic doctors also talk about, but we rarely go to see an M.D. unless we are sick, whereas many TCM doctors traditionally helped "healthy" patients stay that way. In fact, there are some stories from long ago of doctors that charged subscription fees except when their patients were ill, meaning that they saw their role as one of maintaining rather than restoring health, and when they failed at that they weren't paid. In the olden days, Chinese medicine also focused on destiny, self-cultivation and other spiritual aspects of their patients' wellbeing.

In general, TCM focuses on herbal medicines for restoring balance when one is ill. Of course, the other main therapeutic method is acupuncture. Bone setting, a kind of chiropractic, moxibustion, using mugwort smoke on meridians, cupping and other less common therapies are also used. Though most modern TCM doctors are skilled at more than one of these, there has always been specializations (moreso in the past). Aside from treatment-based herbal formulas and

acupuncture, there are many preventative methods used in TCM as well, including exercises, diet and certain herbs and/or formulas that are taken regularly. We could place tea within this category if we want, as it was viewed as a daily medicine used to maintain a healthy balance.

The stronger focus on preventative health moves the line of what is "medicine," which may account for why "Chinese people used tea as medicine for thousands of years" while modern people tend to think of tea as a "beverage." In the same way, TCM views a healthy, seasonal, macrobiotic diet as "medicine," while it is very rare for a modern person to regard their food as "medicine." If you stop and think about it, though, there is a strong argument for this. One's diet might play a larger role in one's health short and longterm than genetics, or at least an equal role. And diet will certainly be more influential longterm than any pharmaceuticals we take in our lives to treat illnesses we face, especially if those diseases could have been prevented by eating a healthier diet.

Tea was thus a "medicine" as it was thought to boost energy, clear the digestive system and prevent the imbalances that TCM views as the "cause" of illness. The origin story I introduced briefly earlier in which Shen Nong flushed the "seventy-two toxins" with tea represents a well-known and oft-repeated bit of TCM and folk medicine in which tea is viewed as having the ability to flush out contaminants. This attribute meant that "drink more tea" was a common part of the healing regimens prescribed to ill patients. However, as I stated, I think that tea was not often thought of as a treatment for an illness, but rather as a "medicine" to take every day to *prevent* illness from happening. And it bears repeating that this may be one of the reasons why the modern world tends to view tea as a beverage rather than as a medicine, just as we usually do not see diet in terms of "medicine" either.

I may be belaboring a semantic issue, but the intention of this work is to inspire questions not to offer answers. In the modern world, we tend to think of "medicine" as what we take *after* we are ill and discuss preventive attributes of veggies or tea as "health benefits." In TCM these are also "medicine." The lines are not black and white; there is a spectrum in both healing modalities (M.D.'s talk about diet and TCM

doctors can focus on treatment of illnesses). While this difference can be reduced to a semantic reshuffling of terms, I have found that exploring these concepts and thinking about how they relate to my own health and tea practice has resulted in a nice harvest of fresh, green and tippy ideas that have helped me tremendously. What happens when we adopt a prevention as medicine perspective? In other words, what changes when we see diet, exercise and tea as "medicine" to maintain balance and prevent illness?

Tea maintains balance. That is the simplest summarization of a TCM view on tea, though we can add worlds of complexity to that, since balance is not thought of as a one-time golden remedy—balance must be continually adjusted, and in relation to the seasons, environment and our unique individual constitutions. Just as there are thousands of medicinal herbs in TCM and infinite potential formulas (and many, many traditional ones), there are also many teas, all with different properties.

This general introduction lacks the breadth and depth to properly explore the relationship between TCM and tea. Acknowledging that, however, let me briefly introduce four broad areas of exploration that will hopefully be useful maps for you to get some general bearings if you do decide to travel your own tea paths to greater understanding of how to use tea as TCM medicine.

Yin & Yang

Like most concepts in TCM, Yin and Yang do not represent forces or substances, but processes or functions—ways things move and change. Like all the following concepts we will discuss, Yin and Yang are not transcendent mythological entities; they are merely labels to describe the relational changes of our world.

Yang (陽) literally was the sunny side of a sloping hill. Yang is any energy or force that is expanding, rising, growing, becoming. It is the "masculine" light of Heaven that is pushing, entering, penetrating and increasing. You could think of it as the intellect or mind in our experience. Yang is associated with heat, movement, activity, vigor, stimulation, excitement and outward or upward increase.

Yin (陰), on the other hand, is the shady side of a slope. Yin is any force that is sinking, absorbing, receiving or digesting. It is the "feminine" darkness of the Earth that receives, ferments and then transforms into new. You could think of Yin as the emotional heart in our experience. Yin is associated with cold, rest, receptivity, darkness, the interior, tranquility and completion.

The two are often depicted as a "tai chi" or circle with dots of the other within each one, suggesting that these two warps and woofs, 1s and 0s, are ever becoming and flowing into one another. It should be noted that within Yin and Yang, each are subdivided into another Yin and Yang since the two are constantly cycling into a becoming of one another. Thus, there is a Yin Yin and a Yang Yin, and so on.

In tea, the buds sprouting from the shoots are Yang. As the leaves mature, they cross a threshold and become Yin. We can see the young buds as a growing, *expanding* energy drawn from the tree and pushed outwards, whereas older leaves stretch out and become photosynthesizers to *receive* energy from the sun. In other words, buds move energy from inside out and large leaves photosynthesize light from without to store within.

Also, the older a tree is, the more Yin the tea will become, and the older we age the tea leaves themselves, the more Yin they become. Yin and Yang can also be applied to tea processing and preparation. For example, the type of kettle we use, the method we use to heat our water and even how strongly or how high we pour it from are all examples of Yin and Yang in tea preparation.

Hot & Cold

Foods, herbs and teas are thought to be heating or cooling in TCM. This can be confusing, as it doesn't really refer exclusively to temperature, but rather to the functions of our organs and energetic systems. Consequently, a raw food, consumed cool, can be warming (like mangoes for example), and vice versa, of course. In general, dark or roasted teas tend to be warming while fresh green teas or young sheng puerh teas are cooling. There are exceptions, like Liu Bao which is a black tea famous for its cooling properties. Understanding this

allows us to drink tea seasonally and/or based on the weather, aligning our bodies in harmony with Nature.

Five Elements
In the West, we tend to see the elements as an antiquated division of matter, categorizing the "substances" that our world is made up of. However, in traditional Chinese philosophy the Five Elements are processes, changes or transformations. In other words, they are *patterns*. Like Yin and Yang, the elements are not entities or forces external to the changes they describe, nor are they substances. The elements used to describe each pattern are done so allegorically, often because the substance in question is an epitome of that particular process. So water, for example, captures the essence of the pattern known as "water" in Five Element philosophy, but as an element "water" is more than just a substance. In fact, throughout the millennia that the Five Elements have been used, they have been applied to understanding everything from the seasons to colors, the flavors in our mouth to our emotions and much more.

The Five Elements move in cycles of support and control, growth and discipline. This understanding is important to an overall application of them in our life and tea. In the supporting, nourishing cycle water makes wood grow, wood nourishes fire, the ash of that then nourishes earth that nourishes metal, and metal supports water, giving it a charge that then helps wood grow and so on. In that way, each element is the nourishing "mother" of the next one. In the disciplining cycle, the "grandmother" controls or disciplines the element across from it, skipping a "generation," so metal disciplines wood and water disciplines fire, for example. The deeper you explore these relationships, the more you will be able to use them to understand health, wellbeing and tea growth, production and preparation.

There are a lot of exceptions to what element a particular tea is predominantly governed by, so we will have to develop some sensitivity to explore tea in this way. But here is a general, simplified start:

Metal: white tea (especially Yunnanese whites), certain black teas, *huang pian* (黃片, mature leaves), some aged oolongs

Water: green tea, often yellow tea, some young sheng, light oolong like *baozhong*

Wood: some black tea, stem tea, some young sheng puerh, middle-aged sheng puerh, some shou puerh

Fire: roasted oolong and most red tea

Earth: most shou puerh, some young sheng puerh, well-aged sheng puerh and some black tea

All of this can spiral into complex webs when we combine the concepts of Yin/Yang, hot/cold and the Five Elements, extrapolating to Yin versus Yang fire, cold Yin water and so on. The depths of this map are theoretically limitless. We can even apply such combinations to an understanding of tea trees and their environments, the production and then preparation of the leaf as well as consumption of which teas and when depending on season, weather, diet and personal constitution.

Jing, Qi and Shen

The "Three Treasures" of Chinese philosophy are Jing (精), Qi (氣) and Shen (神). These treasures represent the energetic makeup of all living things, including us. You can also expand their application to an understanding of all that exists if you want to. Even as conceptual placeholders, they are far deeper than we have space for, so please remember that this introduction will by necessity be oversimplified.

Jing is the vitality that empowers us. It is often thought of as our genetic makeup and reproductive power—seeds and eggs—and therefore related to sexuality and procreation. You could think of Jing as our genetic predisposition to certain diseases, our eye and hair color and all the other traits and qualities handed down to us from our ancestors, which we then pass on when we reproduce. Jing is also the power that we "dig" into when we need to push that extra mile physically or face a powerful emotional challenge.

Qi is a very difficult concept to translate, and no small paragraph will ever capture it. It is not a primordial material, nor a force flowing

through all things. Qi is the flow or movement of all matter—the part that equals energy before MC^2. Qi is the ceaseless throbbing vibration the entire cosmos. On the atomic level, you could think of Qi as the whirling of the electrons around their nuclei. Qi is the movement and transformation of all things, constantly pulsing and flowing. "Qi" literally translates as "breath," which is a metaphor for the winds of change blowing through all existence, creating vibration, movement and transformation. In a single syllable, "Qi" encapsulates the most profound root of a civilization that is thousands of years old. In a more narrow, and less cosmic sense, TCM views Qi as the circulation of blood in our bodies, the breathing of the lungs, flowing of liquids and digestion of foods. It is also our energy, determination and intention.

If Qi is difficult to describe, Shen is ineffable. In fact Shen is the most difficult of the three treasures to understand or describe. Shen is cosmic energy. It is the spirit—the Holy Ghost. This is the sacred star power that moves through the mysteries. In fact, Shen was often associated with stars and starlight, which we have serendipitously since discovered to be the source of all life and of all the periodic elements that make up our world and our bodies.

In general, herbs or formulas in TCM are "tonics" for one of the three treasures, working with our Jing, Qi or Shen. Though tea can balance Qi and Jing, traditionally it was thought of more as a Shen tonic, meaning that it is a spiritual herb, used to invite the cosmic starlight into our hearts. They say when the holy light of the Shen fills a human heart the eyes light up, which is why saints were often depicted with glowing eyes in Chinese paintings. It should therefore come as no surprise to learn that the earliest *Materia medica* to mention tea said that it was consumed "to brighten the eyes."

Spirituality & Health

Given that tea is a considered a "Shen tonic," it is worth discussing spiritual cultivation in relation to tea. There are and have been for centuries three approaches to tea: as beverage, as connoisseurship and as ceremony. The first two are akin to food, in that we can simply put a meal together or we can learn how to select ingredients and prepare

them as fine cuisine. Ceremony, however, is more ritualized, spiritual or even religious than the first two. These three approaches are not mutually exclusive. I drink tea in all three of these ways, sometimes within the same day. In modern times, the first two approaches are much more common, but the further back in time you follow tea's trails, the more tea culture narrows along the latter lines of connoisseurship and ceremony, eventually finding its winding way to a time when it was *only* ceremony. Fact: *ceremony, religion and ritual are the origin of all tea consumption.* All the four families of religious traditions found in China hold tea as sacred, each with their own rituals surrounding it. To the aboriginals, especially in tea's birthplace of Yunnan, tea was plant medicine central to the shamanism of tribal spirituality. In Daoism, tea was a way to connect to Nature and balance oneself, achieving harmony. To the Buddhists, tea was one of the central mindfulness practices, fostering calm and focus through motion—applying the meditative mind to daily life. And to the Confucian, tea was a ritual that brought social harmony and fellowship, allowing our "humanity (*ren*, 仁)" to flourish. Amazingly, tea is all of these things and more.

It is a shame that so many of us have stopped bringing spiritual health up in our conversations about wellbeing, which is reflected not only in the growing trend of tea as beverage but also in the way that most people looking into the health benefits of tea drinking will stop at the antioxidants and polyphenols, never looking deeper into Traditional Chinese Medicine, let alone seeking to understand tea's potential role in our spiritual health.

Stepping back, I am not sure that it helps to think of our overall wellbeing, our health, in specialist terms. There is obvious value in having doctors specialize in the diagnosis and treatment of certain physical systems, but in general our personal experience of health and wellbeing aren't compartmentalized, separating our physical, psychological or spiritual health. We don't experience these separately, in other words, just as we don't really experience our digestive system apart from our circulatory system. In truth, when the body is ill, so is the mind and vice versa. Deep trauma can be a contributing cause in physical illness, just as the latter has a psychological toll. Nowadays,

many people have no concept of "spiritual health" at all and think of their own condition solely in terms of psychological/emotional "wellbeing" and physical "health." Nonetheless, since it is common to view these areas of health as separate areas of our lives, I will discuss them as such for practical purposes.

There is no doctor in any modality—shaman, acupuncturists or brain surgeon—that would argue with the idea that stress is to some degree an unhealthy influence. Whether we are talking about preventative health, psychological wellbeing or the treatment of a physical disease, stress cannot help. It is causative in some instances and contributive in others. When you are sick, the doctor tells you to "take rest" along with the treatments she provides. At the baseline, a ceremonial approach to tea can relieve stress and facilitate relaxation, mindfulness and peace which are great for helping treat illness, preventing future disease and also for an improved quality of life and overall state of mind. Most would call that "psychological wellbeing," with some added physical benefits as a result of reducing stress in our lives. Beyond that, we step into the spiritual.

As this whole book, and you could create a thousand more, is meant to introduce the manifold ways that tea has been used spiritually for thousands of years, I would just like to invite you to investigate that relationship through further research and personal exploration. To inspire that journey, I want to highlight just *one* area that I consider paramount to "spiritual health," in the same way that a functioning digestive or circulatory system is to physical health or as contentment is to psychological wellbeing. May the questions that arise here inspire you to reach for the kettle again and keep searching…

One of the key areas that I think most everyone can resonate with when it comes to "spiritual health" is our personal relationship to mystery. There is a lot of mystery in our life and in our death. Our experience is surrounded by it—literally trillions of light years of space and billions of years of time worth of questions and more questions—endless unknowable Unknown. How do we face all that wonder? One approach to mystery is to erode it with research and discovery—learning more and whittling away at the block of what is

"unknown," by learning and discovering more "known." That is the scientific approach, and over time (generations) it works well and has its value. But within our own lives—our own births, deaths, joys and tragedies—this approach isn't as balanced, effective or healthy. When we try to hold the mystery at bay, it looms and makes scary intrusions into our life, often through illness or death. When we plot and scheme to make everything go a certain way, we "flood the arena of the Dao," as the old sages were wont to say, and leave no room in our lives for mystery, spontaneity or openness—for things to happen *to us*. We can get stuck that way, lost in circular routines that don't let the infinity of space and time which surround us to flow into our lives and expand us, offering us new adventures. The insight of spiritual cultivation isn't about knowing secrets, or even knowing anything at all, but rather an illogical, intuitive understanding that eternity and infinity swirl around and through us.

I think that a big part of what spirituality or religion offer us in terms of health is based on our relationship to mystery. We can choose to have our relationship to mystery be one where we ignore it, but we won't be able to do so for very long (and no relationship is healthy when one half ignores the other). I believe it is better to ask myself where I stand in relation to mystery—to the unknown. Do I fear it? Do I allow the unknown to play a role in my life or do I shut it out, trying to control everything in order to keep the mystery at bay? As the great Zen master Dogen put it, do I let the Universe twirl me or am I always trying to twirl it? In what ways am I ignoring my death and the infinite unknown that lies through that door? And in what ways would allowing the unknown to play a role in my life change the way I live and the quality of my life?

There will come a time for all of us when our physical and psychological health breaks down. We are mortal. Death is a reality that pervades our lives; it surrounds us and contextualizes everything we do. We are small creatures in both space and time. How we relate to those truths is a big part of our spiritual wellbeing, and you could argue that in the long run, our balance in this area will prove more important than all other areas of our health, since our physical health will falter

no matter how many preventative measures we take. (This doesn't mean maintaining our physical health or treating our illnesses aren't important, of course they are.) You could say that a healthy spiritual practice allows us to get the most out of life when we are healthy and then helps us to deal with the times when we are not. And throughout our lives, we will come in contact with the mystery through shadow and light alike: the joy of a dance, the power of a sunset, the death of a loved one or any of the other myriad ways Great Nature shows us Her part in our lives and our part in Her great web.

To be truly healthy, it is not enough for us to balance our own physical or psychological systems as though they are closed loops that can be controlled. You cannot find a healthy organism in an unhealthy environment—the fish in a polluted pond are also polluted. The imbalance in our collective spiritual wellbeing is therefore reflected in the state of our environment. For all our medical technology, advances in treatments and life-expectancy, we are surprisingly unhinged when it comes to the relationship we have to our home, our natural environment. A better relationship to mystery and Nature would create lifeways in harmony with its systems and truths. As we are very much individuals experiencing life through space and time, the Universe is also experiencing us as individuals experiencing life through space and time. Our relationship to the connection and flow of separation and connection, individual and environment is one of many central systems in our spiritual health.

Tea ceremony allows for connection with mystery. It has taught me to rest in flow and relax into being without doing—to surrender the impulse to do and stop "flooding the arena of the Dao." Sometimes (I am still a student in practice), I can stop trying to control details beyond my power and learn to be the moment, to let things happen to me. Then I understand that there are times to act, sometimes strongly, and times to accept. Through ceremony, I have learned when to push, when to pull and most importantly when to let go. Tea has taught me to be okay with mystery, and rest in "I don't know," finding comfort in the openness of not controlling or even understanding my existence/ environment—merely appreciating it. This allows me to step beyond

some of my most limiting fears and befriend death. Ceremony is a way of talking to Mystery that doesn't ask anything of Her, just watches and admires Her shadowy grace unfolding through the dance of our lives—the rippled black cloth topography of our ups and downs on this journey. Tea does this primarily by stepping past the logical, rational mind to meet me where direct experience encounters its environment. Each bowl is a gateway to the moment as it occurs, without any interpretation or understanding, in full-blooming mystery.

There are other areas of spirituality that tea can facilitate, but I hope the idea of having a relationship to mystery, and then asking yourself what your relationship to mystery is, will open some doors into the idea that spirituality is essential to health and at the core of what it means to be a human being. After all, you can find people who are thriving spiritually even as their bodies come apart and others in immaculate physical health who are spiritually imbalanced and lost. I personally would be far less healthy without spirituality (mostly meditation and tea) in my life. If this resonates with you, I recommend you follow these questions where they lead...

Quality Tea

The quality of a tea greatly impacts its healing attributes—no matter whether we are talking about allopathic "health benefits" (I believe), TCM balance or the spiritual wellbeing that tea provides. Tea is a very absorptive plant, moreso even than other plants. In fact, most tea lovers know that any given tea's identity is as much wrapped up in its environment, called "terroir," as it is in the trees themselves or the processing after it is harvested. In this way, the environment is the tea, and the tea is the environment. After all, tea leaves do not arise out of extradimensional portals (though that would be cool); the tree creates leaves out of sun, rain and minerals—out of the soil and other elements of its environment. It gathers energy from its leaves and roots and uses that to make more leaves, in other words. Simply put: *The leaf is the tree's expression of its relationship to its environment.* And that is as valid if you approach tea as a beverage and are looking for a

healthy cuppa, a connoisseur and seeking the highest quality tea or a ceremonialist relating to tea as plant medicine.

Aboriginals in Yunnan often plant camphor trees near to tea to influence its flavor and deter insects. The trees are absorptive enough to absorb something from a neighboring tree and as a result such tea does indeed taste like camphor. And this sensitivity also translates to dried tea leaves as well. For example, most tea lovers know that the kitchen is not a great place to store tea as the spices, oils and cooking smells will change the flavor and aroma of one's tea. In fact, with a bit of heat or enough time together, you can mix flowers or any other herbs with tea and the tea leaves will absorb the flavors, aromas and energy from those plants into its own, changing the liquor of such tea forever. However, this absorbative quality means tea is extremely susceptible to pollution.

Whether tea is a beverage or a medicine to you, it is ultimately a luxury in your life. Traditional Chinese culture viewed tea as a "necessity," and I would probably be amongst the first silly-looking fanatics in line to sign that petition, though it certainly isn't as important to our survival as food or water. And *if* there ever was a time when we could afford "luxuries" that come at the expense of our environment, now is *not* that time (and that's a big "if"). If tea is a beverage to you, don't you want a beverage that is healthy for you, for the farmers that produce it and the Earth out of which it grows? And if you are a connoisseur of fine tea, you know that a tea is its terroir, and if the environment is not rich and thriving the tea cannot be vibrant and rich either. I have often witnessed old tea masters exclaim "good year" at a batch of tea leaves covered in insect bites, knowing that this meant the ecology of the garden was vibrant and healthy that season, and thus the tea would be as well. If we chase away the insects, we also chase away the ones who eat the insects, and those who eat those predators and all their influences on soil fertilization and countless other contributing factors. Biodiversity is essential for plant health, vibrancy and ultimately the complex flavors and aromas we appreciate in fine tea. And if you are a ceremonialist, on the other hand, you must ask if you can find true peace when the instrument of your practice is damaging the lives of people and the Earth.

All quality in tea, therefore, starts with chemical-free, natural, sustainable gardens. *This is the foundation of all tea medicine!* As this work is meant to inspire questions rather than answers, it is worth asking: How do you love a leaf without loving the forest that produces it?

The amazing thing about tea is that the quality is dynamic and alchemical in a powerful way. There is a magic alchemy in tea that requires a powerful dance of Heaven, Earth and Human. As I will discuss in greater detail later in this book, the character for tea (茶) highlights this since the radicals are "grass/herb (艸)" above and "wood/tree (木)" below with the radical for "human (人)" in the middle. In order to make the finest tea, all of these factors have to be in perfect harmony. Even the best tea master, with decades of processing skill and generations of technique refined over centuries, will still have to wait for the weather to be perfect and may only see a few great "vintages" or versions of their tea in a lifetime—those years when everything is aligned. And this applies as much to the quality of tea in terms of its flavor, aroma, mouthfeel and other aspects that connoisseurs appreciate as it does to tea as ceremonial focus or TCM herbal medicine. It is therefore worth understanding quality in tea, as you begin or deepen your understanding of tea, no matter where you are approaching it from. To inspire that journey, here are seven aspects to tea quality:

1. **The Environment**
 The environment is the most influential factor in tea quality. This not only is the foundation for quality but also plays the largest role in the differences between teas. This means soil quality/composition and biodiversity, or lack of it. How much sun do the trees get? Is it morning or evening sun (different photosynthesis)? Is the land flat or sloped? (The latter of which allows for deeper roots.) You could also add what we call "cleanliness" to this, which means the local pollution, soil contaminants and whether or not agrochemicals are used.

2. **The Trees**

This will also determine quality and the uniqueness of any given tea. Healthy vibrant trees produce high-quality tea. How old are the trees? Are they pollarded (cut down to make picking easier)? Are they seed-propagated or cloned cuttings? Which varietal/cultivar are they? All of these factors will be very influential.

3. **The Season**

Which time of year the tea is harvested will greatly impact the tea's characteristics. Traditionally, almost all tea was harvested only in the spring, with some rare autumn harvests. Nowadays, fertilizers have allowed farmers a greater output at the expense of quality. The best teas will almost always be spring teas, and the height of tea quality is only reached when the trees are allowed to rest and gather strength and energy the rest of year.

4. **The Weather**

This is part of the "Heaven" part of the triple-gem needed to make fine tea. This includes rainfall throughout the year, heat, sun, etc. And the best of the best vintages of tea will only sprout when it rains for a day or two before harvest day, which is a sunny morning. This is variable for different types of tea, but is a general truth tea farmers understand. And like all farmers around the world, they all pray for the weather.

5. **Processing**

There are some types of tea where the environment is almost all of the quality of the tea, but for most teas the second half of quality will come through the manner and skill with which it is processed. The differences in processing techniques and skills are what makes a tea decent or a masterpiece. All tea is finished by a human. What method was used? Was it made by hand? Charcoal-roasted? All of this and more will define the tea.

6. **Storage**

How the tea is stored after it is dried will greatly affect its quality, no matter how long it is kept before being consumed. This includes light, odors, temperature, the type of jar, box or bag it is kept in and much more. If you are so inclined, you can even take this to the level of energy and wonder whether tea kept in a temple is different from a bustling marketplace.

7. **Preparation**

The amazing thing about tea is that it arrives to us raw. It takes the skill of fine brewing to really bring out the best a tea has to offer. This will include the water we use, the type of heat (fire), the teaware we use and the method that we employ to steep the tea. Two different brewers will produce very different cups of tea, just as two musicians playing the same sheet of music will sound completely different. To reach its full potential, a tea must be brewed with a skill that matches each of the previous six qualities.

Through Tea Make Friends (以茶會友)

Since we have questioned our way to this point, pardon me as I pull the Zen rug out from under this discussion of tea as medicine and question everything I have considered thus far. I especially question the idea that tea should be pursued for the sake of healing, or towards any other aim at all for that matter. Too much of my tea is aimless for that… Perhaps calling tea "medicine" is allegorical. Perhaps it's best to stop trying to get something out of our tea or drink it for polyphenols, balanced Qi or spiritual insight. Maybe we should *just drink tea.*

At the very peak of a great mountain of treasures that tea has brought to my life, the precious golden-joy-liquor is all the wonderful friends that a love of tea has blessed me with. I am open to the possibility that the best environment, trees, processing and preparation did produce mystical bowls that healed emperors or provided the last spark needed

for an old Zen master to find his awakening (realizing he was the same as before). Though I haven't experienced tea like that, I have had great tea sessions that suggest such is possible (or was). But I still come back to tea for the questions, not the answers; for the cups, not the write-up after the tea is done; for the journey not the destination. Like music, I drink tea for its own sake, which makes it very different from much of the goal-oriented activities in my life. If the goal was to get to the end, the fastest brewer (or musician) would be the best. (Actually slow, steady and graceful brewing will take you much further.)

And so, let the questions ride… Follow your musings on trips to tea-growing mountains to meet the only true "tea masters" on Earth (the farmers), experience tea in quiet, tea in conversation, tea as intimacy between two friends or lovers and tea as a celebration of being alive. There is as much medicine and healing in that joy and fellowship as there was in the brightest sip of the old emperor's life-saving draught beneath the old, intricately carved dragon whose watchful eyes are also oh-so-full of mysterious ruby questions…

CHAPTER THREE

The Veins of the Leaf

Long, long ago before the dawn of man, when the Tao wasn't a word, just a Way, tea trees reigned over the forests of southern China. Like wizened old men, they sat and whispered their silent conversations, unaware of the time passing by them. Connected to the Earth through deep and vast root systems, they spoke of the mountains that loomed over them to the West. They saw the sky when it was clean and clear, the rivers pristine and untouched by the hands of man. Some of them were old even then, with an unaffected wisdom of creation coursing through their trunks to the virgin leaves till then only steeped in dew and sunbeams. Were they perhaps meditating on their great past and future? Waiting for the first people to share their way of life?

Bordering Laos on the southeast, Burma and a small part of India on the south and west, this ancient forest region would later be called Yunnan or "South of the Clouds." Yunnan, the birthplace of all tea and cradle of Cha Tao, is a series of stepped plateaus starting in the tropical jungle-like lowlands of the south and rising upward in three giant tiers sloping towards the Tibetan Plateau and the great mountains there. Scientists surmise that the tropical forest near the bottom of Yunnan began after an ice age around one million years ago, and it was probably at that time that the first evergreen tea trees evolved, *Camellia Sinensis* being one of them. These ancient forests of tea would be alone in this virgin wilderness for many eons to come, long before they were a part of "Yunnan."

Most experts agree that tea probably originates from either one of two districts within Yunnan: the valley of Xishuangbanna, "Twelve

Rice Paddy District" in the local dialect; or the Simao basin, within the region of Lincang. Even today, gloriously tall and ancient tea trees tower over the forest floors of these regions, and some of them are estimated to be around 2,000 years old. Both of these districts lie roughly along the Tropic of Cancer, flourishing with wildlife and spirit, as well as species beyond reckoning. In fact, more than twenty-five percent of all China's native fauna and one sixth of its plants are found in this jungle. Thousands of species of birds and animals have flourished here beyond memory. Also, some 260 of 380 of the world's varietals of tea are still to be found in Yunnan today. It houses one of the richest biological and ethnic diversity in all of Asia. An incredible amount of aboriginal tribes have inhabited the southern regions of Yunnan for thousands of years as well, coming there for perhaps the same reasons the tea trees had. And it was in this rich, fertile soil and misty, rainy climate that the first ever tea plants grew up.

The original tea trees couldn't have found a more healthy and spiritual place on Earth—idyllic for deep and tall trees, for growth and movement. The balance of sun and rainfall is perfect year round, and the consistent fog and mist maintain the ideal humidity.

Beyond just the combination of rich soil and poignant mists, this part of the world is also irrigated by one of the most holy of all waters. More than 5,000 meters above sea level in Tibet, on the Zhanarigeng Mountain, there is a glorious spring the locals call the "Water of Stone." From this fount, a great flow of water and life begins its epic course down the steps of Yunnan, and eventually through six countries on its way to the ocean. Through Yunnan it becomes the Lancang River (River of Countless Elephants), in Thailand it is the Mae Narn Khong (Mother of All Water), in Cambodia the Toule Thom (Great Water), and then in Vietnam the Mekong. This "Danube of Asia" has ever been the mainstay of countless animals and people on its 4,000-plus kilometer voyage from the Himalayas to the South China and Indian seas. The Chinese once called this great body of water the "River of Nine Dragons," referring to the vivacity and spirit of the water elemental. The pure glacial water that flows down into the southern parts of Yunnan from that enshrined spring at the top of the world

brings with it an incredible amount of minerals, nutrients, and the spirit of the highest mountains on Earth.

Sages of the Tao, past and present, have always taught that there are what they call "Dragon Veins" running down into the Earth from the Heavens above, bringing "Cosmic Vitality" (*yang*) down into the energy of the Earth (*yin*). This philosophy forms the basis of the ancient teaching of "Feng Shui" which situated hundreds of the most famous and beautiful monasteries and hermitages in ancient China. Chinese landscape paintings clearly demonstrate this principle, and one can easily see the vibrant rush of energy flowing downwards. All of my trips to Yunnan, and all I have seen there, have left me feeling as if it could have been the very inspiration for such thoughts—the mountains, trees, water, and even sky cascading forward in vibrant rushes of energy, powerful if one gives credence to such ideas, stunningly and poetically beautiful even otherwise. With such an environment as its birthplace, it is no wonder that tea developed into such a powerful, rich plant.

A Meditation on What's Beyond "Southern Clouds"

Most books tend to focus on the portion of tea's story as it relates to the hands of men, listing several important characters, facts, and dates on the Leaf's voyage around the world. Such stories are intriguing no doubt, but for those more interested in viewing tea as a Tao, it is also important to remember that all the written history—all the factoids memorized, the characters that danced across the tea stage and the dates that they invented, bought or sold aspects of tea—all of that is but the very last watered-down steeping in a very long tea session. In a thousand-page book on tea, the whole history of tea as an art or commodity would only begin near the last page or two. Stretching back for a million years, the story of the Leaf is primarily one of trees, undisturbed in their primordial majesty. The real story of tea is a silent one; one where the first 999 pages are written in the quiet languages of the forest. And like the history of man's discovery and domestication of this plant, the greater story had its characters too—these many aged and weathered trees living for thousands of years in harmony with

Nature. And that harmony—that ocean of natural silence—is the real foundation of Cha Tao. While we cannot approach it with the pen, we can with the cup—for this great history is written in the veins of every leaf, and those who understand its language may read on to their hearts content.

One of the oldest Puerh tea companies, Tong Xing Hao, printed a new trademark ticket to put in their teas in 1935, including both Chinese and English since the tea was to be exported. In it they tell us that what makes the old-growth tea trees of Yunnan so special is simply that "the leaves made by the hand of man could not be compared with them." This simple statement, made as part of an antique advertising campaign, captures everything of what it means to connect to Nature through tea.

Cha Tao may also be drunk with an awareness of the legacy of tea, not as a history book of dates and financial transactions, but as a humble tree, lost in a forest of others for longer than we as humans can know. This is the real story of tea. And you might be wondering, then, why we have here glorified its birth, setting the background of Yunnan as a mystical, magical place. Though we can marvel at the perfect climate, the fog and the Himalayan water that formed tea, the reality of that time was actually so simple, so normal to the trees themselves. They just lived—without poetry, without name even. And that is what so much of Cha Tao is about: the elevation of the simplest aspects of life—the veneration of the smallest moments that we walk this Earth. We are learning to live: to live without any drama or effort, like the leaves themselves.

Drinking tea establishes a dialogue between Man and Nature, allowing the participant to communicate with his or her environment and a greater well of experience beyond the transient walls of the bodies we inhabit. This aspect of "man as a part of Nature" is something that is so often missing in the modern world. Like the slanting rays of sun cascading through the verdant tea forests, without askance and before there was a poetry to further polish the way they shimmered, our small handful of moments that we walk this Earth are each and every one dear to the World, as much its marrow and substance as any of the

days or seconds men have deemed more hallowed by some historical greatness.

With awe, I contemplate the trees I drink—their vast, untouched connection to ever-larger ecosystems, starting first with those pristine jungles, then on to the mountains, the rain and the sky, the sun and the moon, beyond even that to a communion with everything—the "Ten-thousand Things," as the Countless was called in classical Chinese literature.

> As the leaves of this tree are,
> I too am made of the water, the sky, sun, and stars;
> I share this essence with all the Ten-thousand Things.
> And in so doing, empty myself and my cup.
> As tea, I am now free to transcend the moment,
> Finding Heaven in a leaf.
> I ride the cinnabar mists
> Beyond the temple stairs
> And blue peaks
> To soar beneath the unveiled moon,
> Glancing downwards but once
> When the temple bells chimed.

Prehistory: The Medicine Pouch

Like anything, the history of tea begins the first time it is mentioned in writing. However, the history of a thing is often misleading in several ways: As mentioned above, there is often an untold story leading back long before the first time people started putting brush to paper. Also, that something is written down doesn't make it true. People often record things based on second-hand information, without ever having witnessed a phenomenon themselves. Furthermore, there are so many characters and events that happen beneath the radar of the pen—real and significant moments that occur ordinarily in times and places history wasn't watching, escaping the memory of future ages forever. Sifting through ancient texts, books, diaries, and trade ledgers of any

kind is a very difficult task, and the scholars that have enlightened us with the historical record of tea's journey through the world should be commended for the breadth of such work alone. Without rambling any further into a philosophical treatise on the nature of historicity, let us at least agree that there are many chapters missing from the story of man's appreciation of tea—stories we can only reach out and hear through our own tea drinking.

Besides the millions of years before man first rustled the leaves of that ancient forest in Yunnan, the first few thousand years that tea was drunk are also all pre-historical. There aren't any written records about this time, only legends. For the most part, it would not be until the Tang Dynasty (618-907 CE) that the story of tea comes clearly into focus within the lens of history's gaze, and from that point on develops into the story so many wonderful books have described. Prior to that, however, tea is but mentioned here and there through scattered texts dating back all the way into the Zhou Dynasty (c 1122-256 BCE). But what of the thousands of years between the time that tea was first discovered and when it was first written, traded, recorded, and made popular?

The too-often forgotten prehistory of tea is just as important, if not more so, as the time it captured the attention of the literati. Though we may not know all the details—the names, dates, and places—we can perhaps use what knowledge has been left in the form of so many pieces of art, texts, and legends as a kind of unsharpened, rough bit of charcoal to sketch out the meaning of tea in prehistoric times; and for me personally, drinking tea with meditative stillness is then the wet brush that fills in the rest of such a drawing.

If we are to draw such a picture, the first outlines would be of what exactly tea meant to the ancients: And above all else, it is clear that man first plucked and steeped these leaves as either medicine or meditation. There were no sales, no trade, no market—not even domestication. In its very earliest days tea was but one plant amongst many in a pharmacopeia used by aboriginal shamans to heal their tribes and communicate with Nature. Beyond that, I think it is quite evident that we have greatly underestimated the beginnings of man's role in the story of the Leaf. When exactly man first steeped tea is a mystery,

but such shamanistic and later Taoist traditions—the very same which began using tea—date back to at least 5000 BCE, and it wouldn't be surprising to find that tea also has such hoary beginnings.

In most cultures around the world, the shaman's role was to use meditations, herbs, or other exercises to transcend the mundane world and travel through the unseen planes within and without. He was an intermediary between the visible and invisible worlds, responsible for the tribe's psychic and physical welfare. He was their councilor, adviser, priest, and doctor all at once. And in China, this tradition of sages and seers lends the origins of tea a kind of mystery, magic, and wonder; for it was in their bowls that these leaves would first be sipped by man.

Even before Taoism would become important in the lifeways of Chinese people, asceticism was already an established aspect of some cultures. It was common for some such shamans to live secluded from others; and they were all, in the end, villagers and shamans alike, living in the forest. There they would seek out the origins of life and man's place in it. Through diet, meditation, and quiet, one imagines, these ancient sages and seers were able to commune with the world around them, learning of the healing powers available in Nature. In crude huts or cave hermitages, surrounded by the forests of Yunnan—in all their glory—man would first establish a relationship with the Leaf.

Perhaps it was intuition, or maybe they touched or tasted various leaves experimentally, expanding their medicinal knowledge through trial and error. However they first came to brew and drink the leaves of the *Camellia Sinensis* tree, I'd like to think that these ancient sages immediately recognized its spiritual and medicinal benefits. Like tea sages today, they too would have recognized the ability tea has to help man feel the universal energy of nature called "Qi," and found it to be a dietary supplement, promoting both clarity of mind and longer, healthier living. This tea knowledge, then, would have been shared and traded amongst the different peoples, slowly becoming a common leaf in the medicine pouches of all the shamans in the region. There are even texts that suggest the Leaf was used in many other ways beyond just drinking the liquor, including grinding it into a paste that was applied to the skin to alleviate rashes and bug bites as well as arthritic

pains. In those ancient days beyond memory, tea was a healer—just as it is today. There is also surviving evidence which demonstrates that tea was also used by these shamans to communicate with divinities, spirits, and even their ancestors.

Tea and the age of Taoist thought

During the Zhou Dynasty (*c* 1122-256 BCE) and the overlapping Warring States Period (*c* 500-221 BCE) Chinese society itself was in great turmoil. Political instability, feudalism, and a lack of enforced laws created a dangerous environment. Throughout the Middle Kingdom, it was common for aristocrats, scholars, poets, and those otherwise spiritually inclined to go forth from the "World of Dust," retreating to the mountains and forests where they were safe and secluded. The asceticism of the shamans from long before had become a part of mainstream life. By this time, Taoism was also already established throughout China, with some of its most famous texts dating to this era.

Taoist beliefs included the worship of Nature and ancestor spirits, the principal of living in harmony with the universe, and enlightenment through simplicity and balanced action without the interference of the ego. In tune with the times, Taoist philosophy also promoted renunciation and simple living in seclusion from sensual temptations. They believed that an unadorned, unspoken life in the forest brought man in harmony with himself and the world. There was no ethical sermon goading them to the mountains, but an inner and unsaid poetic force. As the great Taoist poet Li Po said when repeatedly questioned by a visitor from the city why he lived alone on the mountain:

> *"Oh why do I dwell among these green mountains?*
> *A laugh is my answer. My heart is serene.*
> *See the peach-petals float on the face of the waters!*
> *Ah,* **here** *is a world where no mortals are seen!"*
>
> —Translated by JOHN BLOFELD

In many places, these ancient mendicant sages were called "cloudwalkers," because the fogs and mists that surrounded their mountain hermitages were often even lower than the places they dwelled, and the heavenly analogy—perhaps dreamed up by those lowly mortals in the World below gazing up into those silvery veils—is enough to make any wayfarer, of today or long ago, shed a tear of angst for a scene vivid enough to adorn some wizened, old silk scroll in a Chinese museum.

And the cloudwalkers had also discovered the medicinal, meditative properties of the Leaf. Like the earlier shamans, these naturalists were also versed in herbal medicine, and had found that tea cleared the mind and sharpened concentration, making the transmission between teacher and student swifter. Through their weathered hands, tea became a Way of welcoming fellow travelers, disseminating wisdom, and an aid to transcendental meditation. In their simple, rustic huts or caves they would discuss the meaning of life and Tao over steaming bowls of tea leaves floating in water. They found that their heightened meditations and sharpened minds made the conduction of wisdom as smooth as the liquor itself; and from math to history, meditation to martial arts, the tradition of master and student sharing tea has survived even into modern times.

Tea to these ancient Taoist monks was also a part of the Way that they communicated with the universe. They gathered their water from mountain springs, boiled it in handmade kettles and drank from simple bowls. There was no art to their tea, only spirit.

While there were sages that left the city on quests for enlightenment and wisdom, others had agendas: often searching for the secrets of longevity and immortality, just as Western mystics and alchemists of the time were doing. There are so many stories in China and India of spiritualists living to a great age through meditation, herbs, yoga, or even kung fu. Even today, believe it or not, some are said to be in the hundreds of years old. For centuries Taoism was called the "art of the cultivation of longevity," and those that succeeded "immortals." They were believed to have miraculous powers and were respected and feared by people, as tales abound of their powers, one of which was the

ability to create the "elixir of life" that granted its drinker immortality. And it was these stories that would capture the interest of the early kings and feudal barons. In fact, many of the scholars that went out to research the Tao, medicine and/or meditation, did so for these lords. Just as many Western explorers would later venture into the wilderness seeking the fabled fountain of youth, so too did these early scholars travel deep into the mountains in search of the wisemen that had made their homes there. In fact, several well-known emperors and nobleman died ingesting poison thought to be the "golden pill" of immortality. Though, many of the more worldly sages that attempted such alchemy only made poison, the experimentation with herbs did result in a greater understanding of true healing arts. And as one such herb, tea became a part of the many legends and myths that these scholars would return to the city carrying in their travel-worn bags. Beyond just the sages seeking a life on the mountains, treasure-hunters also sought out the rare cliff-top tea trees, whose ambrosia was said to miraculously heal even deathly ailments and brew Heaven down into a draught.

Perhaps the worldly nobles and the scholars they sent into the forest misunderstood what the great mystics meant when they said that tea was an ingredient in the "elixir of immortality." Maybe this metaphoric speaking was more paradox and rhetorical foolishness that was meant to convey deeper meaning to the initiated. After all, what was the "elixir of life" but the recipe through which these sages attained enlightenment, "immortality"—a return to the "Source," the Tao. And the "recipe" consisted of simple living, meditation, diet, and, of course, tea drinking. As so often happens, the wisdom of such teachers, afraid to speak literally for fear of such misinterpretation from the moment they open their mouths, is ironically misinterpreted; and such was the outcome despite their attempts to winnow out those not willing or able to hear them. Some would come to think of their analogy of an "elixir" as a literal drink that would grant worldly power and long life—bodily, physical "immortality"—when in fact it was but a prescription for enlightenment, and through that a oneness with the universe. It meant immortality through a returning to the Tao, for the Tao is endless and one who was in communion with it would therefore never perish.

However, this was not achieved by mixing material ingredients together in the way such treasure hunters misconstrued, but in the sense of living in harmony with Nature, and the metaphoric "ingredients" in such a life: In essence a death of the ego that such materialistic people from the cities below would be incapable of grasping. Lao Tzu says that "he who dies perishes not, but enjoys true longevity." In fact, there are also some other ancient Taoist texts that continue this metaphor with treatises on "internal alchemy." Perhaps the "philosopher's stone" was a similarly misread tale—a tale of spiritual transcendence, and the method of achieving it, twisted and rewritten by greedy hearts that thought only in terms of earthly power.

Tea and Chinese Medicine

Chinese herbal medicine was an established profession more than 2,000 years ago, and it is therefore easy to see why this humble leaf—found to be so beneficial to the body, mind, and spirit—would eventually make its way through the countryside and beyond to other provinces outside Yunnan. Many of the early healers were the very same Taoist mendicants, which made a living by gathering and selling herbs or treating illness. They had come to replace the shamans before them, practicing more than just meditation or retreat. Some sages did retreat completely from the "World of Dust," living self-sufficient lives of contemplation deep in the forest or mountains, but those nearer to villages and towns all tended to be healers of some kind.

In such olden days, tea masters sometimes referred to tea as "Chang Shen Dan (長生丹)," or "Longevity Medicine," and the men who used it to cure "Tea Doctors (茶醫)," both of which are names I wish could be resurrected, connecting tea and the men that have healed so many of my worst days to these ancient periods of natural, holistic medicine—when health wasn't just an adjustment of the body alone, but a complete alignment of the body, mind, and spirit even onto and beyond the threshold of death, which wasn't a "failure" of a machine that was improperly adjusted, but a natural and indispensable aspect of the Way we all journey.

This chain of thoughts, for me, unlocks another of the insights I find in reverie of tea and its long relationship with man: That saying tea was either "medicine" or "meditation" to the ancients isn't really calling it two separate brews, as "medicine" to them was also something spiritual, and "healing" a lot more than just a mundane swill of bitter soup for the sake of more regular digestion or blood pressure. Similarly, Native Americans used the word "medicine" to refer to anything with spirit, magic, or power, suggesting that healing and meditation/prayer weren't separate spheres of life; and their shamans were even called "medicine men." As even a cursory survey of the history of medicine would show, the separation of the healing arts from the spirit is a very modern innovation, and one that some holistic doctors are starting to rethink in terms of what "health" really means. To be healthy, in the truest sense—"healthy" as only a human has the potential to be—we must have harmony between all the various forces that we are made of, corporeal and incorporeal both; and in this, like so many other things, our predecessors in tea understood quite clearly; for what is "longevity" without the wisdom so many years might grant us? And what is a physical "cure" but a temporary reprieve before the onset of yet another, greater illness?

The End of Tea's Forest Days

At some time in the Warring States Period, the domestication of the tea plant occurred without much historic to-do. There are a few remarks here and there about its presence in the markets, use in rights and rituals, sporadic comments about farming, etc...but very little of content from the period. It was first mentioned specifically by name but casually in a contract between a servant and master, listing the servant's duties, which including buying and preparing tea, written by Wang Bao and called *A Contract with a Servant.*

By the Han Dynasty (206 BCE-220 CE) farming and tea cultivation had reached a larger number of Chinese, and tea boxes have even been found in the tombs of royalty and nobles dating to the period, like the tombs opened at Ma Wang Dui in Chang Shia City, suggesting

that it was important enough to take into the afterlife. Throughout all this time, however, tea sages were still searching the wilderness for the taller, natural plants which were considered to be better than the leaves man had cultivated, though ordinary people would eventually shift their focus from quality to higher yield, pruning tea to bushes and harvesting them like any other crop. There was, however, a very real sense, both culturally and spiritually, that such changes trod upon Nature's garden, ruffling otherwise pristine verdure. Tea was always thought of by early Chinese as a very sacred and pure plant, poetic in its liquor and golden or pink blossoms alike, and many felt that it should never be transplanted. In fact, the tea plant itself was sometimes called "*Bu Qian* (不遷)" in ancient times, which means "unmovable."

Before we go too far and unjustly criticize the humble tea farmer, we might think a bit more on early farming. There is not much historical information about early tea farming, but we can imagine that the transition from gathering wild tea leaves to domesticating the plant didn't happen in a fortnight, but rather progressed in stages. At first, no doubt, the farming was much like many Puerh tea farms in Yunnan even twenty or thirty years before now, some of which still practice similar farming techniques today: in which seeds were planted with enough space for one another and allowed to grow into trees, harvested only after ten to fifteen years when the trees reached maturity. Such "arbor" farms are ecologically sound, and the space between the trees eliminates the need for chemical weed killers, pesticide, or fertilizer, as the trees remain a natural part of the biological ecosystem around them. To the untrained eye, such small gardens are indistinguishable from the natural surroundings of the forest. Also, tea is a rather tenacious plant, with deep roots, an innate ability to produce chemicals in the leaves that dissuade some kinds of insects from eating them, and the ability to grow in adverse environments that many weaker plants couldn't survive in. The myriad strains that developed over time on various mountains, in various climates are a direct result of the different environs the tea plant adapted to, sometimes naturally while at others transplanted there by man. The point being that as long as quantity isn't an issue, and the farmer isn't motivated by higher and higher yields

for commercial enterprise, the tea plant really doesn't need too much attention from the hand of the farmer, just a bit of guidance.

Undoubtedly, even after tea was cultivated in more of what we would think of as farms, with rows of plants that are pruned into bushes rather than semi-wild trees, the first farmers were often monks or tea sages, caring for the plants as part of the way they communed with Nature. On such high-altitude, monastery farms tea would first be nurtured into neat rows of hoed soil, and studied to find ways of improving the cultivation as well as processing of the finished leaf, but all with a care and reverence rarely found on commercial farms today. I'm sure that the early farmers had a deep devotion and respect for the land they tilled, a love of husbandry as a simple act of Nature, and a great adoration and pride in their tea. In fact, I don't think it would be an exaggeration to say that all agriculture in those ancient days was viewed as something sacred—prayed over and ritualized in the planting and then celebrated with deep gratitude and respect at the time of harvest.

Many accounts of tea farming, even up into the twentieth century, suggest that the method of harvesting was handled with great care, especially if the tea was to be given in tribute to the palace. A tremendous amount of religious ceremony would precede the harvest, with offerings to local deities, as well as rights based on Buddhist, Taoist, or even folk beliefs, depending on the region. Often only young girls picked the tea, and did so at a very precise time of year (based on the lunar calendar, but usually just preceding the spring rains— late March or early April). They were strictly watched by government officials who organized them into groups and often had them wear special clothing so that impostors could not steal some of the highest quality teas. They would wake up in the middle of the night and climb up the mountain paths, braving the chilly air, because the tea had to be picked before dawn, when the fragrance was best; and then processed completely before sunset of the same day. They grew their fingernails long, as touching the leaves with the hand would transfer oils from the skin. Their diet, cleanliness, and the precision with which they picked were all factors in such early farming, and some ancient testimony even suggests that they were forbidden meat and required to bathe every day

(a task not as easily performed in those days). Even today, though much of this reverence has been lost, it is mostly females that continue to pick teas in China and Taiwan, perhaps because their hands are thought to be more delicate and dexterous. There have always been exceptions to many of these formalities, but the reverence that surrounded early tea production cannot be doubted.

Tea would most likely spread from Yunnan into Sichuan, and then down along the Yangtze river, eventually passing through the famous "Three Gorges" to Hunnan and Hubei provinces. From there it would slowly diffuse to the other tea growing regions of China. Some of this propagation perhaps occurred naturally, though most plants were probably transplanted by man.

So often, all the important parts in the story of tea are passed over in a single sentence to the effect of "tea originated in Southern China." The story of tea does not begin with those who first farmed it, nor those that sold its powers for gold; it doesn't begin with Tang emperors and their courts; and neither is tea merely a story of processing, farming, domestication, and trade. All the stuff of textbooks—taxes, tributes, and Western boats full of brutes bent on re-creating the world in their own visions—are all but the end of a long journey tea had started before historical "starting" was even possible, a million years long!

The benefices of tea may be plainly evident, but there really is no clear explanation or timeline to describe how tea went from a humble tree in the forests of Yunnan to the second most consumed beverage on Earth. And yet, through tea's jumbled and varied story, passed on and drank by so many different peoples at different times for different reasons, it is clear that for most of the time that tea has been consumed by human beings it was either meditation, medicine, or both—especially, leaving the Ultimate aside, in the sense that tea so often is a calm, soothing "medicine" for the soul.

In fact, its diffusion from Yunnan to the rest of China can be attributed to these two factors: It was, throughout its entire journey, a spiritual method used first by shamans, then Taoist renunciates and later their Buddhist counterparts, or it was a sacred plant used by Chinese herbal doctors. I don't think there can be enough synonyms

or ways of uttering this same truth over and again, as it represents to me the greatest aspect of the Leaf's story. And even today, I'm always meeting other "teaheads" who have also recognized the sacredness of this exceptional plant. We regret to hear of plantations using fertilizers, weed-killers, and other chemicals to increase production, and cringe at the sight of a low-quality teabag. Perhaps a part of what Cha Tao represents, as a result, is also a return to the simpler and more ecologically sound days before tea became a commodity, attracting the attention of businessmen and merchants interested only in profits.

To the City

Firewood, rice, cooking oil, salt, soy sauce, and vinegar were the original "six necessities" to Chinese life. Untaxable by the palace, they were considered the right of every person. Later, tea was added to the list, becoming the seventh necessity central to life. Tea had traveled through the hands of Taoist meditators and healers as a sacred herb, been planted beside the many mountain-peak monasteries and drank with a reverence there, then passed down to the kings and scholars that they seek the poetry and beauty of life in sipping it in moonlit groves, and then on to the hands of simple farmers and tea houses that poured a river of steeped tea into the daily lives of everyone throughout the kingdom. Nearing the end of its journey, tea seeds had been mass produced and planted on farms throughout most all of the southern provinces and grown in a large enough quantity to ensure that each household shelved some, as well as exported to neighboring countries and eventually the West when the boats started arriving. Going to the tea houses became a part of every person's morning, for tea had become more that just a treasure, healing herb, or poetic cup held only by the intelligentsia—tea had become a part of life, too founded to even imagine living without it, like rice or firewood.

Even though tea was now produced in quantities that made the quality and spirit of lost ages seem almost mythical, there is no doubt that tea sages still wandered the hills in search of wild trees, or even that here and there in some small home a lonely scholar sat looking at

the moon through the branches of a winter plum tree between sips of some rare tea. From its earliest days to the present, the poetry, beauty, health, and spirit of tea have always been around, and though lost in what has become a commodity and casual aspect of daily life, tea sages even today share sessions in mountains, shops, and homes; poets still compose songs of tea-inspired beauty, and painters and calligraphers still pause now and again to have a drink between brush strokes.

Eventually, the Tao of Cha would also find its way back to the cities as well. Books from such hoary towns, like *The Ritual of Zhou*, which was written around 500 BCE, describe how tea was used in all kinds of ritual prayers, and for communion with the spirits of Nature. It was a huge part of wedding ceremonies—exemplified by later customs like the Yunnan brides who climb trees to gather leaves for their betrothed, or the Northern custom of offering tea to the groom on the wedding day (I myself was given tea by my wife on our wedding morning)—and also funerals, both as an offering to the dead and as a ward against ghosts. One early story even states that a woman who had faithfully given the best tea as an offering to a tomb on her property was visited in her dreams by the ghost that dwelled there, thanking her for all the tea, she awoke to find gold coins in her room.

Practiced away from the serenity of the mountains and the deep presence of the masters that formed it, however, the freedom and natural movement of the tea ceremony began to slowly formalize, becoming rigid and hollow. As with any meditation, time and repetition without presence and power of true transmission will cause the essence of a method to be lost. Divine principles become hollow ethics and opprobrium, transcendental mythology becomes literal dogma, and connection with the Ultimate a mere fable that was only possible in the past.

Many of the tea sages that lived on those ancient mountains were beyond even the scribbled or spoken concepts of "transcendence" or "enlightenment," as wobbly as they are in the ordinary minds of men. The universal energy was there, but not expressed verbally—it didn't need to be. After all, why talk of that which everyone present is clearly experiencing, and not singularly but again and over years of meditation?

Tea was, to the cloudwalkers, simplified to nothing but hot water and leaves. And knowing very well that the truth of the Tao was corrupted by any words—specifically teaching that in fact—they would have found other Ways to express and communicate the Tao to one another. What better way than tea? If I am empty, vacuous as Lao Tzu so loved to elucidate, then the Tao flows through me, carrying my energy and understanding into a cup of liquor that you, as my guests and fellow travelers, then consume into yourselves—in essence, becoming that which I wish to communicate with more profundity, depth and clarity than an encyclopedia of words. The tea ceremony, consequently, conveyed more of the Tao than was possible in the cities, at least if the people involved weren't themselves open and clear to the flow that would then consume the ceremony, coursing through their liquor.

"But, alas," we can only sigh, "the knowledge of the mountain can't survive long in the marketplaces of the World below." As our own American recluse Henry David Thoreau so poignantly admonished, "…trade curses everything it handles; and though you trade in messages from heaven, the whole curse of trade attaches to the business." Similarly, if the one preparing the tea isn't steeped in the Tao, the Way of Tea is but a performance that is just so many empty and echoing motions and gestures, rather than a sanctification of the essence of tea itself. To be with Tao, Cha must be a "sacrament" as Thoreau's dictionary defines it, "an outward and visible expression of an inward and spiritual grace."

As its spiritual use became more and more for the few, tea as a social lubricant and symbol of culture and aesthetic would slowly begin to spread round the world. In reality, tea has always adapted itself to the culture in which it is enjoyed, changing as it spread through Asia and eventually the West. This isn't necessarily a bad thing, for living tea, beyond just drinking it, means doing so naturally and free, open to all ways and exchanges the day brings—approaching all the ordinary moments of life with the presence and clarity of the mountain where we drink our tea each day, the mountain in our hearts and minds.

To understand and revitalize the energy of these lost eras, we must further explore the wisdom of the early sages and seers, becoming ourselves more than just gatherers of useless information—being not just

THE VEINS OF THE LEAF

"readers and reciters," but "seers" of life and Tao—and then responsibly promote such organic, living wisdom to any farmers, producers, and drinkers of tea that will listen. And I truly believe such a change in approach and understanding of tea can only happen when recognition is paid to the fact that tea is, at its core, something sacred and pure—as naturally majestic and awe-inspiring as any mountain, river, or animal.

For thousands and thousands of years, Chinese people harvested and utilized tea without ever upsetting the balance of Nature, hurting the trees or ecology of their environment in any way. In our lifetimes, so-called innovation is shattering much of what was left pristine for hundreds of generations. Living tea means that we must be responsible for the tea we consume. We must help to educate consumers and promote environmentally friendly agriculture. For myself, it helps to remember that tea is a meditation or medicine, and should be respected as such.

Just imagine those mist-shrouded mountains of ancient China, green with a verdure we can only dream of—and the mendicants there, seated deep in meditation, their long beards stirred by the occasional breeze. Imagine these first tea ceremonies, quietly if you can. Think about the way these sages used the Leaf to commune with themselves, each other, and Nature. Let your thoughts drift to stillness like a falling leaf, a leaf from a hidden, background kind of tree…

Drank with longing for times before,
When the clouds below were the silvery veil,
Separating myself from the world of men.
I remember my life then,
So clean and pure,
And the visitor I had from the capital.
He asked me about the Earth,
So I served him tea.
He asked me of the Sky,
And I poured another cup.
Then when he asked me of the Spirit,
I could only give him more tea.
After that,
He was quiet for some time.

What's in a Word?

The term "tea leaves" first appeared in Chinese written records somewhere around 3,000 years ago. An ancient text called the "Er-Ya" (爾雅), which was a dictionary of sorts, stated that "jia"(檟) was a bitter tea, "ku tu" (苦荼). "Ku" (苦) is the Chinese character for bitter and "tu" (荼) was the controversial word for many different plants. As the word "tu" was used throughout different texts, sometimes poetic other times mundane, its difficult to know exactly when it was used for tea, referring at other times to sow thistle, certain flowers, and other spices in cooking. Wherever one stands with regards to this etymological debate, it is clear that the word "tu," as well as several other words like "chai" and "ming," evolved into the character for tea or were used thusly in certain times and places as early as the Zhou Dynasty.

For quite some time, there were many characters and ways of saying "tea," depending on the region and era. Then, during the Tang Dynasty, all the earlier characters for tea were abandoned, and a new character was created to replace them. This was done by modifying the character "tu" (荼). The lower part "he" (禾) was changed to "mu" (木)—meaning wood. The new character "cha" (茶) has remained the Chinese term for tea ever since.

The various pronunciations of the character "tea" spread far and wide. The Mandarin pronunciation of the character, as "cha," spread overland to the north and west of Yunnan. Tea is, for example, called "chai" in India, Greece, Russia, etc. Another pronunciation of tea as "tey" followed a second sea-route from Xiamen of Fujian Province. The Western sailors that stopped in Xiamen and other local ports would adopt the way tea was said in the local Fujian dialect; and "tey" would later become "tea" in English.

In contemplating the character for tea, one can corroborate the extent to which ancient Chinese revered tea as a sacred plant. The radical for grass is drawn at the top, with trees at the bottom and man in between. Perhaps a more mundane interpretation of this would be that the character refers simply to any edible leaf. And actually, the word "cha" does refer to any leaf steeped in water; and even teas that we would today call "herbal" or "tisane" were still considered "cha" by

Chinese doctors and tea sages, as well as more mundane applications related to culinary pursuits. There are therefore other plants, in Yunnan and elsewhere, that ancient mendicants were also utilizing to heal and commune with Nature. I have drank a few kinds of lichens in such a manner, for example.

The roots of the character for tea date back beyond the Tang Dynasty to the Han Dynasty (206 BCE-220CE) or even earlier, and have deeper elements if one but looks for them. Calligraphers often have the ability to see beyond the characters to the deeper essence hidden in the words. The ancient Taoists invented several scripts that were only legible to initiates, and often resembled the leaves of trees, ripples of water, or even animal footprints—all of which was intentional, as the script was derived from intense contemplation of Nature.

One of my venerable tea teachers, Huang Chan Fang, is a "tea doctor" in every sense of the word. If any artist, teacher, or tea master is connected to the pulse of those ancient Chinese healers, it is he. He spent many years searching for the spirit of the character "cha." Last year, he made the drawing shown here. One can almost immediately recognize the poignancy of painting tea in this way. It is the perfect representation of man in tune with Nature. The person isn't just climbing the tree to pick leaves, he is living within the tree itself. Many Chinese characters have stories—pictographic lessons hidden deep in the ways they have been drawn over time. For me, this drawing of "tea" captures all the majesty of those lost ages when tea, as an aspect of Nature, and Man were in harmony. Furthermore, the symbol of a human in the tree is a very ancient and deep picture, representing the *axis mundi* around which the earth rotates—the center of the universe.

Tea can root us in the ground, as well as free us beneath the sky. There is much in the etymology of the character for tea that I find inspiring. I am moved by the simplicity of drawing a man between leaves, roots, and the trunk of a tree. I once read a Native American myth that told of a warrior that turned into a tree when his people died; first his arms became branches, then his feet slowly moved beneath the earth and extended his spirit into roots, and finally he was

a tree left to watch over the land he had been born on. The metaphor of becoming Nature is also expressed, to me, in this interpretation of the character for tea. The idea is that we also can live tea, becoming a part of Nature rather than standing outside of it as an observer; and that such a "becoming" is really a return to our original state.

The Legends

There is wisdom, too, in the stories that Chinese people passed down as the folklore of tea and its origins. The mythology surrounding tea also relates to the belief that it was sacrosanct, to be respected and revered. In retelling these legends to their descendents, they were teaching their children to respect tea, its qualities and source beyond and before man. The mythology of a people is often a metaphor for the way they see themselves within the greater universe, and the manner in which they believe that a life should or shouldn't be lived. The different legends of tea all highlight different aspects of it, sharing an understanding of the veneration that Chinese people have always had for this plant.

Shen Nong

Shen Nong, the "Divine Farmer," is attributed to be the first person to discover and drink tea. Shen Nong was the legendary second emperor of China, dating back more than 5,000 years. They say that the study of medicinal plants in his kingdom fascinated him. He painstakingly tasted innumerable species of herbs and shrubs, recording their properties for posterity. He is reported to have reigned for 140 years— tea's "longevity" obviously at work again—and been able to ameliorate more than fifty different kinds of poison. He was a king, a teacher, healer, and mystic. Shen Nong discovered that tea leaves were edible and possessed healing powers when brewed, and quickly favored the Leaf above all the other plants he had studied. And thus began his fascinating quest to identify and classify all the varieties of tea. Shen Nong then extolled the virtues of tea to his people and taught them the methods for farming and cultivating it, as well as several other herbs they could use to improve their lives. He is often accredited for helping

the people of rural China change from a hunter-and-gatherer society to one based on agriculture.

As the story goes, Shen Nong accidentally tasted a type of poisonous weed that could kill a man within ten steps. And yes, only tea leaves could save him. But before he could reach any tea bushes, the poison took effect. He died at the seventh step. It was a great tragedy, legendary in fact, but his discovery of tea and the mythology surrounding him would live on. Even today many aboriginal people in Yunnan pray to Shen Nong for a successful harvest.

The mythology of the Divine Farmer captures and personifies the essence of all the shamans and chieftains of the ancient aboriginal tribes that first harvested tea. He represents the greater power of Nature as a bestower of plenty. Shen Nong is the embodiment of all the tribal wisdom handed down for so many generations, capturing the essence of man's place between Nature and Heaven.

Bodhidharma

The early shamans and Taoist recluses may have formed the principles of living tea, but it was the Buddhists that steeped China in the Way of Tea. Buddhism spread throughout Asia from India mostly due to the efforts of the Emperor Ashoka (304 BCE-232 BCE), who sent out emissaries to proselytize as far as the Middle East and Southeast Asia. Buddhist thought most likely came to China through Tibet, fostering cultural exchange on its way.

When new religions enter the lifeways of a people, they very rarely replace the previous ones completely. Anthropologists call this phenomenon "syncretism," referring to the ways that the old and new religions are blended to form new systems of thought. The first Buddhist monks that came to China found that their understanding had a great affinity with the Taoist ideals already established there. The new religion that formed out of this dialogue was "Chan," or "Zen" as it is called in Japanese and often English.

The combination of earlier Taoist, Confucian, and then Buddhist thought would guide the art, literature, culture, government, and society of China for all the centuries to come, as the old saying goes, a

Chinese "wears a Confucian cap, Taoist robe, and Buddhist sandals."

Boddhidharma, or "Da Mo (達摩)" in Chinese, is the legendary first patriarch of *Chan* Buddhism. They say that it was he who crossed over the mountains to bring the teachings of the Buddha to the Middle Kingdom. He is often depicted with a scraggly beard and a ferocious grimace on his face, sometimes practicing kung fu—for it would be the Buddhist monks who would also go on to develop most of the early martial arts traditions, needing to protect themselves in the disorderly and untamed wildernesses of ancient China.

According to legend, Bodhidharma was a very critical master, and when he first came to China wouldn't teach anyone, as he couldn't find a pupil worthy of being his disciple. He then decided to retreat for nine years of meditation. During one of the longer nights of his vigil, he began to feel drowsy. The great leonine monk's eyes disobeyed his will and fluttered closed for but a second. In a rage, Bodhidharma tore off his own eyelids and tossed them to the ground. And as the story goes, his divine eyelids sprouted the first tea trees.

Obviously, this story illuminates the power tea has to sharpen the mind and keep us awake, improving meditation. It also acclaims the "strong determination" that is a Buddhist ideal when practicing meditation.

Eventually, the first patriarch would take on a pupil. The poor student had been pestering him to learn for several years, but Bodhidharma didn't think that the young man was devoted enough. Finally, Huike, as he was called, cut off his own arm and brought it to the old sage as a testament of his willingness. He would then go on to become the second patriarch of *Chan* Buddhism, and, as the legend goes, further the spread of the religion throughout China.

The role that early Buddhism played in the spread of tea cannot be overstated. Both Yunnan and the other provinces where tea was first farmed, like Sichuan, are on the trade route between Tibet and China. Beginning in a region where tea was such a part of daily spiritual practice ensured that the followers of *Chan* would also do so. In fact, some of the early patriarchs that followed Bodhidharma in mythic succession, like the one-armed Huike, were said to have studied

Taoism prior to learning *Chan*. Moreover, *all* the most famous teas in China come from mountains that also have important monasteries on them. Perhaps some of them are even founded on places where special strains of wild tea were found growing. I don't think it would be a presumption either to suggest that in *Chan* (Zen) monasteries the act of farming itself was considered a meditation, as novices and masters alike were encouraged to take part in all the daily activities of the monastery, cultivating awareness during mundane tasks.

Legends aside, it seems obvious that as the new religion mingled with the old, the Taoist sages would no doubt have passed the Leaf on to the monks, especially since it was already the well-established custom when travelers met, the bowls over which deep discussions were held, and the sustenance of transmitted wisdom. Of course, at least some of these Buddhist monks—being sensitive meditators themselves— would have also recognized the power tea has to facilitate meditation and calm, and quickly adopted it as their own.

The people would think of these *Chan* masters in the same way they had the Taoist cloudwalkers, as "immortals." The legend of Bodhidharma clearly elucidates their perspective on tea, and the way in which Cha Tao became an integral part of their daily practice. Early reports from travelers to China offer us testimony that in many of the monasteries tea was offered to the Buddha as a sacrament itself, a part not only of living *Chan* (Zen), but something sacred and otherworldly in its own right, which is of course a sentiment expressed by the legend of Bodhidharma as well.

The Birth of an Art

Aside from the religious routine, early Buddhist monasteries were much like the colonial forts of early America. They weren't just places of retreat and worship; they were also schools, hospitals, and even asylums for refuges and weary travelers. When the common people were in danger, or when they wished to trade, they often would come to the monasteries for sanctuary. This explains why the monks were often also warriors, establishing the different martial art traditions

of China; and many of those schools, even after they split from the monasteries, carried on using tea as a way of passing on knowledge and inspiring inner peace. The people coming to the monasteries would no doubt have been exposed to tea all the time. The legendary *Chan* master Pai Chang was known to have included regulations about tea into the monastic code of those living in his monastery, for example. The Buddhist monks, and Taoist sages before them, had already been improving not only the methods of cultivation, but preparation and aesthetics of tea long before the time when these monasteries became such thoroughfares.

Though the Way of Tea had reached the cities to some extent even during the time of the Taoist sages, it would not be until the Tang Dynasty (618-907 CE) that tea would become a truly common beverage, appreciated by so many people throughout the Middle Kingdom. And for the most part it was through the calm welcome of the monastery that much of the public of China would have its first introduction to tea.

The Tang Dynasty was the golden age of Chinese culture and art. The economy was flourishing through trade, and new forms of music, art, literature, and philosophy began to bloom as well. During that time, tea was being cultivated in more than 40 provinces, some of which would be sent to the emperors as the now-legendary "tribute teas"—a tradition continued throughout the successive dynasties as well.

Even the art of tea itself didn't begin in a mundane shop somewhere in the boisterous cities of ancient China. Tea art, at least initially, wasn't an expression of the plebeian: Like all the previous aspects of this narrative, the art of tea was also born in a tradition of reverence, meditation, and as a way of celebrating life—the serene mountain-top monasteries with all their calmness, tranquility, and equanimity forming the basis of its principles.

The Buddhist precept that admonishes monks not to eat any food after twelve noon, quickly made evening tea an important aspect of the day, fostering awareness during the evening and nighttime meditations, and many of the early tea scholars, poets, and "immortals" were also fond of carrying their tea sets to remote regions to enjoy moonlit

sessions. Their poetry and painting revives these ancient nights for us, like the famous Su Dongpo who often wrote of tea (and wine) drinking on moonlit nights, with all the ambience of the river, temple bells chiming, and other poetic devices backing such sentiments. Another famous poem from the Tang Dynasty captures the same emotion, as translated by Ling Wang in his prolific work on tea, *Tea and Chinese Culture*, elegantly expressing the way tea changes everything from the mundane to the poetic:

> *A guest came to my home on a cold night.*
> *Hastily I made tea in lieu of wine.*
> *Atop the bamboo stove, water boiled in the kettle above the red flame.*
> *Looking through the window, the moon was made more beautiful*
> *by plum trees in blossom.*

The art of tea was, to such early scholars, poets, writers, and painters an attempt to capture some of the depth and serenity harmony brings, and the fervent need to convey such truth to others. As people came to the monasteries—including the upper classes and even royalty—the monks served them tea. They too would recognize its blessings, desiring tea for their own daily consumption. At that time, the story of the Leaf would really become one of farming, processing, trade, variation, etc., with shops opening up in the cities below.

Though there was domestication of tea, perhaps dating back even to the Zhou Dynasty, a lot of the real innovation and experimentation would begin at this time. The processing techniques were refined and tea was compressed into cakes, which were then ground into powder before brewing, and the monks played a big part in the development of the complex process for brewing tea in this way.

For most of the Tang Dynasty tea powder was boiled in a cauldron with other ingredients. The cakes were re-roasted and then ground to powder. When the water in the cauldron reached boiling, the tea and other ingredients were added. The monks encouraged the literati, artists, and even royalty to utilize the time that the cauldron was boiling for contemplation, seeking the answers to the nature of the

universe in the slowly rising bubbles, and books from the period would also proscribe as much. Towards the end of this era, however, a scholar of great importance would teach the people to brew the tea without adding anything, in order to taste the natural essence of the leaves themselves, but more on him later.

As the Tang scholars, artists, and poets found inspiration in tea, shifting away from alcohol which was expensive, and eventually outlawed do to the waste of grain, they began to seek truth in the way sages and "immortals" had before them. At this time the first effort was made to research and publish the Way of Tea. The Chinese, always so fond of making lists—of virtues, of bests and worsts, and even of benefits—made a list of the ten virtues of tea and it became common knowledge:

1. Tea is beneficial to health, as the "Qi" clears all blockages and cures ailments.
2. Tea helps refresh one after a night of drinking alcohol.
3. Tea, mixed with other things like nuts or even milk can provide nourishment.
4. Tea can cool one off in the heat of summer.
5. Tea helps one slough off all fatigue and drowsiness, promoting an awakened mindset.
6. Tea purifies the spirit, removes anxiety and nervousness and brings ease and comfort, conducive to meditation.
7. Tea aids in the digestion of food.
8. Tea removes all toxins from the body, flushing out the blood and urinary system.
9. Tea is conducive to longevity, promoting longer, healthier life.
10. Tea invigorates the body and inspires the mind to creativity.

Clearly, even the public of the age thought of tea as more than a mere beverage for refreshment. Tea was viewed throughout its artistic career also as a means to balance, holistic health, purity of mind—inspiring a museum of paintings, poetry, literature, ceramics, philosophy, as well as all of the unheard meditations. Eventually, tea drinking would spread

beyond the palace and tea houses to the countryside, and we can hope that a few poems and meditations were to be had there as well.

These early tea scholars were in some ways like the tea sages of long ago, in that they cared for every aspect of the tea ceremony. Books from this period list a "basket to place picked leaves in" as a necessary accoutrement to the tea ceremony, as they felt that the true master picked and processed the leaves himself. They gathered their own waters and traveled to the mountains in search of wild or cultivated tea plants, slept in Taoist or Buddhist temples or simple huts, devoting their lives to tea. They then picked, baked, ground, and boiled the tea they drank by themselves, often fresh.

In the beginning of the Tang Dynasty, tea would also find its way to Tibet in the hands of the famed princess Wen Cheng who was sent there to marry king Songzan Gambo. She took caskets of tea with her and trade was very soon opened between the two nations. By the end of the Tang Dynasty, travelers to Tibet reported sharing tea with some of the nobility, expecting that it was something they knew nothing about, only to find that they were already experts and could recognize the region the tea came from.

Very quickly, the Tibetans would come to revere tea in their own special way, as it provided them with valuable vitamins and minerals that are absent from their primarily meat-based diet. Today, they still make it mixed with milk or more commonly yak butter, boiled in a cauldron much like it was in the Tang age. The Tibetans developed deep respect and devotion for tea itself, and rather than drinking it to achieve oneness or improve meditation, it was viewed as a scared and holy substance in and of itself. The tea bowls and processing accoutrements in Tibet have always been made of the best silver and gold, inlaid with precious stones, and monasteries would keep cakes of aged tea on the alters as they believed that their energy would protect and enhance the temple. Lamas and even the Buddha statue itself are offered tea daily. Even to this day, Tibetans refer to tea as the "nectar of the gods."

In the Song Dynasty (960-1279 CE), tea art would truly prosper, growing with all the verve and creativity of a passion backed by the

wealth of the ruling class. Very soon, a whole array of new teaware developed around the art of making powdered tea, expanding beyond the already full tea set of the Tang Dynasty, and each was sophisticated as emperors came and went; and many of these innovations, like the earlier ones, happened in the monastery.

There were grinders, whisks, bowls, and other ceremonial instruments, for the first time incorporating the ideals of art and aesthetic expression into tea drinking. The tea cakes that had previously been simple rings with holes in the center for strings, began to be compressed with dragons, phoenix, and other art impressed into them. The tribute teas were wrapped in yellow silk and sealed with golden padlocks before making their way to court, where they were considered priceless. And the powder was no longer boiled, but whisked individually in each bowl.

Great tea competitions started in the Song Dynasty, in which tea makers from all over would compete to see who could whisk the best cup of tea. Owing to the preference for light green teas, made from powder much like the Japanese *matcha* today, the people of this era began to move away from using the jade-blue celadon to brown or black pots, "rabbits fur (*tian mu* 天母)," named after the mountain in Zhejiang, which brought out the colors of the whisked tea. The tea houses became cultural meeting places, expanding in number during the Song dynasty, though not really flourishing until the later Ming and Qing ages. However, many scholars, poets and artists of the day found such competitions and the more boisterous tea houses vulgar, and were more interested in brewing tea in natural, quiet environs, inspiring the truer sense of Cha Tao.

The later Song, and then Yuan Dynasty (1271-1368 CE), emperors advocated a return to simplicity in lifestyle, royal or common. They tried to be examples for their people, shying away from all the luxury of the earlier ages. The Yuan kings were Mongols and took to tea in its simplest form, usually with milk. The whole ceremony began to simplify and many of the accoutrements were made more crudely or not used at all. During the Ming Dynasty (1368-1644 CE), powdered teas were eventually banned by the emperor and replaced by whole-leaf teas. Political turmoil and paranoia in the capital forced the literati into

seclusion, like ages before. The early Ming emperors even forbade the congregation of the intelligentsia, fearing revolution. The revitalization of the aestheticism of earlier ages, simplicity, and social seclusion were all conducive to the Way of Tea. Even the prince Zhu Quan himself retreated to a secluded monastery to be ordained. There he practiced drinking tea and wrote the book *A Manual of Tea,* in which he outlines the tea ceremony and the ways it can be used as a part of a spiritual life.

Near the end of the Ming Dynasty the common masses would really start drinking tea; and as it shed its formality, the modern method of brewing tea leaves in clay pots was developed. Brewing with skill and mastery, with "gong fu," became the ideal of tea preparation. New cups, pots, and utensils were developed to meet the demand of this new method of brewing, which was now focused on more intimate settings and hence the teaware grew smaller—especially in the southern parts of China.

The art of teaware itself flourished in the Ming Dynasty, establishing the great tradition of collectors, tea scholars, historians, and artists making teaware—all of which continues on today. Like the earlier Tang era, the later Ming and even Qing dynasty saw a great diversity of artistic expression, including tea art, though for the most part all occurring in a more secular setting, without as much of the poetic and spiritual power of previous eras.

The Civil Service that had been established in the Song Dynasty saw more and more of the educated in government positions during the late Ming and Qing Dynasties. These scholars enjoyed the arts, and used their wealth to develop them; and so many of their conversations were had over tea, while the very poems they wrote, calligraphy they stroked, etc. were also often in homage to tea.

As the Leaf continued its journey towards commodity, the tea house spread all across China, reflecting the cultural differences of each province it was built within, often with art, storytelling, drama, singing, or even business taking precedence over the tea.

The political turmoil of the Ming age would drive many of the true, spiritual sentiments of the tea ceremony underground. Tea became, in

this age, a common beverage, a refreshment. Not that it hadn't been mundane to some people before this time, but that such an expression of tea—as a social institution forming the basis of congregation and conversation at best, as mere refreshment in its basest form—became the mainstream. There were still tea sages here and there, as well as artists and scholars inspired like those of the previous ages, but there was also more trade, more business, and a bit less of these ideals—and this included the beginnings of Western dealings, and the exchange of tea culture that would result in all the politics, war, and economy that characterized much of tea's story thereafter. The political problems eventually led to the Manchu northerners seizing the government again with the beginning of the Qing Dynasty.

One might think of the development of tea art as passing through three stages of boiled, whisked, and steeped, representing the Tang, Song, and Ming Dynasties respectively. Kakuzo Okakura, in his classic introduction of Japanese tea culture to the West, *The Book of Tea*, labeled these three eras as the "Classic, Romantic, and Naturalistic," and also noticed the decline of spiritual ideals, as well as poetic and aesthetic inspiration, over time, as tea shifted from an ambrosia drank beneath the moonlight of some mountain hermitage, to the boisterous tea competitions of the Song age, and then eventually as a pot of leaves steeping so casually beside various snacks in the noisy teahouses of the Ming and Qing Dynasties. The latter, then, would be the tea that was introduced to the West. Though there were also the occasional poet, artist, or otherwise spiritual inclined person, more apt to listen to the silent melody of transcendence humming beneath the surface of their liquor, who would—even on the other side of the world—express an understanding of the peace and tranquility, the Ultimate in tea. Besides those rare individuals, however, the Western perspective on tea would be as economy, refreshment, and social refinement, just as it was in China during the time the West was first introduced to tea.

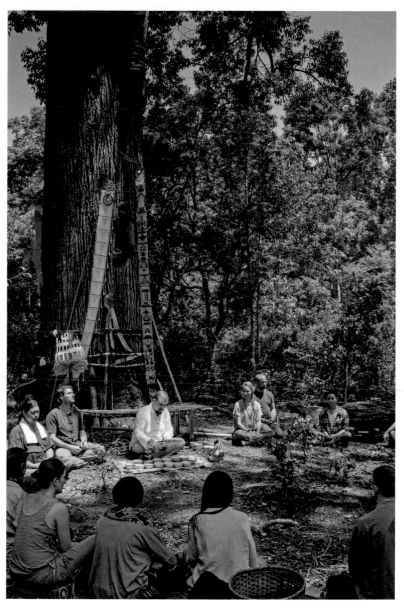

Tea under the Guardian Tree, an ancient Laurel in the tea forests
of Jingmai thought by local aboriginals to protect the forest.

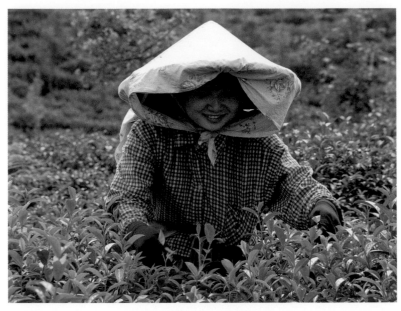

A tea maiden, in modern times.

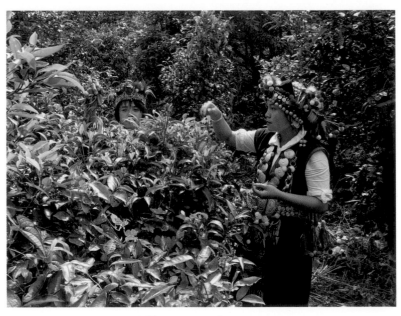

A Nannuo tea-picking song.

Cloudwalking in Taiwan.

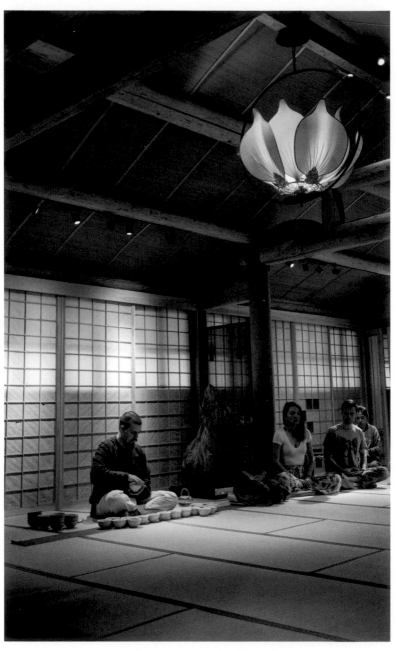

Tea and Incense ceremony in Hangzhou.

An old *ginbin* (silver kettle)—a thousand, thousand steepings old.

Huang Xian Yi (黃賢義, 1949–202) was one of the greatest tea makers we have ever met, committed to preserving the heritage of Wuyi Cliff Tea and to passing on traditional handmade tea skills to future generations.

天然無汙染高山茶

Natural highland tea.

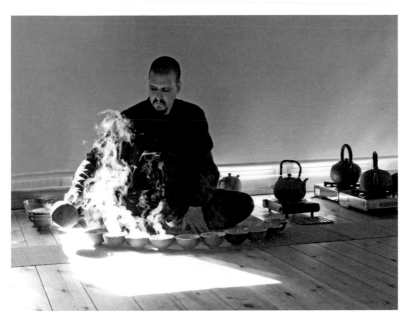

As the steam rises, so does the soul.

Remember the soul, forget the bowl. *Bowl by Master Deng Ding Sou* (鄧丁壽).

The Eighteen Scholars Enjoying a Cup of Tea.
Illustration by Anonymous, Traditionally attributed to the Sung Dynasty.
From the collection of the National Palace Museum, Taipei.

Riding the black dragon.

Leaves, ancient and wise.

Master Zhou Yu smiles a bright Puerh smile.

Love is changing the world, bowl by bowl.

Simple tea so elegantly served.

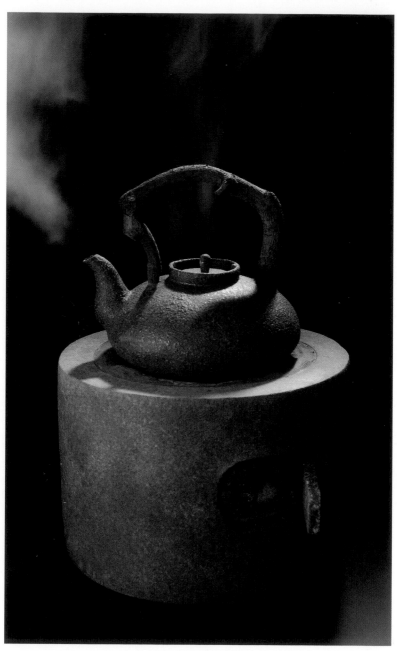

Tea is elemental.

The meditation cell for a long retreat.

Tasting Tea Made From Spring Water. *Illustration by Chin T'ing-piao, Ch'ing Dynasty. From the collection of the National Palace Museum, Taipei.*

Brewing Tea. *Illustration by Wen Cheng-ming, Ming Dynasty.
From the collection of the National Palace Museum, Taipei.*

Sipping Tea. *Illustration by T'ang Yin, Ming Dynasty.*
From the collection of the National Palace Museum, Taipei.

Tang Dynasty Tea Brazier by Master Chen Qi Nan.

In Contemplating Art and Tea

Not all of the art and aesthetics that developed through tea culture are necessarily a progression away from the wisdom of the ages past, when tea was meditation or medicine. After all, what the ancient Taoist sages and later Buddhist monks espoused was not relevant to the ceremony itself, and not dependent on what pots, cups, or pitchers one uses. The essence of the Tao is in the tea and the mind, not the tearoom and its accoutrements. The art of tea, and its refinement, can also take place with all the spirit and presence of the Way. Using one's intuition and soul to experience tea fully, as both an artistic expression and a Tao, is what "gong fu" tea is all about. Taoist and Buddhist thought, after all, had long since influenced and inspired the literature and art of China, even in the mainstream.

In contemplating the age when tea was art we might use the example of the tea master Chen Mei Kung who exemplifies a disposition common to the entire age. Like so many other government officials before and after him, Master Chen retired very early from service under Ming Dynasty rule. He lived as a recluse in the Kun Lun mountains of Tibet, drinking tea, writing, painting, and making calligraphy. Like many others, he also wrote a manual on tea, amongst many other things. And his scenario was a classic example of the Tang/Song/Ming approach to tea as a retreat from the World to a more poetic place to contemplate, write, and enjoy harmony with Nature—even if only for a short time. For some, like master Chen, this became a lifelong practice, while for others it was an occasional trip to the mountains or river for tea; or perhaps if they were wealthy enough, the building of such a tea garden and hut on their own property, surrounded by water, stones, and fountains meant to mimic such isolated locals, and at least allow the tea drinker to dream of being in the mountains alone, even if he or she couldn't go in the physical sense.

Within the breast of man and woman, there has always been an affinity between the Ways of the spirit and the artistic creativity that expresses it. We have always used art, in all its many media, to bring forth the deeper and transcendental experiences we have in our varied meditations. We paint pictures of the gods and legendary figures that inspire us as mythological symbols of what is beyond, create

symphonies that enrapture us to glimpses of the higher planes—there are so many ways that man has sculpted, sung, written, painted, or even acted his way into transcendence.

The story of art and spirit are one in the same, and in every ancient culture artists were primarily involved in capturing the essence of whatever religious cosmology they lived within, be it the simplicity of a Song bowl or the refined elegance of a chapel ceiling. And as such these truest of artistic expression were always beyond form.

The art of tea may also lie within the transcendental realm, capturing the essence of one of the most ancient spiritual traditions—based on balance and communion with Nature, a life of calmness and the simple aesthetics it inspires: kindness and generosity in sharing tea and wisdom with fellow travelers, as well as the ability to convey deeper meditations that offer experiential wisdom of the universal energy, the Tao.

The ceremony moves without movement,
Though images gently pass by:
The mountain water flows,
Crisp and sparkling with power,
And the leaves expand the moment—
Encircling it in wisps of steam.
Ancient cups welcome
A liquor so deep and dark,
It's ringed in gold.
At that moment, the flowers that adorn the table
Quietly turn to breathe in the aroma,
Before it is lost in silence.

The Immortals

Entering the Shadowy Portal,
we pass beyond the world of dust into the realm of Immortals.

—traditional Taoist insight

The Poet

Lu Tong was a tea sage of the Tang Dynasty, born near the end of the eighth century of our era. Little is known of his life, other than that he declined an offer to be a provincial officer, preferring a quiet life of renunciation and tea. He lived a secluded existence somewhere in the mountains of Hunan Province, writing poems under the name "Master Jade Spring." His poems oh-so-elegantly wrap around the Way, capturing all the beauty and serenity found in a life of tea. And though his life took its course without any history or much story to speak of, other than his tragic death, I often find that my affinity to him is greater than other more renowned tea masters. His poems clearly demonstrate his presence and understanding of the power tea has to help us live more natural, complete lives. The artist and poet in me is also moved by the elegance of his writing, as it stirs my soul and makes me yearn in my heart for the next trip to the tearoom.

Lu Tong also studied Taoism, growing up on one of China's most sacred mountains. Though he was married and had children, he still lived a life of leisure withdrawn from the world. His poetry and lifestyle, however, attracted the attention of some officials and it would seem that the tea sage himself kept up these relations in exchange for the high-quality tea they offered him. He was even given some Imperial Tribute Tea, which was priceless and unavailable accept by gift from the Dragon Throne. A government official and friend sent some to Lu Tong, inspiring his most famous poem, the *Song of Tea*, or *The Seven Bowls of Tea*. The most famous and inspirational part is:

> *The first cup moistens the throat;*
> *The second shatters all feelings of solitude;*
> *The third cup purifies the digestion,*
> *re-opening the 5,000 volumes I've studied and bringing them to mind fresh;*
> *The fourth induces perspiration, evaporating all of life's trials and tribulations;*
> *With the fifth cup, the body sharpens, crisp;*
> *And the sixth cup is the first step on the road to enlightenment;*
> *The seventh cup sits steaming—it needn't be drunk,*
> *as one is lifted to the abode of the immortals.*

It is difficult to translate the depth and perspective of Lu Tong's poems and one is better served by reading several. In this poem he elucidates the affects tea has, slowly rising from a physical sensation, to one of comfort and warmth—like the company of a true friend—and then on to the communion with the universal energy (Qi) and all the heavenly transcendence of those final draughts. It is amazing that in just a handful of words, this ancient master captures all the breadth I'm questing for in this book:

> *To honor my tea, I shut my wooden gate,*
> *Lest worldly people intrude,*
> *And donning my silken cap,*
> *I brew and taste my tea alone.*

Unfortunately, Lu Tong lost his life while visiting the capital. The emperor plotted to remove some of the eunuchs that were manipulating the throne. He sent them out of the inner palace to collect some dew from an important tree, believing it to grant longevity to those who drank some. Assassins waited for them in the grove. The eunuchs, however, realized the plot and fled back into the palace. They called in the army, and the emperor supported their investigation in order to feign innocence. They ransacked the city and executed many officials, even without convincing evidence. No doubt, they used this as an excuse to get rid of some of their own political barriers. Unfortunately, Lu Tong was visiting the very same official that had sent him the tea that had

inspired his poem. The soldiers captured the official and his household, including the guest. Years earlier, Lu Tong had written a satirical poem that mocked the court eunuchs, and they hadn't forgotten. He was beheaded and buried in a humble grave, his children orphaned.

There may not be a colossal gravestone commemorating him, and even much of his poetry has drifted into obscurity, but there hasn't been a tea lover since his time that hasn't learned, and often memorized his tea poetry. The above poem captures all of what tea is about for me: mindfulness, reverence, and withdrawal from worldly concerns.

The first time I saw one of Lu Tong's poems, it was inscribed upon a Qing Dynasty pot for tea storage. While others were busy drinking tea, I found myself revolving the pot over and again, trying to comprehend the meanings of these words. I found myself imagining this man on some mountain—images of Wuyi dancing in my head—brewing his teas and writing his poems with brush and ink. I imagined the vivacity his calligraphy must have had after such seemingly powerful tea sessions. When I returned to the table that day, my tea tasted all that much sweeter.

The Scholar

Lu Yu was the first scholar to ever write a detailed treatise on tea. His *Cha Ching* (茶經), *The Classics of Tea*, is the definitive book on the cultivation, processing, and preparation of tea in the ancient world. It also teaches us how to find the Universal Tao in the particular. Like so many sages before him, he recognized the power tea had to speak to the soul, and spent his life trying to convey its teachings in words. Down through the ages it would be those 7,000 some odd characters that would be brushed again and again as the paragon of tea spirit for Chinese—while Lu Yu himself would become a legend, an immortal revered and even worshipped in some places.

Scholars estimate Lu Yu's birth to around 730 CE, in Jinling County (today, Hubei Province). At that time, China was in another of its many periods of war and chaos, and for whatever reason Lu Yu was abandoned as a baby. Like the mythical "Hero with a Thousand Faces," Lu Yu was abandoned in a basket by the river. He was found

and adopted by the abbot the famous Dragon Cloud Monastery and raised as a novice. At the monastery, he was first exposed to tea, and we can only envision that it affected him in the same ways it has affected us.

Lu Yu was more of a scholar than a monk or meditator, and to discipline him the abbot gave him the job of tending the oxen. This, however, didn't seem to bother the boy as it allowed him time to study. Even today he is often depicted laying astride the back of an ox leisurely writing calligraphy. He was also in charge of the cultivation and preparation of the monastery's tea, apparently making such excellent tea that the abbot soon refused to drink any bowl not poured by his hands.

Eventually the world, and we can only imagine a longing for books and new experience, prompted Lu Yu to leave the monastery. In 760, before he was fully ordained, he fled the monastery to make his own way.

Amazingly, Lu Yu joined up with a theatrical troupe where he performed as a clown and even wrote plays for several years. He never lost touch with the tea that had stirred his soul as a boy in the monastery, though. In his travels, one imagines, he would find time to visit the various tea farms, try new teas with fellow travelers and locals alike—absorbing as much information as he could. In one such tea session, his passion for tea and sharp intellect attracted the attention of a local governor, Li Qi Wu. The older man offered to sponsor the young man's research and education, impressed by his writing and acting ability. With access to the provincial and private libraries of his patron, Lu Yu was in scholar's bliss. He studied earnestly, took more trips to tea-growing regions—including an extended stay in the region of Hu Zhou where he and his sponsor were forced to flee because of the political turmoil of the age—and befriended the literati and artists of the day, including the poet Huang Pu Zheng and artist Yan Zhen Qing. (Another version of the story has it that Li adopted him when he was a boy and that he spent part of his childhood growing up in his household.)

The Classics of Tea is an in-depth study of the origin of tea, the tools and instruments used to brew it, as well as legends, anecdotes, and the principals that guided the tea ceremony of that age. As mentioned

before, Lu Yu scorned the addition of other plants, flowers, or fruits to tea, stating that real tea connoisseurs must drink the leaves simply, to taste of their essence. During his lifetime, tea was processed into cakes, then ground into a powder form. Lu Yu refined the process and popularized it amongst the literati and royalty of his day, and his book was a huge success—widely distributed even long after he was gone.

Lu Yu believed in the purification of every aspect of tea, and by concentrating on the refinement of the tea, the water, the fire, etc. one could also master oneself. Lu Yu writes extensively about the cultivation and harvesting of tea during his time. He speaks of the guidelines for plucking the best quality tea, whether from a wild or cultivated plant, saying the tea leaves:

> *...are first selected from those that resemble ferns four to five inches long. The shoots should be picked while the morning dew is still cool. Do not harvest tea on rainy days. Do not pick on clear days with clouds. Pick tea only on clear days... The tea buds issue from the lush shoots at the crown of the plant. There are shoots of three, four, and five stems. Select the fullest buds from the middle stem to pluck.*

He noted that leaves that were picked early were what he called "Cha (茶)" and the later flush "Ming (茗)," borrowing terms already well-established during his time. After the initial leaves were picked, the second growth would be stronger and juicer as a result of the stress the first harvest had put on the plant. This second flush was of much higher quality, flavor, and texture and valued the most by true connoisseurs. The use of these terms no doubt predates Lu Yu, exemplifying that the cultivation and appreciation of tea had already been refined greatly by the time that he began his studies. Eventually, tea connoisseurs, emperors, artists, and the intelligentsia alike, would all be asking if the tea was "Cha" or "Ming," perhaps demonstrating that even in his own lifetime Lu Yu had become respected and renowned by the Dragon Throne itself.

Lu Yu also demanded that the whole tea ceremony be treated with reverence, as an art in the purest sense. He outlined all aspects of tea

preparation from the baking and grinding of the leaves, the water preparation, and even the arrangement of the tea sets. He emphasized the higher ideals of enlightenment throughout the book, suggesting that the golden mean of Confucianism, the Buddhist quest for higher truth, and the ancient Taoist quest for harmony with Nature all found their perfect expression in the tea ceremony.

He also suggested that tea drinkers should be virtuous above others, so that the tea ceremony itself was pure, perhaps knowing that as such it could result in a sharing of hearts—life-changing experiences as one comes to know the Tao.

Like the other tea sages of his day, Lu Yu also spent much of his time sleeping in temples, winding up through mountain peaks and valleys, talking to farmers, and drinking tea beneath the moon. He suggested drinking three bowls, a reference to Taoist and Buddhist numerology, signifying that enlightenment was possible after these three draughts. All of his teaware was also covered in such numerological and geomantic symbols: three legs on the tripod, three trigrams, three vents, etc. He himself tried to refine all of the five elements to their purest states to prepare the ultimate cup of tea, and given that he had studied Taoism and Buddhism both for many years and was living a quiet life in retreat from the World of Dust, we can only assume that it wasn't the best flavor or aroma that he was chasing in the purification of the elements. In fact, some scholars believe that Lu Yu traveled to Mount Mao in 779 CE to study Taoist alchemy, and that he was quite versed in all the theory up until that period.

It is said that in his old age, Lu Yu returned to the monastery were he grew up to share tea with the abbot that had raised him. He had come full circle, realizing that the peace and quiet of the mountain were actually more in tune with the Way of Tea—as opposed to the scholarly, intellectual method he had pursued for most of his life. His trip through the carnival of senses that is the World had brought him back to the peace that his life had begun in.

Lu Yu then retired to Xiao Qi (now Wushing county, Zhejiang) to spend the rest of his days in quiet seclusion, drinking tea and meditating on his growing beard. It is assumed that he left behind a whole body of

other work besides *The Classics of Tea,* including an often-mentioned book on the best sources of water in China, though sadly all the other ink that flowed through his brush was later lost. (Even the version of the *Cha Ching* existent today only dates back to the Ming Dynasty.) The stories of his amazing ability to discern the differences between water from the center and bank of a river only demonstrate the heights to which his Taoist training, and communion with Nature, had taken him.

Lu Yu is in so many ways the source of books like this. He was the pioneer that first popularized the idea that tea could be a Way of life beyond just spirituality and meditation. He helped establish the culture of collectors and scholars that would flourish later in the Song and Ming dynasties. So much art—calligraphy, teaware, pottery, and even music—owes respect to its heritage as a descendent of the work that Lu Yu began. I am humbled by his life and work, and thinking of the difficulties he overcame—the distances he walked, sandled and robed, to write his opus makes me want to set down my pen and allow one of his friends, the aforementioned poet Huang Pu Zheng, to express my feelings:

The Day I Saw Lu Yu off to Pick Tea

A Thousand mountains will greet my departing friend,
When the spring teas blossom again.
With such breadth and wisdom,
Serenely picking tea—
Through the morning mists
Or crimson evening clouds—
His solitary journey is my envy.
We rendezvous at a remote mountain temple,
Where we enjoy tea by a clear pebble fountain.
In that silent night,
Lit only by candlelight,
I struck a marble bell—
Its chime carrying me
Deep into thoughts of ages past.

The Emperor

Emperor Hui Tsung ruled from 1101 to 1125 CE. He has since come to be known as the "Tea Emperor." Not much of a ruler at all, the emperor spent most of his time composing poetry, painting, writing essays, holding incredibly grand parties, concerts, drinking wine, and visiting his 3,912 ladies in waiting, including empresses, concubines, attendants, and even courtesans he brought to the palace, shaming the sacred halls which had previously only ever had virgins enter its gates. Beyond that, he apparently took numerous trips into the city incognito, since apparently several thousand ladies weren't enough to satisfy him.

In his defense, the emperor was the eleventh prince and had not spent his early years preparing to become the monarch. He grew up expecting that the government would rest on one of his elder brothers' shoulders. Though decadent, the emperor was also one of the most artistic, educated, and charming men ever to sit on the Dragon Throne. He was a great patron of the arts, summoning poets, painters, and musicians to him from all over the kingdom, making many of them famous beyond antiquity to the present, and helping re-establish the earlier Tang court as the very emblem of China's golden age of art. For most of the duration of his reign, his kingdom was at peace, and its king free to seek the heights of less terrestrial peaks, though one may argue that Hui Tsung would have been thus in any age. He himself was a gifted scholar, poet, calligrapher, and painter and several of his pieces are still exhibited in museums around the world.

Emperors of China took active roles in the production of tea beginning in the Tang Dynasty. Tribute teas were sent to the Dragon Throne from tea-growing regions throughout the Middle Kingdom, and at some periods of history spring was officially heralded when the emperor drank the first flush of spring tea. Though each emperor had the best of teas and no doubt enjoyed them, few were inspired as passionately as Hui Tsung.

In 1107, the emperor composed his treatise on tea, entitled *Da Kuan Cha Lun*, which was a marvelous first in many ways. Very few "Sons of Heaven" brushed their own thoughts onto paper in this way; and the treatise contains thorough descriptions not only of tea

preparation of the time, but also farming, harvesting, and processing of tea into cakes, which all occurred very far from the isolated king in his palace. The emperor seems to have learned enough to start a farm and factory should he have chosen. He was an amazing character indeed, and the fact that he found his way into the Story of the Leaf isn't so surprising given the charisma and erudition rarely shown by other emperors.

One of the first English books on tea, *The Chinese Art of Tea*, by John Blofeld, has a lengthy chapter on the emperor in which the author describes his tea drinking and study of the Leaf so elegantly that I cannot help but quote him at some length:

> *Sometimes, when drinking tea alone in reflective mood, I like to fantasize about him. I am sure that somewhere within the depths of his magnificent palace there was a small, rather unpretentious room where the Lord of Ten Thousand Years experimented with fine teas, brewing them in various manners with his own august hands. No doubt such conduct was puzzling, and even shocking, to the horde of palace ladies and eunuch attendants whose duty it was to bathe and dress the emperor, wait upon him hand and foot, and ensure that nothing remotely suggestive of manual labor—other than the wielding of a writing brush or Imperial chopsticks—ever came his way.*

And indeed, no other emperor before or after is known to have prepared his own tea by hand. The introduction of his treatise also suggests that Blofeld was right in assuming that the emperor did understand the stillness inherent in tea, as he often states that tea is a time to set down the cares of the world, finding serenity away from daily life. It would seem that tea was a solace from the debauchery that highlighted other aspects of his life.

The emperor's kingdom fell into disarray as he more and more neglected it, and in 1125 a rebellion of the Northern Tartars stormed the palace and ended the Northern Song Dynasty. Hui Tsung and his son were banished into exile beyond the Great Wall, where they would live in captivity for the rest of their lives. The emperor then wrote sorrowful poems, longing for the palace days that he had lived in his youth. His treatise on tea was studied by tea masters down through the

ages, capturing all the art and spirit of tea art during his age.

Despite his lascivious tendencies, the emperor Hui Tsung remains one of the most interesting and talented emperors ever to rule the Middle Kingdom. Like Blofeld, we may also perhaps envision him waking up before the attendants and servants even—perhaps moving the arm of some snoring ladies to do so—and quietly sneaking off to his private tearoom to brew some morning tea away from all the hubbub of the palace. And in that space, as his mind drifted softly into lucent peace, he was no longer an emperor, a king, a moral satyr, but a tea sage as simple and elegant as any mountain recluse.

The Sage

The Zhou Dynasty (c 1122-256 BCE), as I stressed before, was for the most part a time of great turmoil and change in China, and so many of the Taoist sages, already inclined towards simplicity and Nature, retreated to secluded mountain hermitages.

Disgusted with the moral decay of the cities, one such legendary figure would find refuge in mountains destined to be dwarfed by his own stature. At the ripened age of 160, Lao Tzu (老子) followed these sages into Nature sometime between the third and sixth century BCE. He would go on to write the most influential Taoist text ever, the *Tao Te Ching* (道德經), "The Book of the Way and its Power." This great book would influence almost all areas of Chinese life for many centuries to come, covering great spiritual breadth and the proper construction of a healthy secular society.

Several poems, paintings, legends, and folklore link Lao Tzu's inspiration to a quiet life of meditation, seclusion, harmony, and stillness. We might also picture him drinking tea in the way other Daoist sages of his time were.

The practice of giving tea as welcome to an arriving guest is often attributed to Lao Tzu's disciples offering him a bowl of the "golden elixir" when he returned home after some travels. According to legend, the Sage is said to have left the World with naught but a cup of tea as well. Fed up with those who hadn't ears to hear, stubborn disciples, and the Dust of the World, Lao Tzu decided to leave the mortal

realm forever. At the legendary Han pass, painted over and again ten thousand times, his favorite disciple Yin Hsi stopped him and served him his favorite tea, begging him to write down his teachings before departing the world forever. This was, they say, the moment when his brush dipped into the inkwell those 81 times and calligraphically penned the first *Tao Te Ching*. When the last stoke had been danced to a halt, the old Sage filled his cup one last time and mounted his trusty ox, slowly ambling through the Han pass to Eternity—his weeping disciple so poignantly holding the 81 scrolls in a bundle more precious than a mountain of jade.

While legendary, such stories further corroborate that early Taoists were drinking tea with the sincerity we have heretofore emphasized— nay, even over-emphasized—as well as demonstrating that tea was indeed an ingredient in the "path to the Eternal," and consequently inspiration for the Tao teachings which were also themselves the poetic or intellectual sugar in that recipe.

Scholars argue that the *Tao Te Ching* itself was simply a collective gathering of the wisdom of all the sages living in the mountains, and that Lao Tzu was just the personification of their ideals, or perhaps a mythic teacher from their past. Whether he did walk the Earth or not, the depth of those many lines, written so many times over these thousands of years—on bark, rice-paper, silk, and linen alike— captures as much of the essence of living tea as it does other aspects of the Tao. Substitute "tea" for the word "Tao," as Lao Tzu himself would smile upon, both for its perspicacity and daring to break from the idea of formalized language:

> *The movement of [tea] is a returning,*
> *And its use is a softness.*
> —Lao Tzu, Tao Te Ching, Verse 40

One should use fewer words to describe the Way when approaching its actual application to the life we live. The Way of Tea is not a thought process or a philosophy; it isn't even an approach or method in a strict sense. Most of what Cha Tao is becomes incommunicable the moment

we try to utter a word. The pen is left tapping…and we can't know what to say, for a collection of words can never improve one's spiritual condition. They only serve their purpose if they inspire one to live. Like Lao Tzu's hallowed words, this book only accomplishes something as either the inspiration or testament of a life *lived* in tea. And being with tea isn't spoken, but experienced. Without that experiential connection, tea is a hollow pastime—celebrating life and friendship at best, causing attachment to sensual desires at worst.

As hypocritical as it sounds, the great opprobrium of the *Tao Te Ching* that "He who knows doesn't speak; and he that speaks doesn't know" is also an affirmation of the need to maintain what Zen practitioners call a "beginner's mind" when approaching Tao, tea, or tea as Tao. In order to progress, we must remain humble, quiet, and attentive to our teachers— some of which are people (masters), while others include Nature itself, as well as the ordinary situations we encounter every day. To all of these, we must be receptive and reverent, and as such we develop insight and experience of the true nature of the world and ourselves.

Through awareness and being attentive to that which is before us, we may find the Tao of all the "Ten-thousand Things," and learn their nature without having studied or even left our cushion, sipping our way to Heaven. That is the Way of Tea. Sitting quietly with my cup in hand, I imagine similar in so many ways to Lao Tzu holding his tea bowl, I take a sip and travel the world. Then having seen the sights, I lean back on my ox, have a last sip, and ride off into Eternity:

> *Without going out of your door,*
> *You can know the ways of the world.*
> *Without looking out a single window,*
> *You can see the Way to Heaven.*
> *The farther you go,*
> *The less you know.*

> *Thus, the Sage knows without traveling,*
> *Sees without looking,*
> *And achieves without action.*
>
> —Lao Tzu, Tao Te Ching, Verse 47

The Story of the Leaf

I don't think it took any stretch of the imagination to reach the point at which one is hushed in wonderment of the great legacy of this simple tree and its leaves floating in the waters of time. The story of tea is a romance, with joy, peace, transcendence, oneness, and even healthy living as its central motifs. I have left out many characters, dates, financial transactions, wars, explorers, and texts—enough to fill all the volumes of a few dozen authors—but, as I said, this isn't a scholarly work. My intention wasn't to just provide information about the story of tea, through history and before. Instead, I wanted to elucidate the many Ways that man has used tea as a *living* reflection of deeper spiritual concerns. To some, tea may be just a commodity, and art, or perhaps a collector's passion. There is nothing wrong with those sentiments, and they don't necessarily betray the essence of tea or any of its story. However, there will always be those of us that recognize the connection tea has with its source, as meditation or medicine.

Furthermore, this was, after all, not merely the story of "tea," but the story of the "*Leaf,*" and I can't think of a better way to leave this topic, turning down other Ways and Paths of understanding tea, than for us to be pondering the difference. A deeper appreciation and reverence might just be the basis for experiential change, beyond just witty, poetic words to the actual cup of tea you'll drink today, and the Way in which you'll approach it.

Even in this modern age, with a bewildering array of teas from all over the world, and an equally baffling variety of approaches to tea, there are still many people using the Leaf in the Way it was long ago: as a spiritual tool, or perhaps an artistic expression of spiritual wisdoms that would otherwise be incommunicable; or even as a cleansing, healing supplement to a "healthier" life in the holistic sense we discussed earlier.

The deepest of spiritual insights aren't easily trapped in words, and arts often have a way of exposing their essence much more limpidly. The art of tea can be that too. If this tale, wandering through millennia of tea culture, was at all successful it will have firstly become a part of that art, using the written word to try to express the insights of a life

of tea; and secondly, and perhaps more importantly, if this story did anything right, you will feel inspired to have a cup of tea—a catalyst for the sensations I have eluded to so often in this narrative. May the following chapters also pluck and steep such ambrosia as well.

CHAPTER FOUR

Chanoyu

They say in Japan that the taste of tea and the taste of Zen are one and the same; and without knowing of one, you can't learn of the other. As we shall see, there were indeed other elements of art, aesthetics, poetry, and culture that affected the development of tea as a Way in Japan, though nothing influenced Japanese Cha Tao as much as Zen. Tea was carried to the islands by monks, and planted and tended in their gardens it would grow. From the deep and silent gatherings in China—monks all sharing bowls of whisked tea as the summoning gong faded to silence—tea would spread to Japan just as it had to the populous of China who had visited such monasteries and been so impressed by the way the monks ground the cakes of tea, boiled the water, and listened to the wind soughing through the pines, sharing moments of breadth quietly sipping its bitter truth.

Like the Taoists before them, in the *Chan* tradition the truth of enlightenment cannot be transmitted in words, and all the great masters through the ages therefore used whatever skillful means at hand to transmit the silent lightning-flashes of wisdom to their students: from riddles to meditations, dialectics, and sometimes a bowl of tea. Obviously, such bowls were sipped by the monks visiting from the "Land Where the Sun Rises," for they often returned to Japan "teamen," enthusiastically converting their fellow renunciates to a life of tea.

It was, after all, Zen monks who first brought tea to Japan sometime in the early ninth century. During the Tang Dynasty several mendicants went to the mainland to learn *Chan* Buddhism and in the course of staying at the monasteries there, were introduced to tea

and the importance it played in the spiritual and daily life of the local monks. When it first reached Japan, tea was drunk in the blossoming Zen temples in much the same way as it had been in China. They whisked large bowls of tea and then passed them around, all sharing in a very meaningful gesture of unity. In the same way that Chinese people had, the Japanese would be introduced to tea via the monastery. The fact that tea was literally carried over by Zen monks and then planted in Zen soil in part explains the impact Zen philosophy would come to have on the development of Cha Tao in Japan.

Later, during the Song Dynasty, the legendary monk Eisai would also make such a journey, studying for four year on the mainland. He returned with scriptures, a deep understanding of *Chan* Buddhism, and tea plants. He went on to write a treatise on tea, in which he glorified it as a panacea for all ills and suggested that everyone begin drinking tea for their health. According to legend, tea was given to the sick shogun Sanetomo, and his complete recovery did much to help spread its popularity. The tea cuttings that Eisai brought back were planted in Uji, which remains the most prominent tea-growing region in Japan today. In the beginning, tea was an expensive luxury only available to the monks that grew it themselves, or nobles who could afford it. The teaware and preparation mostly involved the use of Chinese teaware that was beyond the taste of most ordinary people.

The monks continued with the traditions of tea and spirituality established in China over thousands of years of tea consumption. The royalty and newly-founded military class, on the other hand, quickly developed a tea culture based on art and entertainment. They threw extravagant tea parties that were often really games and/or contests to guess a tea's origins or quality, often winning prizes the host and guests both provided. As time passed, and tea production made more available, the aristocracy of Japan found in it a chance for social discourse. They held tea parties that were really just the latest version of a long-standing tradition of "games of guessing," which included art, incense, and other rarities. The host could then display galleries of Chinese antiques and the guests could bring presents and leave with prizes. These were usually just occasions to eat decadent

food, display large quantities of expensive art and artifacts—which were almost exclusively Chinese antiques or master-crafted pieces of jade, ceramics, paintings, etc. that were rare and expensive—and often ended in debauchery and drinking. Throughout history, tea—like anything conducive to spiritual insight—has been susceptible to neglect, vulgarization, and commercialization. Tea had entered Japan's World of Dust just as it had China's.

Meanwhile, changes in the philosophy surrounding *renga*, linked-verse poetry, and *Noh*-theater were influencing the future aesthetic and spirituality of Japan, fertilizing the soil in which the Way of Tea would flourish there. Overcoming this profane approach to tea, the Japanese masters and the times they found themselves in would go on to shed such casual extravagance and develop a very rich and deep spirit of tea. Whereas the warrior class was concerned only with the taste of tea and the sensory enjoyment, not poetic or spiritual insight, these later masters would turn away from the sensual impressions of tea, forming a tea culture inspired by the inner world of tea experience.

Wabi

The various influences that combined to form the traditional Japanese tea ceremony are complicated and vast enough for a library of scholarship. Many historians say that the Way of Tea was a ripe fruit waiting to be plucked when Murata Juko entered the garden path (*roji*). Prior to him, other Zen monks like the famous Shinkei (1406-75) had found ways to integrate various art forms and spirituality. Shinkei used poetry not just as an expression of spiritual insights, but as a path to such wisdom itself. In other words, in creating and refining one's poetic impulses and achieving mastery, one also learned truths about oneself, life, and ultimately spiritual enlightenment.

Another example from the time was the way *Noh*-theater actors trained to be selfless and detached, amongst other insights, during performances. At the time of Shinkei, the aesthetic ideal of those using art as an expression of and the very path (Tao) itself began to lean more and more towards ideals they called "cool" and "withered," which were considered the highest level of mastery in these arts (and spiritual

traditions). Such profundity wasn't found in the verdure of summer gardens, or the art it inspired, but the "lonely hut by the seaside" and the "grass peaking through the snow of a barren mountain landscape."

Before the Muromachi Era (1392-1568) the word "wabi" was negative and was used to express heartache, desolation, or loneliness. During the time of Juko and Joo, the word took on a new positive meaning based on the trend of "withered" and "cool" that had been developing for some time. The influence of Zen on the culture, spirituality, and tea of the times cast new light on simplicity, renunciation, and emptiness. Being alone and empty was an expression of beauty. *Wabi* came to mean an imperfection in the tea aesthetic, so that the tearoom was built from simple, rustic materials like *tatami* and wood. *Wabi* also was an attitude of unpretentiousness, simplicity, and direct communication of the heart. Through simplicity and emptiness, even tea can be transcendent and lead to enlightening insight.

By making *wabi* the ideal of tea, the tea masters of Japan made the tearoom a place without social distinction, where the rigid garments of class could be shed for a more comfortable, human serenity. The tearoom became a place where ego could be left behind and ordinary people share the heart and spirit of Nature, each other, and of course tea. The gate to the *roji*, or "dewy path," and the small entrance to the tearoom itself are both symbols of this shift in consciousness from the normal, material world to a deeper, silent one where there are no societies or individual desires, only Nature and peace. Of course, many tea people (*chajin*) would miss the inner *wabi*, getting lost in the quest for rare or expensive teaware, being overcritical of a host's performance, etc.—all of which then led to criticism from outsiders—but the ideal of *wabi* itself has always been a pure one: to be at one with the Tao in tea. The fact that some people enter the garden or tearoom with envy and desire, coveting some antique for their own, is a reflection of their spiritual development, not of the garden itself. And the more simple and natural the tea, the more *wabi* it is, the more limpidly will it reflect ourselves as we sit within its presence.

Of all the aspects of the ancient Japanese tea ceremony, it is this *wabi* that resounds the loudest even today. The Way of Tea is one of

humility and simplicity, and as we progress we find that our aesthetics, as well as our approach to tea and life, naturally simplify. The simpler one's mind as one brews tea, the cleaner and purer the teaware and the simpler the aesthetics of the tearoom, the stronger the chance that the situation will have a powerful and lasting effect on those present.

Wabi means that things are okay the way they are. The world is only imperfect when compared to some imaginary world we've created, saying "if only" this or that were different. That imaginary utopia, however, is an incomplete world. Perhaps there isn't any violence or negativity there, but it also lacks all the complexity and depth—the endless subtlety and variation—of this, our *only* world. By losing the desire to change things we perceive as imperfect we learn acceptance. This is also important when brewing tea, knowing that this cup before me is the right one, perfect or not—I don't need to have any stress over my brewing methods or technique. I can let go and relax. It is okay to be imperfect.

I'm reminded of the movie *The Last Samurai*. In one scene the character Kazumoto quotes an old Japanese poet as saying "a life spent searching for the perfect blossom would not be wasted." Later, near the end of the film, as he looks out onto the cherry blossoms with all the clarity of his last moment, he so poignantly utters "Perfect…they're all perfect!" Likewise, one may look back at one's quest for the perfect cup of tea and realize that they were all perfect!

Murata Juko

There are many stories and myths about Murata Juko, but little historical information has survived. Most scholars agree that he was born in Nara around 1421. Some stories suggest that he was the son of a traveling, blind story-teller/priest, a common occupation during those times. Apparently, he was dissatisfied with the "World of Dust," and at the age of just eleven entered a local temple as a novice in the Pure Land Buddhist sect. However, some time later, while he was still a young man, he was dismissed from the monastery for neglecting his duties and studies. Juko had found another passion: tea.

Juko began spending all of his time attending tea competitions and

learning about tea from local teachers. After he was sent away from the temple, he decided to devote his life to tea. He traveled to Kyoto, maybe to get a job as a merchant or trader of some kind. He began spending all his money on collecting antique teaware from China and spreading tea culture amongst the merchant class there. His personal life at that time revolved around tea and the collection of more and more extravagant pieces of teaware.

At some time during his adult life, Murata Juko returned to the spiritual sentiments he had started life with. Perhaps the tea had taught him lessons, sitting alone beneath a pine tree on some hill and listening to the kettle sough. He started studying Zen under the renowned master Ikkyu, who played an important part in Japanese history in his own right. Of course, Juko's tea was affected more and more by the insights he discovered in meditation, and vice versa. As a result, he completely changed the way tea poured through his life.

It was common for higher-class people of Juko's time to have a small study built into their house with a shelving unit on which they would display their antiques. The room usually had a small table, writing instruments and other scholarly or poetic decorations. It was also customary to have what was called "*shoin*-style tea," in which one drank tea in these small rooms with brightly colored walls and displayed one's treasures to guests. Juko began a trend moving away from this excess that would continue after his death, culminating in the tea of Rikyu. He decreased the size of the tearoom to four and a half mats of *tatami*, and began taking out or simplifying many of the decorations. Juko also began to use more rustic, local materials. The upper classes of his time were still passionate about all things Chinese, which would continue after his death, but he was planting the seeds that would lead future tea lovers to seek out and find the beauty in simplicity, combining Japanese teaware with the expensive, imported pieces from China and Korea.

Juko is often attributed as the founder of the "thatched hut" style of tea since he invented the four-and-one-half-mat room, the sunken hearth, and the incorporation of more simple materials in the construction of the tearoom. As Juko simplified his decorations, tea

sessions began to incorporate less utensils and art, often just revolving around a single scroll painting. With less utensils, the highly-formalized "*shoin*-style tea" became plainer and simpler to perform. Juko still kept his collection of rare and treasured Chinese pieces, but began surrounding them with simple bamboo or other natural materials. He is most famous for saying that tea was "a fine steed tethered to a thatched hut," suggesting that by contrasting local implements with fine Chinese ones, the practitioner could achieve the "cool," "withered" aesthetic of Zen art. The idea wasn't to create contrast, but harmony between the beautiful and plain in the way a flower garden or some mountain scenery does.

Of all Juko's contributions to tea, especially as he taught more and more in his older years, his greatest influence was to promote the idea that tea and Zen were the same: "The flavor of tea is the flavor of Zen." He began to view tea as a Way (Tao). His blooming ideals of *wabi* were a big part of this inspiration. He is quoted as saying, "The moon not glimpsed through rifts in clouds holds no interest," meaning that the pure, bright full-moon that is the symbol of enlightenment in many Buddhist traditions isn't as elegant or expressive as the partially obscured moon—that we find perfection in the imperfect, embrace the discordance in life to achieve concordance, and so on.

Tea to Juko was more than just guests and hosts sharing time together; it was a poetic expression of human experience that, if performed properly, could achieve wisdom. As one devotes oneself to the formalities and movements of the tea ceremony there is an immersion in the simple, humble aspects of daily living that can encourage emptiness and freedom from mind and ego, beyond the trappings of worldly existence. One finds the "formless in the form" of the teaware, tea, and even the silent communication between the participants.

Only a few scattered letters attributed to Juko remain: the *Letter on Heart's Mastery*, a few responses to questions posed by students, and some records kept by others, during his time and later of his teachings. The *Letter on Heart's Mastery* poignantly admonishes students of tea to remain humble and selfless, as progress on the Way is hindered by

attachment and self-satisfaction. He often suggests that one's manner should be "natural and unobtrusive." He also suggests that guest and host both clear their minds when entering the tearoom so that tea can be an expression of silence: pure and simple.

Takeno Joo

Murata Juko influenced the aesthetic of Japanese tea dramatically, shifting the focus from magnificence and extravagance to simplicity, *wabi*—his predecessor's glorious steed outside the straw hut and cloud-covered moon. Some scholars call the new trend he inspired the birth of Japanese Cha Tao. *Chanoyu* would then mature towards an even purer expression of *wabi*, crystallizing many of the tea ideals that would continue up to the present, under the guidance of Takeno Joo. Though he was not a direct disciple of Master Juko, he definitely studied in the same tradition. (The priest Soshu is considered to be the heir of Juko's tea art and Tao.) And it was among some of Juko's students that Takeno Joo would first learn the tea ceremony.

From the limited accounts left us, we know that Joo was born in 1502 in southern Sakai. His grandfather had been killed in the Onin War, and his orphaned father was a bit of a nomad, wandering for several years before finally settling in Sakai. Joo Ikkan Koji was his Buddhist name when he came of age. When he reached adulthood, Joo moved to Kyoto and took a post as a retainer of the Udaijin Kimiyori, which lasted for fourteen years.

At first, Takeno Joo was an ardent student of the Tao of Poetry. Through his literary contacts, he was then introduced to tea, which he soon took to with an even greater passion than his study of words. He first studied poetry with Sanjonishi Sanetaka, beginning in 1525. His teacher was more than seventy years old at that time. From notes in Sanetaka's diary, scholars think that he was a friend of Joo's father as well and that Joo might have first met him at the age of twelve.

At the age of twenty-eight, Joo received some secret transmission from his poetry teacher, which apparently enlightened him in many ways. It was at this same time, in his late twenties, that he would first start practicing the tea ceremony. Many of Juko's students, who

met him and passed on the tradition to him, like Yamanoue Soji, commented that even at that time he had tea wisdom.

The more Joo practiced tea, the more involved his heart grew. He began to approach the tea ceremony with some of the wisdom he had cultivated in practicing the Tao of Poetry, slowly changing the tradition Juko had handed down. Joo would later recommend to all his students that they too devote some of their time to the study of poetry, calligraphy, and art in order to fully develop their understanding of tea. Murata Juko himself had never explicitly used the word "wabi," though he expressed its meaning in his tea and also in things he said, like the famous quotes repeated often herein. It would be Takeno Joo who first brought the term of "cold and withered" from the Tao of Poetry into tea. No one knows exactly why he chose that particular word to express this growing trend towards simplicity, acceptance, and imperfection, but in doing so he would forever change the tradition of tea in Japan.

To Joo, *wabi* also meant honesty and straightforwardness. It meant communicating, whether it be in poetry or through a tea ceremony, directly from the heart—in the calm center where we are all one. It is interesting to note that Juko and Joo both were practitioners of Zen and had spent significant portions of their lives learning meditation as novices and laymen. And one can see the flavor of Zen brewed in their tea and steaming from all they taught about it.

As discussed before, Juko began the practice of incorporating some local Japanese pottery and simple, natural things into the tearoom. Joo continued this trend by advocating the use of unadorned Japanese pottery along with Chinese treasures. In his later years, when Joo himself was a master with students of his own, he would teach more and more that the focus of the tea ceremony must be internal, and that the utensils were just expressions of this and consequently secondary. He started to use discarded items and utensils in his tea ceremonies, arguing that the practitioner of tea must live a life detached from the world as much as possible, much like a Buddhist monk. In fact, Joo explicitly stated in his "Twelve Precepts" of tea that the tea person (*chajin*) should "clearly understand the precepts of Buddhism." He

suggested that to truly master the Way of Tea one must live a "quiet life in retreat." The man of tea should be neither extravagant nor too poor, for he is not a monk. He should practice humility and simplicity in all things, not just tea.

Joo knew that every aspect of one's life affects one's tea, and that a mere life of 60-70 years was not enough to learn it all. One must always remain the humble beginner, with a spirit of *wabi* in all things. Here are some more of his Twelve Precepts:

> *One should practice generosity and loving-kindness towards others.*
> *One's manners should be polite and harmonious.*
> *One must not be critical of others or their tea ceremonies.*
> *One must be humble, without pride.*
> *One should not covet the utensils of others.*
> *The tea ceremony must never be reduced*
> *to a mere appreciation of utensils.*
> *Every tea ceremony must consider first and*
> *foremost the heart of the guests.*

All twelve, in fact, express similar sentiments—of simplicity, humility, and a focus on the internal happenings during tea. Joo's greatest contribution, in this author's opinion, was the idea that every aspect of one's life must be pure if one wishes to pour wizened tea. Just as good tea could never be made in an unclean vessel, I don't think an impure mind can brew great tea either—and I know Takeno Joo would agree with me.

Master Joo followed his own advice and retired from his position as a retainer after fourteen years service and moved back to Sakai to live in peace and quiet. I imagine he spent his days writing calligraphy, meditating, and drinking quiet tea. He passed away from natural causes in 1555 at the age of 53, though the lasting impression he made on the tea world, particularly regarding "wabi chanoyu" would last up until the present.

Sen no Rikyu

If the tea ceremony in Japan was planted and tended to a sapling by Juko and Joo, it reached its full height and found its glorious crown of green under Rikyu's care, who refined it and lent to *chanoyu* its final shape, artistically and philosophically. Much of the simplicity of *wabi* that *chajin* had practiced up until the time of Rikyu extended further, to its natural conclusion. Rikyu also finished the last few philosophical steps that Juko and Joo had implied, though never explicitly taken. Joo got away from the tea in the study (*shoin* style) and its focus on demeanor, instead promoting *wabi* and glances inward as one drank. He eventually retired to a quiet life of tea and companionship with Nature, but it would be his student Rikyu who would go on to transform the tea ceremony from a means of cultivating manners and social accord with the occasional potential for transcendence and spiritual insight to a purely spiritual focus, where every step down the "dewy path (*roji*)" was meant to be one of wisdom.

Rikyu was born in Imaichi, in the Izumi Province, sometime in 1522. His father, Tanaka Yohei was a wealthy fish merchant who also sat on the local council. Like his predecessors, young Rikyu showed spiritual proclivities early on and studied Zen at Daitokuji, where he took the name Soeki, which he used for most of his adult life. The name "Rikyu," which history would remember, was given to him much later when his lord, Hideyoshi, wanted to serve tea to the emperor and Rikyu had to be temporarily ordained in order to attend, since commoners could not be in the presence of the emperor.

Rikyu began to study tea at the age of eighteen under the guidance of Kitamuki Dochin who practiced the "Higashiyama" style of tea. His teacher wrote a letter to Joo, saying that the boy was skilled and often initiated very provocative conversations about tea. Curious, Joo asked to have tea with him. He quickly became one of Joo's favored pupils, combining what he had learned in both traditions to advance the tea ceremony towards its culmination.

In 1570, Rikyu met the daimyo Nobunaga and served tea for him. The lord was so impressed with Rikyu's tea and aesthetics that he appointed him official "tea advisor," as part of a group of three

including Sokyu and Sogyu. They not only taught the lord how to prepare tea, but helped him find and appraise antiques, design tea rooms and organize tea ceremonies for visiting guests and dignitaries.

Later, when Hideyoshi succeeded Nobunaga, the three continued on in their positions. Hideyoshi proclaimed them "tea masters" of the land. Over time, however, the influence of Sokyu and Sogyu thinned, as the new daimyo forged a greater affinity with Rikyu—forming one of the most interesting relationships in Japanese history. Sokyu was, in fact, later banished with his ears and nose cut off for speaking out against the daimyo and serving tea to another daimyo Hideyoshi considered an enemy.

Hideyoshi was born in 1536 to humble parents. He supposedly had two thumbs on his right had, and didn't amputate the second one as most people at the time would have done. He joined a temple as a novice at a young age, but was too ambitious and worldly and soon left to seek out adventure. After traveling for some time, he joined Nobunaga's clan as a low-ranked servant. He rose up in service to the position of "sandal-bearer" and was present at the battle of Okehazama in 1560 where Nobunaga defeated Yoshimoto to become one of the most powerful daimyo in all of Japan. Apparently, the young servant established his reputation at that time, for he quickly rose in power and rank afterwards. After helping his lord negotiate several important treaties, he was given command of a regiment of troops. In 1570, Hideyoshi led his troops to victory at the battle of Anegawa and Nobunaga made him a daimyo of three provinces. Then, in 1582, Nobunaga and his son were assassinated and Hideyoshi rose in power and influence, eventually succeeding his lord. Hideyoshi would go on to unite much of Japan and thereby end the Sengoku period of Japanese history. He began constructing the legendary Osaka castle and later a grand palace, the Jurakudai, to entertain the emperor. Hideyoshi sought to be Shogun, though the emperor would never grant him that title. He was instead offered the position of regent.

Hideyoshi was in many ways antipodal to his tea teacher Rikyu. Having risen from low to high class, rags to riches, he was often ill-mannered and lacked the subtlety that Rikyu seemed to embody.

The contrast between the ambition and politics of the daimyo and the spiritual simplicity of his tea master is well-captured in Hiroshi Teshigahara's 1989 film *Rikyu*, in which the tea master is characterized as a serene, monkish elderly man and the daimyo as a flamboyant, aggressive, and hyperactive brute. While the film may in fact exaggerate their differences, their was undoubtedly a dynamic caused by the very different natures of these two men.

Rikyu took the simplicity and serenity of *wabi* one step beyond the "fine steed tethered to a thatched hut." Before him this meant, in part, the juxtaposition of fine antique tea utensils with simple, rustic surroundings and aesthetic. Rikyu, however, interpreted the fine horse to symbolize the spirit of the *chajin* (tea people), having nothing to do with the utensils or decorations of the tearoom. It was the spirit of the practitioners, in other words, that was noble and magnificent, even in the humblest of surroundings.

Rikyu further supported local potters in the creation of black Raku bowls and himself made the tearoom smaller and even more rustic, incorporating the simplest of materials for everything from the walls and pillars to the tea utensils and flower hangings—often carving them out of bamboo himself. Hideyoshi, on the other hand, constructed the fabled golden tearoom, in which everything in the room was either solid gold or gilded. It was there that he served tea to the reigning emperor, Go Yozei. It is difficult to truly comprehend the role these men played in each other's lives. Was it that Rikyu enjoyed the prestige and salary his position offered? He no doubt had access to the best tea and teaware that way. Of course, he often scolded his students for focusing on the financial value of tea utensils, arguing that a utensil's value was only in its beauty and function. If it makes great tea it is a treasure, and if you hand it down to your descendents it too will be an expensive antique like those coveted by tea lovers, he often argued. Still, he himself did own some treasures. Perhaps he wished to serve his country and lord? Maybe he viewed his position as one of duty and service, lending a sometimes-gentle, sometimes-severe hand to correct the understanding of the immature daimyo and thereby lead his country to a brighter future? That is the perspective of Teshigahara

in his film, that the aesthetics of art were in conflict with the politics of the time. If that were true, then Sen Rikyu would have found a true friendship in his contemporary Michelangelo, had he traveled that far. He too was constantly struggling for artistic freedom from the political milieu he found himself in, forced to paint mural after mural for popes when he only wished to carve stone. Did Rikyu similarly wish to leave to the country or the monastery and drink tea in quiet? Or was he still, in part at least, attached to the World of Dust and the benefits his position in the daimyo's court offered?

There is a very meaningful scene in the movie *Rikyu* in which he and the banished Sokyu are discussing Hideyoshi's golden tearoom. Sokyu is disparaging the lord and arguing that he doesn't understand tea at all, making of it a gaudy, showy display of wealth rather than an expression of the participants' inner beauty. Rikyu politely corrects him, saying "Strangely, I find a quiet beauty in it (the golden tearoom). It is as if my spirit is lifted to a better world while in there." He then goes on to explain that Sokyu is too focused on the value of the gold, shunning it simply because it is expensive, which is the same as coveting it because of its value. One has lost the Way in seeking out only expensive antiques, and yet also by failing to recognize the beauty of an expensive antique simply because it is beyond one's means and one is trying to cultivate simplicity. The financial value shouldn't matter, in other words—a feigned poverty is just as gaudy.

> *When you take a sip*
> *From the bowl of powder Tea*
> *There within it lies*
> *Clear reflected in its depths*
> *Blue of sky and grey of sea.*
>
> —SEN NO RIKYU (translated by A.L. Sadler)

Rikyu's tea was often expressed so poignantly in non-verbal teachings, as it has always been with any true master. There are two different versions of his "blossom party," one involving Hideyoshi himself and another one of his friends. The former seems deeper as it further

contrasts the two characters, and was for that reason the opening scene of the movie: Having heard that the blossoms in Rikyu's garden were particularly gorgeous that year, better even than the palace, the daimyo invited himself over for a viewing and tea the following morning. When he arrived early the next day, however, he entered and found the garden completely bare—every single blossom had been plucked. Furious, the daimyo strode towards the tearoom and went in. Before he could scold his teacher, though, he raised his eyes and saw there in the alcove a gorgeous vase holding the most beautiful of all the blossoms the garden had yielded. He smiled, understanding that he had just been taught a deep lesson. One can only imagine what the tea tasted like after that.

Once, Sen Rikyu called on one of his senior disciples unannounced while he was gardening. Unflustered by the fact that he didn't have time to prepare, the student cursorily plucked a chrysanthemum flower on the way to the tearoom and gently rest it in the alcove. Student and master enjoyed a tranquil hour of tea without false modesty or any kind of flattery. When they were done, Rikyu said that his student was a student no longer, for he understood that the Way of Tea was not a list of dos and don'ts.

There is another story concerning the famous "Tae Mugura" scroll of calligraphy. It belonged to a wealthy *chajin* named Hisahide, who could not bear to part with it, though he was often offered very large sums of money. However, moved by Rikyu's deep understanding of tea, he presented it to him. Rikyu was overjoyed and claimed to many friends that it was his most prized possession. One day, he invited Sokyu to tea and hung the scroll in the alcove (*tokonoma*). Apprently, Sokyu had never seen the scroll before and was so moved by its beauty and poetry that he fainted and then returned home without having drunk any tea. Rikyu not only felt bad, but realized the impression this scroll made was not fitting for the Way of Tea and presented it to Sokyu the next day.

In his service to the lord Hideyoshi, Rikyu helped him prepare tea in many different settings. He designed the golden tearoom and helped Hideyoshi serve tea to the emperor there. And as we discussed above, that

was the occasion in which he got the name "Rikyu," which somehow became the name history would record. Hideyoshi was a very avid tea drinker, and even carried tea utensils with him into the field when he went to battle. He also entertained other samurai, dignitaries, and even foreign officials at his castle and palace, and Rikyu was responsible for overseeing all of it. In 1587, Hideyoshi held his famous "tea gathering" in the fields at Kitano, in which he insisted that every tea lover in the land come or else they couldn't ever practice tea again. He put all his treasured utensils on display and hundreds of huts were constructed to share tea together, most of which was again supervised by Rikyu. People of all social classes were invited, without distinction, even if they could only bring "a bucket for water" as the public invitation suggested. This, no doubt, was due to Rikyu's influence.

> *Though invisible*
> *There's a thing that should be swept*
> *With our busy broom.*
> *'Tis the dirt that ever clings*
> *To the impure human heart.*
>
> —SEN NO RIKYU (translated by A.L. Sadler)

One of the greater innovations that Rikyu introduced into the tearoom and garden was the so-called "crawling-in entrance (*nijiriguchi*)." This small entry-way forces everyone who comes into the tearoom to stoop down and crawl in on their hands and knees. Apparently, Rikyu got the idea from seeing similar entrances in fishermen's cottages. The idea was that the tearoom was a place without social distinction—the prince and pauper both are humbled before the Leaf and must enter on their hands and knees, none better than the other. Samurai left their swords outside as well. In this way, all the class, wealth, and any other distinction of individuals were swept away like the Dust of the World. Even foreigners were allowed to attend. Rikyu wrote that "not only Japanese, but even persons from the continent may attend if their hearts are set on *suki* (translated by Dixon Morris)." "Suki" means a love for tea, the passion in other words; it also often meant having a

taste for the Tao, which is probably what Rikyu meant here.

In a land with such rigid social distinctions and more decorum and manners surrounding class than most any other culture, this ideal was not only profound, but perhaps in many ways cathartic. It must have been something of a release for Hideyoshi and other samurai to come to the tearoom and shed all the disciplined pretension of normal social discourse. Of course, Rikyu intended for the lesson to be a deeper one, for the distinctions to fade away in more than just a relaxed hour, but in meditative stillness and wisdom.

> *Though you wipe your hands*
> *And brush off the dust and dirt*
> *From the Tea vessels.*
> *What's the use of all this fuss*
> *If the heart is still impure?*
>
> —SEN NO RIKYU (translated by A.L. Sadler)

Rikyu also introduced several other innovations to the tearoom, utensils, garden, and even methodology of *chanoyu*. While there were other famous tea masters after him, like his famous students Enshu, Oribe, and the five other of "The Seven Tea Sages," all of them would look back to him for guidance. Later, after his death, two main schools of tea would develop in Japan, continuing to the present times. One of them, the Urasenke School, still traces its lineage back to Rikyu.

Rikyu's teachings were mostly recorded in poems and the famous *Namporoku*, which was a list of his teachings on tea. It was said that as the "grass hut" style of tea that Rikyu taught became more popular and the *Namporoku* disseminated, many people regarded *chanoyu* as even more pure and holy than practice at the temple.

There are many reasons listed in the annals of history for why Hideyoshi and Rikyu's different characters finally clashed in the ultimate way. Some say that Rikyu was always a conversationalist and philosopher and through arguments had made enemies within the palace. Others say that he found enemies who were jealous of the affection Hideyoshi had for the master and the way in which he

regarded his opinion, for there is evidence that the daimyo often sought Rikyu's opinion on matters of state as well. Another explanation is that Hideyoshi saw Rikyu's widowed sister walking on the road and found her very attractive. When he later learned of her identity he asked Rikyu to help introduce her with the intention of making her a concubine. Rikyu supposedly refused and thereby distanced himself from the daimyo. Whichever of these are true, it is clear that their relationship became more and more strained as it wore on. From his writings and the descriptions of him given by others, one could more accurately suggest that Rikyu was a blunt man, often willing to speak the truth at any cost. He was an artist also, willing to take risks and to innovate from the soul, regardless of what the world thought of his creations.

The dispute came to a head when Rikyu donated a large sum of money for the construction of a new gate at the Daitokuji Zen temple. The abbot there, who greatly respected the tea master, then decided to put up a wooden effigy of Rikyu, wearing sandals and carrying a staff as he stared off towards the horizon. This enraged Hideyoshi as it meant that he himself, and any other dignitaries visiting the temple, would have to pass beneath Rikyu's feet when entering. Rikyu was promptly banished to his hometown in Sakai.

Then, a week or so later, in February of 1592, Hideyoshi sent word that Rikyu was to die, forcing him to commit ritual suicide (*seppuku*). Afterwards, Hideyoshi had the wooden statue destroyed and Rikyu's head put on display.

Rikyu's death has been debated by scholars of Japanese history, and tea lovers as well, to no end. It cast an even brighter light on the tea master's life, granting his legacy a much greater poignancy than it would have had if it hadn't ended in this way. His family was pardoned very soon after his death, suggesting that Hideyoshi regretted what he had done. Rikyu had prepared tea one last time, drank it in silence, and then composed two death poems, as is the Japanese custom—one of which is:

Man's life is too short,
And constantly surrounded by danger
He rarely knows is there
This precious blade is welcome
Slaying all the Buddhas together.

—Sen No Rikyu

Most scholars agree that Rikyu could have avoided this fate had he gone to the daimyo and pleaded for forgiveness, but then he wouldn't have been the master he was. Rikyu wouldn't ever bow and be servile towards those that he had offended by being true to himself. In the movie *Rikyu*, it is suggested that he first offended Hideyoshi by suggesting that his planned campaign to conquer China was not a good idea. He would have known the cost such a useless campaign would have had on the nation, and that it was only motivated by personal greed and lust for power. Rikyu is perhaps best remembered in this way, uncompromising in his beliefs. I like to think that he was such a master, unafraid of death or any other punishment if it meant subjecting himself to that which was not true. I'm also sure that he would say that it was the Leaf that had taught him to be that way.

Tea in Japan would be forever changed by master Rikyu. In *The Record of the Words of Rikyu*, written after he died by students, he discussed the future of tea: He said he worried that the smaller tearoom he had created would be replaced by a much larger hall to seat a vast audience. He said that as tea reached the general public it would be subject to negligence and vulgarization, perhaps losing its soul forever. While some of that has happened since Rikyu, there is a passage at the end of this teaching where he says, "In the Way of Tea also, people with a true realization will come forth in later ages, and they will surely sense and share the aspiration that you and I have kept. If such a person extends a bowl of tea toward me—even though a hundred years have passed—it will moisten my bones. Will not my departed spirit rejoice in accepting it? Without fail I shall become a guardian spirit of the Way of Tea (translated by Dennis Hirota)." In many ways, Rikyu has become one of the legends that guard the Way of Tea.

Rikyu often said that when we enter the "dewy path (*roji*)" we leave the world and all of our ego behind, becoming buddhas we sit down for tea as one. With reverence for this and the inspiration Rikyu left behind, let us indeed pour a steaming cup for him, as he suggested, with the hopes that it *will* moisten his bones and invite his spirit into our tearooms, for its presence could only grace us and our tea.

Rikyu's Four Merits of Tea

Rikyu often taught that there were four "merits" or "virtues" of the *chajin*: **harmony**, **respect**, **purity**, and **tranquility**. These teachings are as applicable to life and tea today as they were so long ago. They are some of the best of what Japanese *chanoyu* has to offer any lover of tea or life. There are many virtues of tea expressed by those that practice living a life with it, and later in this book we'll explore some others. Many of these overlap with Rikyu's, and are equally profound expressions of Cha Tao and the benefits it offers.

We have already talked much about harmony. Without harmony, there is only tea without Tao. Harmony means leaving your ego at the door. It means that the gateway to the "dewy path (*roji*)" is a magical portal to another dimension of consciousness, and that when we stop along the way to wash our hands and face, we're washing off all the Dust of the World, and our egos as well. When we are completely present in this moment, we are in harmony with Nature and our actions will all follow the most appropriate path to completion.

Also, there must be harmony between guests and hosts. In leaving our egos behind, we also leave all social distinction and discord at the door/gate. In the tea space, we're all equal. This also means that we should seek out tea sessions with those in whom we find concordance and harmony, and even though we may disapprove of other's tea, refrain from gossip or condemnation.

The aesthetics of tea are also all about harmony. Creating a nice tea space and decorating it is about finding elements that are in harmony with another. The teaware also achieves a greater result if it is in harmony, each of the pieces with each other and with the décor of the room. This can be extended to even minute details, as the Japanese have done,

including the garden, clothes, and one's manners during the tea session.

Respect is a very important aspect of learning to infuse tea with Tao. Without humbling ourselves we can't ever truly learn. Many Westerners, myself included, struggle with the idea of bowing beneath others and admitting the mastery of another. However, in order to progress in a spiritual tradition it is important to cultivate a more Eastern respect and gratitude for the teacher, humble and open to receive any wisdom, and attempt to find it in our own tea as we develop and blossom into our own *camellia* flowers. Respecting the guests when you're the host, or vice versa is essential, expressing a gratitude and reverence for the tea they have prepared and the changes it will have on our constitution and consciousness.

We must also respect the tea and the tea space itself. Another translation of this virtue is "reverence." Without reverence for the tea and the space we drink it in, it will become too casual. Of course, some of us will find that when our tea is too constricted, we also don't achieve our Tao, our Way; but we must bring reverence to the Leaf and our drinking of it if we expect it to transform our lives. When we treat it with reverence, we'll listen to its wisdom that much more attentively, mindful of all the details of its surroundings, preparation, and consumption. When there is reverence, we prepare and drink our tea with love and wisdom.

Purity is also a very important part of why tea is a Way at all. It is not enough for us to practice these principles in the tearoom and then act differently elsewhere, just as Master Joo taught us. One's diet, conduct, and spiritual practice outside the tearoom are all part of what make up our minds, and we cannot expect peace and purity in the tearoom if we live impure lives outside. *Chajin* should practice simplicity, forthrightness, compassion, loving-kindness, temperance, and generosity in all facets of life. When one really listens to the lessons tea is brewing, one cannot but find that on the days when we are disturbed or impure, in diet or conduct, the tea is different. The tea space itself should also be a place where only wholesome activities are performed, thereby imbuing it with a positive energy that makes it easier for those present to find peace.

Tranquility is what most of us are really seeking in tea. We all want calm joy in our lives, and by having some time for stillness, quiet, and peace, we also cultivate insight into the art of living; and that is why tea is a Tao. By sitting quietly and enjoying tea, we are learning sensitivity—learning to listen to the moment and to the sensations in our bodies—and that translates to a better, more harmonious life.

Rikyu's gifts to tea people are treasures worth more than the rarest teapot or vintage of Puerh. One can have great tea and teaware, but if it is brewed with ego, covetousness, or pride, it won't be nearly as rewarding as some simple green tea drunk from the wooden bowl of a person steeped in the Tao. I have had the same great vintages of tea in scholarly settings, at shops who wish to sell the tea to me, and amongst friends in silence, seeking these four virtues in ourselves and each other. The latter is so much more rewarding in every possible way. In other words, tea isn't just about the tea leaves, water, fire, and technique, it's also about the attitude you bring to your sessions.

Baisao, The Old Tea Seller

"The Old Tea Seller," as he called himself, is one of the most important figures in the history of tea, especially as it relates to spirituality. Not much is known of his early life. He was born in 1675, the third son of the Shibayama family, living in Hasuike, Kyushu province. His father was a Confucian doctor that worked for the local daimyo, and the boy was educated to be one of the intelligentsia, learning calligraphy, Confucian ideals, Chinese history, reading, and writing, as well as *chanoyu.*

At the age of eleven, he entered the priesthood, joining a burgeoning sect that had been proselytized in Japan by Chinese monks. It favored rigorous study of the *sutras*, meditation (*zazen*), and adherence to the monastic precepts of old. He took the religious name of Gekkai, and was the attendant to his master Kerin. For a large part of his life he remained there, serving his master, though this sometimes entailed traveling around Japan. He retreated several times a year, meditating to purify himself. Later, when his master died, Gekkai was offered the abbotship of the temple. He refused the post, claiming that distinction

would hinder his practice, and it was given to a junior disciple. After that, he was free to travel.

Planning to live the life of a wandering monk, he slowly made his way to Kyoto, which was then a blossoming center for the arts. Since most of Japan was still under the rigorous legal and social codes of the Tokugawa Bakufu, Kyoto—the old capital—was really the only place one could enjoy a degree of individualism, creativity, and artistic expression. As a result, scholars, calligraphers, artists and poets flocked to the city to wander by its glorious rivers, surrounding hills studded with temples, finding inspiration therein.

In a time of great conformity, Gekkai carved his life against the grain. He let go of his priestly way of life and began selling tea out of a small stall he moved to various locations over the years. The monastic code prevented monks from working for a living, but Gekkai was put off by the greed most monks had for donations, stating that even in a mountain hermitage with the clearest sky and cleanest water, if one's mind is impure, all the world is unclean; and conversely, if the mind be pure, even a brothel or gambling den is a "hall of enlightenment." Better to live amongst the people and develop purity than in the mountains and kowtow to donors who wish something in return for their donations, he thought. At the time, selling tea around the city was one of the lowliest of jobs, mostly done by dirty old men who sold watered down, cheap powdered tea. Choosing this profession, therefore, and accepting the shame that went along with it was a profound expression of the Buddha's teaching of "right livelihood."

In no time the old monk came to be known as "Baisao," and his fame rapidly spread throughout the city. He never charged anything for his teas, giving them freely. Instead, he would place a bamboo tube on the table of his shop asking for donations. The bamboo was often carved with insightful lines that one give a donation if possible—if not it's free and, "I only wish I could give you the tea for less." He donned the black and white "crane" robes of a Chinese Taoist mendicant, decorated his small shop with bits of calligraphy and verse, and went about selling his tea.

Baisao sold mostly loose-leaf teas (*sencha*) from Japan and China. His hometown was near Nagasaki, which was then the only port open to foreign trade—mostly Dutch and Chinese—and supplied him with Chinese tea—though the only kind he mentioned explicitly in his writings was Wuyi yancha. He became famous for his poetry, tea, and the bits of spiritual advice he passed on to his customers. He also began toting his teaware around in bamboo baskets and setting up shop in various scenic spots around Kyoto, further establishing his fame. He eked a meager living that suited him, and over the years composed a large body of excellent poetry that conveys quite lucidly the essence of Cha Tao.

Baisao was forced later to abandon his monastic name for a lay one, but by then it wasn't important to him. He died peacefully at the age of eighty-eight. Near the end, his friends compiled his poetry into a book that was published as the *Baisao Gego*, which is profound because the word "gego" means "religious verse," rather than the common title "kanshi" used for literary verse. Even then, his words were regarded to have spiritual power. There are so many wonderful poems attributed to Baisao, that we can only quote a couple here, recommending that you find a volume of his work in order to further explore his deep understanding of Cha Tao.

> *Set up shop this time*
> *On the banks of the Kamo*
> *Customers, sitting idly*
> *Forget host and guest*
> *They drink a cup of tea*
> *Their long sleep ends*
> *Awakened, they realize*
> *They're the same as before*
> —translated by NORMAN WADDELL

> *Set out to transmit*
> *The teaching of Zen*
> *Revive the spirit*

Of the old masters
Settled instead for
A tea-selling life.
Honor, disgrace
Don't concern me
The coins that gather
In the bamboo tube
Will stop poverty
From finishing me off.

—translated by NORMAN WADDELL

Cha Tao and Chanoyu

The Japanese tea ceremony does have some variation from season to season, and place to place, called by the masters "temae," which means literally "that which is before you." The focus of the tea ceremony itself, however, is on using the garden and its symbology—of transcending the ordinary world, and of the renunciation and simplicity of a hermit's grass hut—as well as the method of preparing the tea to achieve a heightened state of mindfulness and purity. The Japanese masters had students learn a rigorous code of conduct for tea preparation for the same reason that martial arts students practice forms again and again: in the repetition and perfection of the ceremony, the ego is lost as one becomes a part of something greater than oneself. The form forces one to be present and attentive with the Tao. Through a balance of repetition and spontaneity achieved over years of practice, one might still the mind, achieving equanimity and insight into one's true nature.

The Chinese tea ceremony has always sought the essence of the Leaf, and found the Tao through a dialogue between the tea as Nature and the one drinking it. By perfecting all the elements that go into tea, seeking that ultimate, perfect cup, we achieve the same mindfulness and purification of ourselves. The Japanese, on the other hand, have taken a more Zen approach to tea and sought the Tao not in the essence of the Leaf and the dialogue between man and Nature that it inspires, but in the form of the ritual, or "ceremony" itself. By creating a repetitive space where the mind and ego are lost and the simple act of

making tea in a traditional way takes over, they reach the same heights of mindfulness and understanding as the Chinese tea sages did: which is the realization that the highest and only true expression of tea is drunk as Tao. The goal is the same, though the process is different.

While most nations went on to develop their own tea culture, they are all also related to their source in the mountains of China. Authors often incorrectly suggest that Japan was the only culture to develop a spiritual approach to tea. Actually, China and Korea also have strong traditions of using tea as part of the focus of a spiritual life. In China, as we discussed earlier, tea began thousands of years ago as a meditation and medicine, first by shamans and then later by Taoist and Buddhist monks. What was unique in Japan was the method, not the idea or practice. The results of these different paths are the same, like two mountain trails leading to the same temple. In ancient times it was always assumed that the Way (Tao) was really thousands of smaller eddies flowing on in one great river, and that no two people or situations would ever require the same approach to achieve a union with that great flow. Consequently, the Taoist would say that different times and places require different movements to bring man in touch with himself and Nature, and neither is more or less valuable.

Though I myself practice more Chinese than Japanese tea, I often drink deeply of the wisdom offered by Japanese tea masters. I also have found that incorporating a small bit of garden, even if it is just a few plants, near the entrance of my tearoom helps to make the movement inside a transformative one. I also like to place water near the entrance, or give my guests warm and moist towels to wash off their hands and face, as I respect the idea that this symbolizes: washing off the cares of the World. Most importantly, though, I respect the idea that silence is integral to a happy, healthy human life, as well as true tea appreciation. It is possible to enjoy company and friendship through tea, but true contact with the subtle flavors, aromas, and sensations of a tea can't happen when one is chatting. Jean Arp said "Soon silence will have passed into legend. Man has turned his back on silence," and I think his prediction has in fact come true in these bustling, noisy times. More than ever we need to learn from the tea masters of Japan and devote

some part of our day to a time for silence, basking in the wisdom and tranquility it can immerse us in.

The Japanese have a saying, "Ichigo ichie," which means "one encounter, one chance." It means that this meeting of people in the tearoom is unique. It will never happen in this way again. Even if we have tea with the same people every day of our lives, each encounter is a unique, bright and shining moment that will never occur again. These diamond moments are our ownmost. They are more precious than gold, for in their totality they are all that we are, you and I. So also, following me on this journey through tea and Tao, we are here together now in a special moment of your life when tea speaks to you; let us pause and have a bowl, whisked and raised to the spirit of the Japanese masters who came before us.

留迫

為盡寶物
不老丹

The Way of Tea

Moving from the story, through the art, we now can turn to the Way of Tea itself: the tea session, drinking, the Qi, and the virtues that Cha Tao brings as we live in harmony with Nature through tea. I would always suggest that you spend at least as much time with tea as you do with this book, for as grateful as I am that you have followed me this far, a real "passing on" of the wisdom that was given to me—flowing through me rather than created by me—will only occur in the Way you drink your tea each day, and the changes a life of tea brings.

CHAPTER FIVE

Calm Joy

Tea should ideally be drunk with a small number of guests. Many guests lead to a noisy atmosphere, which diminishes the refined pleasure of tea drinking. Sipping tea alone can be called spiritual; two people is superb; three or four is entertaining; five or six is excessive; and seven or eight is charitable alms-giving.

—ZHANG YUAN

Like everything Chinese, tea has been affected as much by Confucian social ideals as Taoist and Buddhist internalization. From the huts of the mendicants to the monasteries and the society at large, tea has journeyed bowl by bowl, cup by steeping cup. It's as much a social treasure as it is a meditative or medicinal one, for through tea we make new friends and celebrate the old ones.

A contemporary of Lao Tzu, Confucius authored the ideas that would course Chinese social etiquette and morality for the coming centuries, including tea. And there was one fundamental principle that the Confucians and Taoists agreed upon: that the inner-nature of all things was to be trusted. Confucius called our inner virtue "ren," which is often translated as "humanity" or "humanness." However, when he was asked to define this quality, like Lao Tzu, he declined, arguing that it was something that needed to be felt, rather than explained. He knew that human virtue could never be captured in a set of rules or guidelines, but was expressed uniquely in each situation.

So much of tea is about sharing our *ren* with others. Even to the ancient Taoists, tea often represented a means of communication. Since the Tao is by definition ineffable, they had to seek other ways of sharing it from friend to friend or master to student—a tradition that

would be continued in *Chan* Buddhism. There is a very real sense in which the mind of the one brewing tea has a tremendous impact on the quality of the flavor, aroma, and Qi of the tea liquor: a sense of sharing from the one pouring to the one drinking. It is almost as if she were pouring herself into the cup. And the more sensitive you become, the easier it is to recognize just where a person's mind is from the taste of their tea alone. If one is rushed, the tea tastes so. If a businessman is trying to sell his teas, and has money on the mind, the liquor will taste of the proverbial coin. Only you are responsible for the mind and mood of those you prepare tea for, as they are—in part at least—drinking the vibrations of your mind. And if you're at peace, you make peaceful tea. Couldn't the same be said of any art?

There is indeed a hidden quality that goes into the way an art is created, which changes the way it affects others—you might call it "soul" for lack of a better word. Why is it that our own mother's cooking always tastes better than even that of a gourmet chef? And you may see a hundred live concerts, but one particular performance was such an experience that you never forget it for your whole life. Similarly, of five portraits painted with equal artistic skill, one expresses an indescribable majesty that makes it a masterpiece. Couldn't it be said that the musicians poured their soul into their music, the artist lost his in the paint, or that your mother put her love into her cooking? The same principles apply to tea—to all art, in fact—which is one of the main reasons it has always played such a large part in the spiritual traditions of all cultures: it is a transmission.

There is an un-*known*, unsaid harmony between individuals who sit silently together, forming bonds of memory and friendship more unbroken than that which can be forged in the fires of speech. So much more life can be shared, as well as understanding, when we rest comfortably in our true natures, without any of the ego-stuff needed when we talk with others about our places in the World. The tea space can be a clear and inviting pool in which we can shed the scales of our outer lives and egos and swim silently and unpretentiously, free like so many koi fish. It is a place where we meet as equals, powerful millionaire and pauper hermit, and through drinking tea and sharing

some calm joy find the more beautiful parts of one another—the inner self, our "Buddha-nature," the Tao. Tea contains within it the state of No-mind; it doesn't discriminate or classify—it just is.

When I speak of a tea session that is successful, or "steeped in the Tao" as I have mentioned elsewhere in this book, I envision the many tea sessions that have left me feeling peaceful and connected and those that haven't. I have had tea in literally thousands of tea houses, shops, homes, and even outdoors with as many different kinds of beings for company as there are, and experienced a variety of tea from boisterous and argumentative to profoundly transcendent, and everything in between. The best sessions weren't necessarily somber and silent either, though I have had great sessions like that. I've also made lasting memories and found great joy in laughter and mirth, sharing and love between great friends, even celebration.

In the age of the Taoist recluses, the serenity of the tea session was transmitted much more naturally, and very little about the leaves, water, teaware, or even company mattered. For one, they were living in the grandeur of Chinese mountains, breathing clean air imbued with the smell of pine, and perhaps drinking their teas beneath the shade of great tea trees themselves. Even when the scholars and artists came to visit them from the city, they weren't annoyed by their loquaciousness, but served them the Tao in a cup and accepted them as part of the flow of life. In this modern world, however, we must cultivate the situations and tea sessions that may bring us Calm Joy, connection, Quietude, and even the occasional glimpse of transcendence. It isn't enough for us to hope that the pieces will all fall into place on their own. We have too much Dust on us. Though we cannot control others, we can change the Way we are with tea, hopefully learning from the times we ourselves get caught up in the negativities that spoil or distract from a tea session steeped in Tao.

Natural Grace

One of the most important concepts in Taoism is "tze lan (自然)," which is often translated as "natural." It means that things are as they

are—"just so." There are so many forces in this world that we will never understand, though we use them all the time. Life happens; it isn't controlled—you must experience it, not solve it as you would a riddle. You don't grow yourself. You didn't determine your shape or bone structure any more than you beat your own heart. Your breath comes and goes on its own, without any effort to control it. Similarly, the Taoists knew that the mind could be unfettered and left to think itself, without control. Most of us are terribly afraid to let our minds go in this way; and yet, it is essential if we are to find lasting contention, as well as true friendship with others.

Beyond the quiet transmission through tea we discussed above, there are so many ways that tea can bring people together to form lasting bonds. It is the pinnacle of civility, which is the very quality that carried it on Western ships to spread around the world and become the second most consumed beverage on earth. It brings out the best in us. No matter how you prepare tea, or where, the sharing of tea becomes a time to relax and let go of the worldly mind. One reverts to *tze lan*, and stops getting in the way of the situation.

Just as the trees naturally grow towards the sky and the plants turn towards the sun, our minds turn towards our own calm center when we let them go and stop trying to control them. The same can be said for situations, including tea. The best tea isn't monitered or controlled by rigorous parameters. As anyone who has ever had a terrible day can testify, the more frustrated and tense you become, the more mistakes you make, which only compounds the problems you're facing. Similarly, tea cannot be controlled like an experiment. The best tea sessions are relaxed and smooth. If the one brewing lets go, relaxes and finds his or her calm center, this will be communicated to the others present and they will similarly let go of their cares for a while.

The ancient Chinese and Japanese built tea huts in their backyards that resembled mountain hermitages because they understood that in order to live a healthy life, even a government official who lives in the heart of the city must have a time and a space where he can occasionally go to shed all his rank and responsibility, and for that little while be just as the carefree hermit out walking the clouds. And you don't need

a hut or garden to do this. You don't need a ceremony or a method. You just get together with some people whose company you enjoy and let go of yourselves. Tea really can be that simple.

One of my favorite tea shops has a piece of calligraphy by the door that says: "Leave your egos here," as if our ego was a pair of shoes to be put beside the door. There is a very real sense that as we enter the tea space, we can relax into our own unpretentious, natural self and be comfortable sharing ideas, wisdom, and love in a relaxed environment that supports this. Because of that, conversations naturally take on a glow, shinning with a greater truth and more forthright expression of our selves. There is no longer any need for us to wear the masks of the world; to play our various roles—as parent, employee, boss, teacher, student, etc. In that way, conversion flows as smoothly as the tea. People relax. Everyone lets go of that certain something and finds comfort in one another. We find ourselves sharing things we wouldn't otherwise, letting go of inner tensions, laughing more, smiling more; and all the problems we had with the guy next to us seem trite now. I call this energy/experience/ambience: "Calm Joy."

Successful tea company is about being in harmony with Nature and each other, best achieved in quiet, but if there is talk it should be gentle, free, and spontaneous without any need to puff up the ego and show off tea knowledge, which is all terribly unimportant anyway. I have watched some of the greatest vintages of tea ruined by a bunch of "tea scholars" arguing silly and inconsequential details as they drank, rather than paying any attention at all to the wonderful tea before them, or the wonderful company around them.

The participants should also have respect for the tea and each other, often best expressed within humility. We practice humility and gratitude to the tea, the one brewing and the whole situation, placing the tea ceremony itself above ourselves. In that way, we find that more and more of our tea gatherings express this calm joy. Many of my teachers always say that the most important aspect of the Way of Tea is reverence for the Leaf, the tea space and the people we share tea with. Just by approaching tea with an attitude of respect and reverence will ensure that we find better tea sessions, higher quality leaves and

teachers. With an attitude of reverence, in other words, one's tea journey can only lead upwards.

Finally, I think the best tea sessions are the simple ones, where we let our minds be quiet and still, calm and joyful without trying to impress; where the space is conducive to relaxation without the need to be or know anything—where the tea, teaware, and water combine smoothly and unostentatiously, and the company is as natural as the inner "mountains" we are retreating to as we leave the "World of Dust" behind for the higher paths of tea. One should remember to shake off one's Dust, in other words, before sitting down for tea, perhaps recollecting harmony, respect, humility, and simplicity as ideals that, like good tea and water, can mix magically to create a tea experience beyond any flavor or aroma.

Quietude

We cannot act rightly and effectively unless we are in the habit of laying ourselves open to the leadings of the divine Nature of Things. We must draw in the goods of eternity in order to be able to give out the goods of time. But the goods of eternity cannot be had except giving up at least a little of our time to silently waiting for them. This means that the life, in which ethical expenditure is balanced by spiritual income, must be a life in which action alternates with repose, speech with alertly passive silence.

—The Perennial Philosophy by ALDOUS HUXLEY

Quietude is perhaps most important aspect of the Way of Tea. If one is busy chatting and the mind is running, then which part of oneself is enjoying the tea? Who can chat about the weather and really taste a tea deeply at the same time? If one is drinking precious and rare tea, the experience must not be wasted. Fine teas are appreciated much better in silence. The conversation between the tea and oneself is far more important than anything that needs to be said out loud—if one wishes to listen. In this modern age everything, everywhere seems to lead the senses outward and away from oneself. Don't be afraid of quiet. Find the time for peace and introversion, and life will have new meaning.

Of course, a big part of tea is a celebration of friendship—sharing time and a common passion with others. However, no matter what your approach to tea is—as a hobby, pastime, or spiritual journey—progress is founded on the ability to quiet yourself. If you wish to develop your palate and discriminate quality, or if you really want to fully enjoy a cup of tea, you'll need to learn to shut the mind off for

some time. This is essential to proper brewing and drinking alike. When brewing tea, your state of mind plays a large role in how the tea will turn out, as so many of us have found on those days when we are rushed or frustrated by the comings and goings of life. And when drinking, the subtler flavors, textures, aromas, and sensations all require some relaxation, which begins with quiet. Even those who drink tea purely as an outlet for a bit of pleasure and relaxation will find their sessions so much more rewarding if they have a bit of quiet time and space within which to enjoy their cup of tea.

My grandmother drinks a mug of tea, made from a tea bag, each evening. There's nothing fancy about it, but she always asks us not to disturb her; and when you see her face, leaning back in her chair and slowly sipping her tea, it's obvious that she's completely relaxed; and I'd say that has as much, if not more, to do with the quiet time as the tea.

Through many years of drinking tea and spending time with those that drink tea, I have found that even those that approach tea as a hobby or a bit of warm refreshment on a cold night—even they really aren't seeking the Leaf just for its own sake. The hobbyists and collectors may enjoy arguing the nuances of particular vintages or the history of tea, but when they drink it they are often really seeking the quiet comfort it offers them.

In the modern world, everything continues to speed up. We move about our lives in faster and faster ways—technology always groping for ways to make everything quicker and less conscious. In such a stream, many people will find it all too difficult to cease the rat race for long enough to even "practice" meditating. However, most can find the time to drink tea once a day. Through conversations with many people who enjoy drinking tea regularly, I have come to find that most of them really crave this quiet, peaceful time to themselves as much as they do the tea itself. Deep in their minds, the tea is in part a symbol for the refuge that they seek from a life in the hectic modern world, with all its trials and tribulations. The cars and planes buzz by, but they look out as if from a bubble of silence in their houses. The raging river flowing just outside disappears and only some leaves and water remain. Even the idea itself is profoundly tempting.

Sometimes when people become uncomfortable in the silence of a tea session, they will ask silly questions that they don't really care to have answered, just to make small talk. One of my teachers always responds to this by extolling the rarity of the experience. He says that these old teas we are drinking were first produced in such limited amount, then stored for so many years carefully by many hands passing them on, some of which have since died. And in the future, these very rare and expensive teas will not exist—they will just be photos in books for future tea lovers to wonder about. "All of those people would love to travel back to our time to share this experience with us," he jokes. Therefore, out of reverence and respect to the extreme preciousness and rarity of these leaves, we are quiet, focusing fully on the tea. Our questions aren't stupid, he reminds us, "Let's just save them for later. For now, let us concentrate on enjoying the tea, fully aware of as many tones and shades of it as we can, so that it couldn't be said that such treasured liquor was wasted." And this could be applied equally to any loose leaf tea, no matter its rarity or vintage—for every tea required a lot of work on the part of the farmer, not to mention all that went in to getting these leaves from the farm to your pot. Intellectual curiosity is fine—we all have a desire to learn—but save it for the times you're not actually drinking tea, for those times are better spent paying attention to the tea at hand.

Usually, we start a tea session with some lighter teas and a bit of conversation before moving on to higher-quality leaves. Sometimes when one of us who has been coming around long enough to know better gets uncomfortable and starts trying to chit chat, which happens to all of us at some point, my teacher will simply raise his eyebrow, reach below him and grab the *gaiwan* or pot of whatever oolong or other tea we were drinking earlier and switch it with the deeper one we're having now. Without saying a word, he is basically admonishing us, as if this switching itself says: "Okay, you want to chit chat, no problem; but not with this tea. If we are to talk, let's not waste this very rare tea. Let's instead drink this more common one, since the tea isn't going to be the focus of our day." So are you drinking your teas fully? Are you there with the experience completely, or is it just

the background for other activities, conversations, or even internal contemplation? If you are with the tea, then you are quiet.

To learn to appreciate all aspects of a tea, the mind must be still. The subtleties within different teas are endless, and reflect perfectly the subtleties within the mind. Learning to become more sensitive not only improves the taste and smell of the tea, but the Way in which the experience of drinking it changes our lives. As long as one approaches the tea with unaffectedness, the quietness within the tea will invariably follow. Just by drinking good tea in quiet, then, the mind learns to be more peaceful and sensitive, so that we may better enjoy the subtler sensations, flavors, and aromas within the leaves. It is not the act, belief, ceremony, or technique that brings mindfulness—it is the plant itself, and the reverence one brings to the drinking of it. Just by maneuvering the tea through whatever ceremony one chooses, the Way is achieved. This is because the quality inherent in the mind/tea is enough. The mind will center itself naturally, without effort. Finding the Way to do something in harmony with its essential nature, in harmony with our own inner Way as it unfolds, is more than just our own personal Tao, it is *the* Tao. Where else may we find the Eternal, if not in harmony with/in ourselves?

Once people begin talking, all the aspects of their egoes come to the surface, and all too often the conversation leads to debate—even if it is about the tea itself. Of course, not all conversations are thus, and there are many we can chat with freely and comfortably, spreading Calm Joy. However, when people and talk mix, it is very easy to lose the tea in favor of the conversation.

Disconnecting to connect

It is amazing, but most of us need to disconnect from various outlets in order to even begin connecting to our very selves. There is a constant, nagging need to plug in to all the quicker and faster ways we make our lives electronic, as well as more and more externalized. We email and text message before we phone. And it seems, strolling through an urban center, as if no one even takes the time to look in each other's

eyes anymore. With tea it's the same: people rarely want to take the time needed to have a tea ceremony each day, and even those that do often cannot shut off the internal dialogue, choosing instead to record the whole event in notebooks and blogs for others to scrutinize, analyze, and argue over the trivialities. Faceless, we have internet and telephone avatars, little cartoons and pet names that take the place of real human contact. The average person in these times will spend more time gazing into a television than they will the faces of those they love. And having grown up in America, I am no different. One of the saddest facts of my existence came to light when I realized one day that I had forgotten the color and beauty of my great-grandmother's eyes, who had lived until I was about 8 or 9 years old; though I will never forget the theme song to *MacGyver*, or the color of the main character's eyes. Even commercial jingles are sometimes more clearly a part of my childhood consciousness than the people I walked with. Needless to say, I don't own a TV these days.

In discussing the philosophy and poetic inspiration of thoughts revolving around the Tao, the simplicity and stillness such a life engenders, John Blofeld poetically says that no matter what level our understanding, a mind "fed on words such as heaven, earth, dew, essence, cinnabar, moonlight, stillness, jade, pearl, cedar, and winter-plum is likely to have a serenity not to be found in minds ringing with the vocabulary of the present age—computer, tractor, jumbo jet, speedball, pop, dollar, liquidation, napalm, overkill! Who would thrill at the prospect of rocketing to the moon in a billion-dollar spacecraft if he knew how to summon a shimmering gold and scarlet dragon at any time of the day or night and soar among the stars?" Similarly, a mind filled with simplicity and harmony, tea and the quiet it instills, will help us to leave behind the rat race and develop tranquility, harmony with Nature, and movement away from the World and all its turmoil, returning to the place where words like "dew" and "jade" make sense again.

A big part of Cha Tao is learning to have some time to disconnect from all the "World of Dust." Most of the people who come to the tea houses I like to frequent, first thing when they arrive, shut off their cell phones. We must practice disconnecting from the TV, movies,

internet, our work in the World—finding a way to make a little room for the tea ceremony to breathe in.

A human being cannot live a healthy life if periods of stillness are not interspersed amongst activity; and in fact a lot of the sickness represented by humankind itself is due to a collective disregard for stillness. A big part of Taoist thought revolves around quietism and naturalism: Watching Nature, we see that everything moves in cycles of activity and rest, and those forces without periods of stillness interspersed amongst the movement are always off balance, and quickly burn up.

Brushing the Dust of the World aside, we create a little bit of peace and cleanliness in our day—clean of all the noise and clutter. No one need share it; no one need know even. We just sit and be with our tea, enjoying it fully—the taste is deeper, the aroma more fragrant and the energy in our bodies more imminent. And as I have already mentioned, the one who brews the tea is more important than any other aspect of the ceremony—all the best leaves, teaware, and a gorgeously peaceful tearoom won't help if the one brewing isn't steeped in the Tao—so, by practicing peace, your skill at brewing and appreciating tea will improve.

If we are in a rush, our tea will taste messy and the energy will only further these emotions in those that drink it. We must calm down, play some relaxing music, do some breathing meditations—find a way to clear the mind as we approach our tea each day. Let the Tao prepare the tea and we can just sit back and enjoy it.

One of my teachers always discusses the peace and quiet so needed in every life, yet passed by on the way to or from some illusion thought to be of greater importance. His tea shop is just fifty feet or so from a main thoroughfare, surrounded by a nice garden and lots of great tea. Sometimes he will gaze longingly out the window, sigh, and say something to the effect of, "all those people are running to or from some place, their minds quickened as they hurry to get something done; and in that state they don't realize that such peace lies just fifty feet away—just a simple right turn and they could share this calm joy. Then, when they returned to all those jobs that needed done, they

would be better workers, parents, or students, having found a bit of calm intention to approach the day."

Don't miss that right turn, my friend.

The Real Quietude, Found Between the Spaces

Any spiritual practice of any kind, anywhere, under any teacher, must begin—fundamentally—with a bit of quiet time. And yet, there is a deeper state that we must achieve in which the quiet is within our actions. This is aptly expressed in the Zen adage that, "it is easy to have peace in moments of inactivity, it is hard to find it in activity, but the peace and wisdom within activity are true peace and wisdom." The true Tao is in the movement of all our experiences, and we must learn to be quiet even when everything is noisy. We do this by learning internal quietude at the same time as we learn to shut off the outside world. This is why reading a book or writing in a journal, though practiced in external quiet, is not usually as powerful a practice as tea is.

With tea we are indeed active—pouring, steeping, and sipping on the outside, and even accepting and digesting on the inside. However, there is a great opportunity to shut off all the internal noise, let it drift away naturally as we explore the experience of drinking the tea itself. The more fully aware we are of the moment, of the tea, the more we will find the quietness inherent in the tea (or perhaps you could say it will find us). There is no need to really put any effort into quieting the mind. Just practice making the environment still, and concentrate on the tea. Enjoy it, drink of it fully, notice every nuance of its flavor and aroma—travel deeper to the Qi in the body and ride those tides to the great silence that is our true nature.

There is quiet pervading the entire Universe, even in the remote corners where there is noise. Stillness is behind all that we do, all that we are. As Lao Tzu often pointed out, it is the space that makes the house useful, the empty space in the teapot that allows for the tea, and so too must we move through emptiness as we go about our lives. He believed that the Whole would always be master of any of its parts, and resorts to this method of teaching several times. Only within space

is movement possible, both here on Earth and in the celestial sense.

No concept was as important to the early sages as stillness. They believed that a person who could still herself would ultimately become emptiness, allowing all experience and change to flow through her. Such a one would be a master of all situations, connected to the movement of the whole universe, the Tao; and though composed of matter, would be like the walls of a house, only useful as a vessel for the air of change that breathes through it.

The Way is being open and empty to all experience, and thus finding beauty and truth in the most mundane aspects of life coursing by—each moment an unaffected part of ourselves as the Whole.

Once we begin shutting off our lives on the outside, closing our mouths to all but the tea, we will find that the calmness inherent in the tea—the world, the Tao—will quickly sooth the moment and we will more and more naturally find ourselves okay with this peace. As we drink tea in this Way each day, we will also find that the quiet we have inspired in our tea ceremonies stays with us longer and longer as we move out into the World. All the reasons that we began drinking tea, seeking quiet and calm in a life of whirling noise and turmoil, will begin to be a part of us. Once you have found the quiet that is our true nature, the "Tao" or "Buddha-nature" or whatever one wishes to call it, then every moment can become a step along the Way.

Perhaps the mind itself wants to calm. Maybe the underlying non-dualism of pure consciousness, unoccupied by anything, is our natural state. Do we crave that rapture in all that we chase after in the world? Does it come naturally to us once we let go and relax? And could the peace and joy we have always sought be so simple as a cup of tea?

CHAPTER SEVEN

Presence

Our free will can hinder the course of inspiration, and when the favorable gale
of God's grace swells the sails of our soul, it is in our power to refuse consent and
thereby hinder the effect of the wind's favor; but when our spirit sails along and
makes its voyage prosperously, it is not we who make the gale of inspiration blow for
us, nor we who make our sails swell with it, nor we who give motion to the ship of
our heart; but we simply receive the gale, consent to its motion and let our ship sail
under it, not hindering it by our resistance.

—St. François de Sales

Presence means that we stay in the moment, here and now. The Way of Tea compels one to be present. One practices concentration and focus by being with the pouring, sipping, smelling, and movement as it is. This helps calm the mind and center it on the moment at hand, without drifting in the past or worrying about the future. There is much relaxation and peace in the present moment.

Every saint, sage, and seer that has ever had a student used some method to try to achieve Presence. The more quiet we become, outwardly and inwardly, the more natural being in the present moment will become. The past is gone forever and never can be changed, and the future remains eternally beyond us. The only connection we can have to Reality, to the Tao, is through the present moment. There is great bliss, joy, and wisdom when one learns to be fully present. Our actions become spontaneous, free and produce much greater results as they are clear, untainted by the warped looking-glass of the past.

Since ancient times, Taoist mystics have realized that there is never anything to achieve, for all is perfectly and endlessly contained in this

moment. Even if you retire to a hermitage and meditate day and night for thirty years, you will still, in the end, be here and now. No matter what time of day it is, it's now; and no matter where you are, it's here. Even if we roll in memories of the past, or fantasize about the future, that act of thinking or imagining is still taking place in the present, the "eternal present." And as this realization becomes a part of us, rather than a witty philosophy, our actions travel in accord with the movement of Nature, rather than against the grain.

The more aligned and present we are, the healthier we will live—the more our every waking moment becomes in harmony with, and an expression of, the Tao. If you are present and aware, fully mindful of the moment in all its beauty, then that moment is "enlightened." Through quiet tea, we will eventually reach the state of mastery over the moment, the here and now, where the real tea ceremony is happening—each pour, each steeping, each sip.

Wu wei: Action Without an Actor

After *tze lan*—our letting natural phenomena be "just so"—the concept of "wu wei (無為)" is the second most important Taoist ideal. So often, we get in our own way, stand in our light, block our own growth, etc. *Wu wei* means getting out of the way of the current and letting it flow unobstructively. It might literally be translated as "not forcing things" or "without force." Lao Tzu often used the analogy of water, as we have mentioned, as a guide to all skillful living, since it is the weakest force in the world—cleaved by even the dullest knife—and yet it overcomes even the strongest of stone, through its very softness. The greatest canyons and cliffs were all carved by its patience. It is the highest, because it puts itself lowest, in other words.

Those that try too hard to be spiritual—or loving, compassionate, intelligent, etc.—always fail, by tripping up their own effort with too much effort, as paradoxical as that sounds. Spirituality is often confused for the ability to talk in a soft voice or act with a calm demeanor. There is nothing wrong with acting pleasantly towards others, but if this isn't matched by a natural, inner expression of such peace, then it really is

just an act. When spirituality is genuine, it isn't forced or practised. The saint doesn't need to devote energy to being saintly, in other words, he naturally is. In that way, he's free to respond to the moment in the most conducive and skillful way, rather than trying to compel it to his ideal.

When we use all our power to concentrate on a book we're reading, gritting our teeth and straining our face muscles til they twicth, we read a whole page and realize we didn't understand a single word because we were trying too hard. We were focused on concentration iteself, rather than the meaning of the words. In any art, the one who is tight and compressed will always produce inferior creations to the one who is loose, free, and open to the medium itself. That is not getting in your own way, or standing in your own light. That is "wu wei."

Almost all of our confusion comes from not understanding which aspects of the universe we can change and which we have only the power to accept, allowing them to flow through us. We try to influence other people or situations and then when they act in ways we find offensive we get frustrated by our inability to change them. We also fear the changes that we can afford to make, in ourselves, shying from the deeper looks into the mirror; and in the world, preferring to avoid confrontation. The Christian theologian Reinhold Niebuhr wrote a prayer in the 1930s that would capture the essence of living with the Tao. Later, it was simplified to:

> *Grant me the Serenity,*
> *To accept the things I cannot change;*
> *The Courage*
> *To change the things I can;*
> *And the Wisdom*
> *To know the difference.*

This simple reminder, so clean and clear, cautions us to find an accordance with the greater universe around us, focusing on the moment at hand so that when we act, we do so knowing where our will can have the greatest and most positive influence.

As a result, much of finding such harmony with the Tao, in all the

confusion of this modern age, begins simply with taking the time to introvert. After all, living the Way is about doing something in tune with the essential nature of how that thing is done, naturally; and we can't ever achieve such harmony if we aren't open to the flow of the Tao, returning to a sensitivity of Nature, the moment and a mindfulness of whatever we're doing. We must learn to return to an understanding that the universe isn't separate from the mind, but contained within it in this very moment.

A Tea Session with Presence

Drinking tea with Tao means that we use the tea session as a clear and clean space within which spiritual insights might flourish. It does not mean practicing any kind of right or religion, "believing" in anything, etc. It isn't about offering cups of tea up to a divinity, or drinking them in somber gloom. Drinking tea with Tao takes place in the heart, a cultivation of a stillness that can be there even in mirth, laughter, sociability as well as mountain-like serenity.

Tea's ability to both stimulate our awareness and calm us down at the same time makes it the ideal center for a natural and spontaneous meeting with the Tao. By being quiet and present to the tea, on the inside, we are sharing ourselves with the moment. The tea, once a plant—rain, earth, and sky—is now becoming human, a part of the stream of human consciousness. The dialogue between our selves and the tea goes both ways, we become a part of it and it becomes a part of us, literally and metaphysically.

There is then, a kind of sharing between myself and the moment, as well as a dialogue between Tao and the tea. After all, I am *drinking* the tea, consuming it—taking it into my being in every sense of the word. It enters my body and my consciousness, becoming a part of the stream of experience that is my life. Therefore, the tea becomes a person—the moment awakens and becomes the all, the Tao.

By being in the present, fully committed to the moment and the tea, we may lose ourselves, acting without ego or attachment—we ***are*** tea, in other words. There is no "Self," no you or I, just tea. This is

what the Taoist sages meant when they said "wu wei"—action free of ego, liberated from of a sense of "Self" within the action. *Wu wei* also means doing things intuitively rather than intellectually, from the heart; it means living spontaneously and free, reaching out and participating in the world from the still place at the center of your being. One of my teachers likens this to the movement of a clock, the hands busy twirling away the time, while the point at which they meet in the center is always still. That stillness is the Tao, and when it has the reigns—when we act outwards from that stillness—we are living not just from our center, but from *the* center, which is why the ancients said there was no actor in such action.

Wu wei, then, is like the way a plant bends naturally and intuitively to face the sun, and yet the effect is the same as if the action was done with force. In fact, it is better, for if we forced the plant to grow a certain way it would lose its natural ability—in one or many generations—in the same way tame animals lose the ability to find their own food and survive in their natural habitats. In trying to twist the world to his own will, mankind has found itself mirred in all kinds of environmental quagmires—problems that could have easily been solved had we used the natural movements of Nature to gather our energy, like the sun, wind, or water.

You might consider the analogy of an athlete, whose body, mind, and spirit are working in conjunction, and when he or she is at the height of his/her powers, all forces align and adjust to the changes of time without any thought or contemplation, spontaneous and free. It is no wonder so many great scholars have compared the greater spiritual states to the centered stillness the best athletes achieve at certain times.

There is no book you can read to teach you how to dance or make love. In order to do these things properly, they must flow of their own accord, naturally. So, also, the best tea is not prepared through a list of guidelines or parameters for brewing—it is poured out of the needs of the present moment, and into the cup of the present as well. Like a great dancer, the tea master brews to the movement of the music, not from a choreographed routine.

The emptiness and presence that we encompass when we do

something intuitively and mindfully, from the heart—that to me is what I refer to as "Tao," both in terms of the "Path" I'd like to follow, the "Way" I'd like to live my life, and the Great Truth, the Beyond, Ultimate, God, *Atma, Brahman, Nibbana,* the moment, "Zen Mind," or whatever else it is you call that place where our beings meet the greater Universe we are a part of.

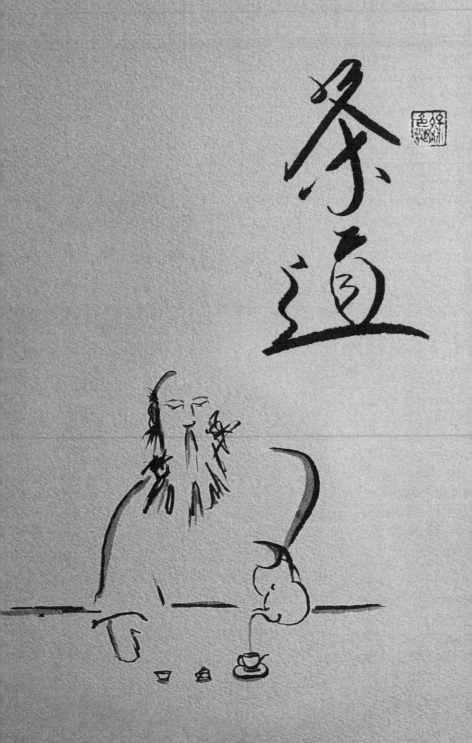

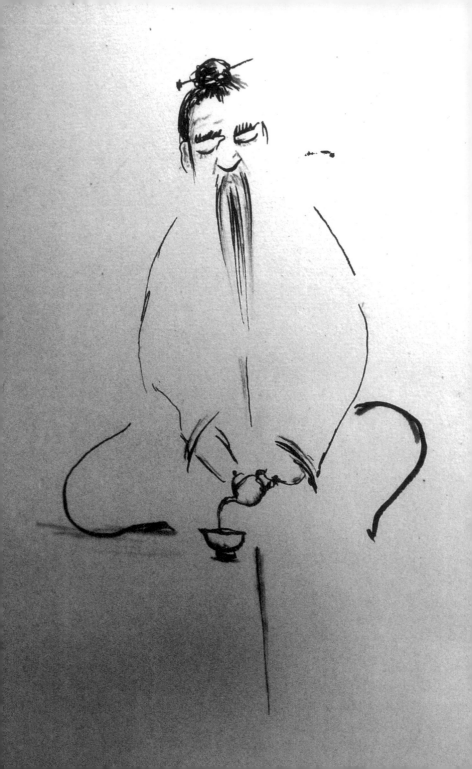

CHAPTER EIGHT

Clarity

Heaven and Earth and I were born at the same time, and all life and I are one.
—CHUANG TZU, as translated by Martin Palmer

Insight will definitely occur as one practices more and more. The subtler sensations caused by the tea will become apparent. With time, one will begin to feel the Qi in the body and recognize its movement. As the mind becomes clearer, the waters less ruffled, more aspects of the tea are available for enjoyment. This clarity and subtlety will later translate to all aspects of life.

The Way is one of truth, finding ever-expanding and clearer viewpoints of the World, as it is. My meditation teacher says, "as it is, not as you would like it to be" more than he says any other words, almost like a parrot if it weren't for the depth and power behind the words. The Buddha also admonished his disciples with the same words, "ya ta bhu ta." If we don't learn to see things clearly, experience them as they are, we cannot achieve wisdom. The whole Path of introversion must lead to the truth of our existence—not in the sense of a scientific thesis, a comprehensive philosophy of the Universe, etc., but as a living, experiential truth of the ground of all being. The Tao, like life, is a sensation to be lived through—experienced—not a problem to be solved intellectually.

The Way of Tea is an expression of the deeper truths we find in connection with the Universe, living truths about what it means to be human, to be alive. Learning to see limpidly is as natural as any of the other virtues that come with a life in harmony with the Tao. As we drink tea in quiet, present in the moment, we become more and more

sensitive. This sensitivity is an acumen that affects all aspects of our life: our diet, our interaction with others professionally and personally, our capacity for work, etc.—all are improved by our sensitivity to the needs of the moment.

So many people know how to talk, but so few listen. Emerson once said that it took him five or so years to learn how to speak the English language and more than fifty to learn to hear it. I would say the same is true for all experience, not just language. We learn almost right away how to exert our influence onto the situations and people around us, but only after years of practice do we ever learn how to truly watch and listen to the Tao, and respond patiently, naturally. Such responses, based on clarity, observation, and understanding, will always achieve more, in every way.

Cha Qi

Any discussion of the Taoist worldview must include an understanding of Qi (氣). Like the Tao, however, Qi is a very difficult word to translate or understand without experiencing it. It is the life force that moves and breathes through all things. One might translate "Qi" as "energy," "flow," or even "breath," but actually it involves much more than that. It is, in fact, similar to the Indian word "prana," which also refers to the vital life-energy of living beings, as well as the energies that move the material Universe. As this ethereal substance sustains the body, it can also be thought to sustain the mind. Consequently, its ability to be felt by body and mind, and the fact that it also flows through the Universe outside us, has made this energy the focus of countless methods of meditation throughout time. On the other hand, one need not assume that it refers to anything mystical or magical. Qi can be viewed simply as the movement or vibration of the subatomic particles of which all things are formed—the movement of the matter of the Universe itself.

Of course, Western scientists have also found that the world is actually composed of atoms that are all vibrating, as the subatomic particles within rotate at incredible velocity—acting as both particles and waves. All matter is, in fact, energy, and is in a constant state of motion. By feeling this vibration as it also flows within us, we find a

Way to experience a concordance with the Universe. In essence, Qi is the Way that we can find a connection to the Tao, and the insights that harmony affords us.

As the word "Qi" has been used in so many ways throughout Chinese history, its meeting with the Western mind and its typical philosophical foundations often causes confusion about whether the Qi is within matter, causes matter, or results from matter. In fact, arguing about the deeper meanings of Qi has been a part of Chinese scholarship for centuries, so it shouldn't come as any surprise that Western notions of "energy" would only complicate things. However, I feel that Qi can only be disputed when it is treated as a concept or philosophy, rather than an experiential sensation that people may feel within their own bodies and minds. After all, we don't argue about what "itchy" means.

It is important that one approach Qi not as a concept or some form of dogma related to a certain religious view. Qi is an actual, physical sensation that can be felt in the body. It is concrete and tangible. And it is not really important how one goes about explaining what it is, as long as one is able to feel and connect to the actual sensations of Qi "flowing" through one's body and mind. Of course, the movement of all Qi in the Universe is a much larger concept and true connection with that great energy is a very high state, indeed. On the ultimate level, Qi is much more than the subtle sensations that we feel in our bodies. It is the substantial movement of the entire Universe, well beyond— yet including—human experience, sensory or otherwise. Nevertheless, the subtle sensations of Qi that we experience are the Way that we as human beings can relate to the energy of the Universe; and as such our focus, experientially, should remain there. Without experiential, living wisdom of what it is like to feel the Qi moving through us, these ideas remain just words or concepts for books; and without developing the sensitivity to actually undergo Qi, aware that it is our very self, harmony with the Tao would be nigh impossible.

Through self-awareness, based perhaps on instinct, or maybe intuition, one may begin to feel the Qi within the body and mind. This is often achieved through some method like *Tai Chi*, *Qi Gong*,

or meditation. Since ancient times, tea sages have also known and discussed the Qi of tea, and "Cha Qi" has always been a part of the appreciation of the Leaf. When we drink tea, the Cha Qi moves through our bodies, becoming the focal point for self-awareness, and living tea as a Tao. Some experts believe that the Qi is already in us, and that the tea only inspires it to begin moving, flowing. However it occurs, there is definitely a very real sense of Qi in tea. One might think of it as a sort of dialogue going on inside the body between the soul and the tea.

Different teas produce different kinds of Qi. Often the flow of the Qi changes direction, moves quickly or impulsively, or encircles the body. Sometimes the Qi stays on the surface; other times it's deep inside. And sometimes there isn't any Qi at all, or it is perhaps too subtle for us to feel. Many times natural, organic teas have a Qi that slowly rises throughout the duration of a tea session: The first few steepings are devoid of feeling, but then ever so slowly the Qi will begin to flow through the body and may be felt as vibrations, tingling, or other subtle sensations.

What Cha Qi is <u>Not</u>

Sometimes when a concept or experience is difficult to explain or share with others, as is definitely true with Cha Qi, it helps to eliminate some of the factors surrounding one's focus to help illuminate the obscurity. When practicing meditation in my tradition, for example, the teacher often reminds us to always try to sublimate gross sensations, dissecting them to find the subtler components that make them up. Slowly, by refining our sensitivity we reach subtler and subtler sensations, ultimately experiencing the subatomic vibrations of which we are composed: Qi.

Even those that are not trained to feel the subtler sensations that come with the flow of Qi within us will still be affected by it. After all, the atoms of the world are vibrating with energy regardless of whether we are aware of the fact or not—our bodies are vibrating and changing all the time whether we are sensitive to it or not. Unfortunately, many

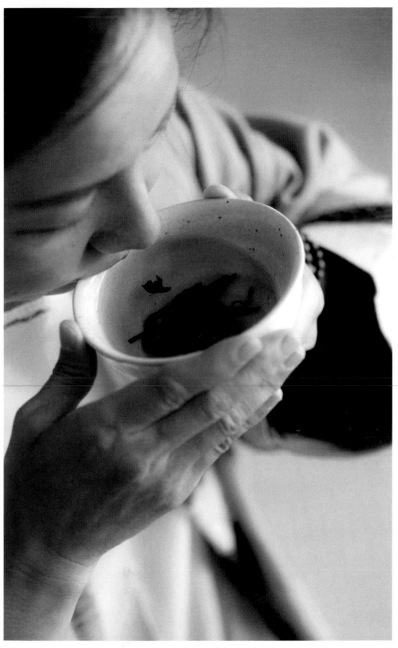

Light meets life

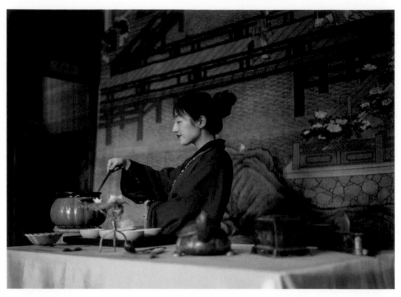

Tang Dynasty (618–907) boiled tea ceremony at the Lu Yu museum.

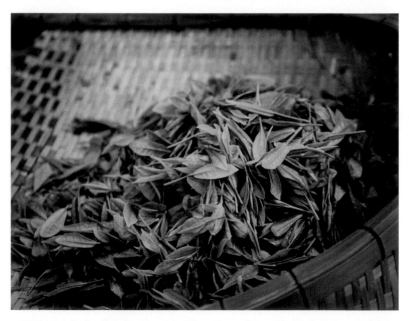

Withering before hand-processing. Though we change them, the essence of the Leaf is there and the magic happens between the human and Nature.

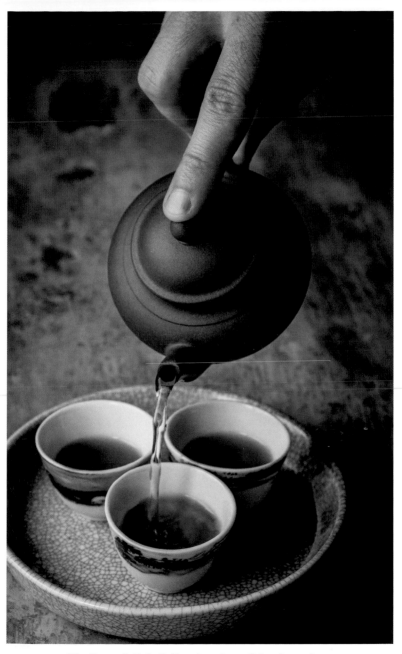

The General's Role Call, a phase in traditional gongfu tea.

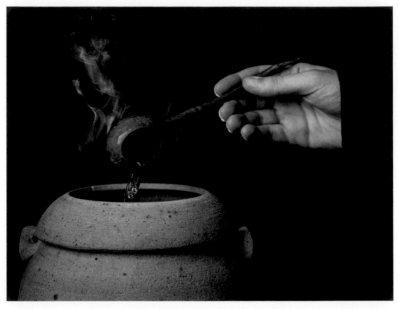

Boiled to find the essence, ladled out to empty it.

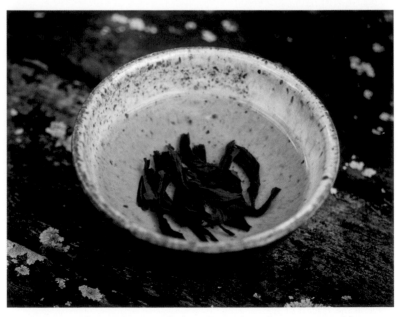

Sometimes the simple way is the best. Keep it easy: leaves, water and heat.

Fire is the Teacher of Tea, bringing out the essence and moving it through our bodies. And nothing beats a charcoal stove when it comes to water for tea.

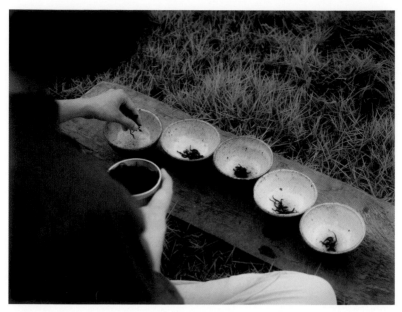

The perfect afternoon.

A bowl for each of the three.

Two hands and we sit up naturally, finding a balance at the axis of all the wobbles.

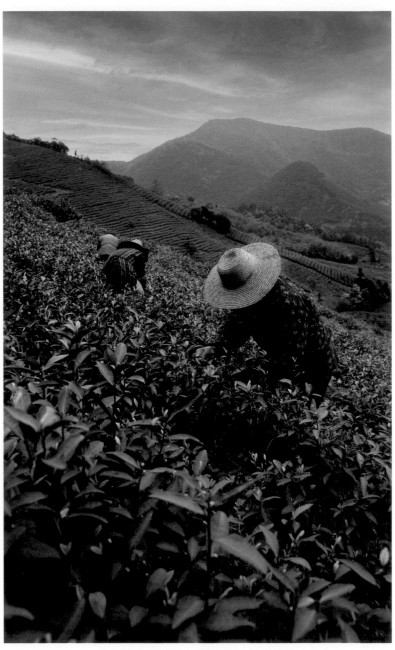

The mountains have a rhythm we can taste.

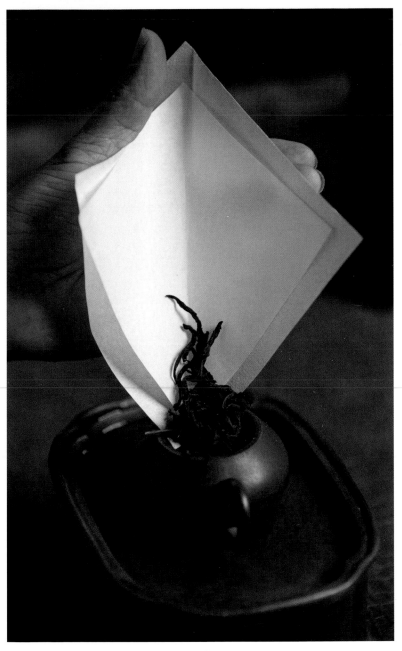

The sometimes-best tea scoop,

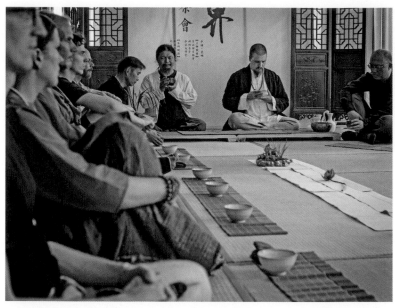

Tea ceremony with master Tsai Yi Zhe (蔡奕哲), our teacher and friend.

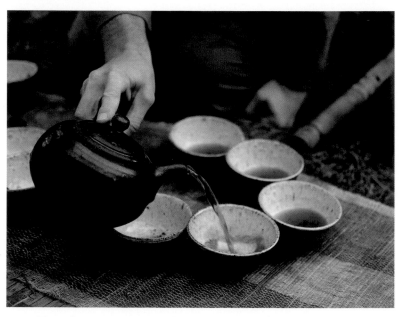

Tea and music out amongst the trees, a pastime of Chajin for millenia.

Less if often much more.

Summer sencha and a few poems.

Master Tsai Yi Zhe (蔡奕哲) shares tea and wisdom
with Global Tea Hut members from around the world.

Rather than pouring, place the water in the teapot.

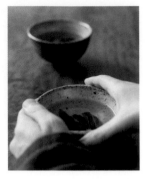

Tea scoops in need of leaves.

One for you and one for me.

Guides, one and all.

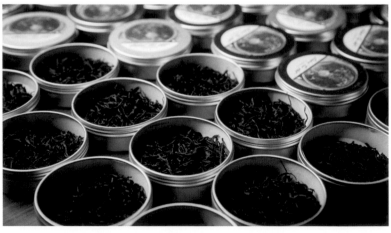

Medicine for a thirsty world in need of love.

Warmth for soul. The path from the mind to the hands leads through the heart.

Peace is only ever a kettle away.

The stage is set.

The point of no return.

human beings have lost their intuition and sensitivity because modern civilization is too focused on external stimuli. Often times, people will just feel a general sense of ease or comfort when drinking good teas.

When we drink tea, the Qi within our bodies begins to flow in various ways. Because of poor health, diet, or even posture many of us will at times, or even often, have blockages that will hinder the movement of Qi. Breaking through these obstructions often results in some kind of gross sensation or even emotional uprising in us. Besides these obstacles to the flow of Qi, tea drinking itself also results in grosser sensations, of course. Drinking tea may produce gross sensations like heat, perspiration, or palpitation. Any of these sensations are either the effect of the Qi moving through blockages or perhaps the nature of our tea leaves, maybe the caffeine even. These gross sensation should not be confused with the Qi itself.

It can't be stressed enough that Qi is <u>not</u> a synonym for caffeine; it is not a heightened sense of hyperactivity, a warmth in the chest; it is not sweating or heat—all of these are either the effects of the Qi as it moves through us, characteristics of the tea itself, or perhaps merely the reactions of the body on a gross level. Actually, the best teas—like very old Puerh teas for example—will not keep us awake at all. Quite the opposite, in fact. Really great teas will calm us down to the point that we often sleep better, longer, and deeper after drinking them. I can't tell you how many times I have heard someone mention how surprised they were to find that they slept so well and comfortably after a long session with some very good teas.

By ruling out all the gross sensations that come as effects of the Qi or tea itself, one can try to begin to concentrate on finding the sensation of the Cha Qi itself, for it is there. Remember, Cha Qi is not an illusory concept in the mind, a belief, or a philosophy. It is an actual sensation and can be felt in the body, if one but learns how to listen. Of course, finding the words to describe that sensation is very difficult, and subjective. To me it feels almost like a tickly, tingling, prickly kind of flow when it is on the surface. Almost like, yet also different from, a feeling of goose-bumps when one is frightened. Others times, when the Cha Qi is deep and penetrative it feels almost cloud-like, puffy and

one's body feels very light. In those instances the "wavelength" (for lack of a better word) of the vibrations seem too quick to be what I would call "tingly," and the sensation is more akin to numbness.

Alas, no turn of phrase or curl of the pen, no matter how skilled the calligrapher, could ever really capture the essence of experiencing Cha Qi. I have however, had several guests from all over the world—and many that were not tea drinkers at all—that were able to begin feeling Cha Qi after practicing for a bit. I have also witnessed several seminars in which hundreds of people have attended, many very skeptical, who then went on to describe similar sensations and experiences. I remember an America friend who had already been a tea drinker for a few years when he came to visit. By following some of the guidelines suggested by tea masters for learning to approach Cha Qi, he was at the end of a week or so experiencing it himself. He told me later that he had used the words "Cha Qi" in tea reviews and discussions prior to this, but hadn't really ever experienced it—confusing it for a caffeine rush or the warmth in his chest as the hot liquid went down. He was very excited that he now had the ability to discuss Cha Qi in the way it was meant to be, the Way it was approached even in ancient times.

The Fanning's Settle and the Liquor becomes Clearer

Most tea-lovers these days pay much more attention to the fragrance, liquor, flavor, and sensations in the mouth and throat (*cha yun* 茶韻) that their teas offer. Maybe some feel that the idea of Qi is too abstract or perhaps beyond the experience of an average person. However, with Quietude and Presence there will ultimately come Clarity, which is just another word for sensitivity. Even as a casual tea drinker, one obviously wants to enjoy as many facets of a tea as possible. Becoming more sensitive, peeling away the layers of subtlety, one reaches deeper and deeper impressions of a tea—leading, ultimately, to the very Nature that created it.

Mine was a typical tea journey: first I became incredibly intrigued by the delightful flavors that Chinese tea offered. I was intrigued and lured into the tea world through the bliss it brought my senses. Then

I began focusing more and more on the ways that brewing techniques improved these flavors, leading ultimately to the very real truth that tea is an interaction between a human being and some liquor, and the human mind is therefore half the experience. I then began to notice the sensations in my mouth, throat, and stomach as I drank tea—experiencing as much joy from a nice "yun" or "mouthfeel," and "gan," which is the way the tea lingers in the breath and throat, as I did from flavor or fragrance. Slowly, becoming more sensitive, I refined my palate over the coming years, focusing mostly on these three aspects of tea (flavor/aroma, *yun*, and *gan*). Then, when I met my master I began to recongnize and feel the Qi in tea, adding another, deeper dimension to my tea drinking. As time progressed, I would learn to follow the movement of the Qi within my body to the movement of all Qi outside, called Completion, which we will discuss in the following chapter. The point is that the whole journey is one from gross to subtle, refining your sensitivity to tea. This, then leads to a sensitivity in all facets of life, changing one's whole outlook in amazing ways.

A complete experience of any tea must involve fragrance, liquor, taste, sensations in the mouth and throat (*cha yun*) and Cha Qi. Nevertheless, Cha Qi is often discussed less amongst tea connoisseurs who appreciate it because it is considered to be more subjective, or perhaps less understood. This really shouldn't be the case, though, as all of the other aspects are affected by the constitution of the tea-drinker as well. In reading tea reviews, one will find as much variation in the tastes, smells, and sensations as there could be in the experiences of Cha Qi. Still, some tea drinkers may feel intimidated by notions of Cha Qi, thinking that it is something "mystical" or unapproachable to the ordinary person. However, Cha Qi is as perceptible as any other gross sensation like heat, pain, itchiness, etc. I have overemphasized this point here not just because there is some misunderstandings to clear up, but because fundamentally it is through the concrete, literal experience of life that we climb to the subtle and transcendent.

Like the journey we take within ourselves, finding subtler and subtler aspects of experience and connection to the Tao, the whole Way itself is one of transcendence—constantly sublimating reality to find

deeper and deeper aspects of existence. At first tea is sensual, connecting us with pleasure, enjoyment of flavor and aroma. Then we begin to feel the Qi, the bliss inviting us to explore ourselves deeper until we find the empty place where our flow is the flow of the Universe, the Tao.

Connection to Qi

The connection that we can achieve and maintain through tea, is an understanding that there really is no difference between the various aspects of the Universe, in the sense that they are all facets of the same totality, the "Tao," which The Sage tells us is just a word for something we "don't know what to call." Qi is the movement of this totality. For us, we use our bodies and minds as objects of focus, becoming aware of the present moment as it is experienced, lived. The feeling of Qi connects us to the energy as it flows through us, moving in and out like the breath that also connects us all to each other, to the world. As we mentioned in the Story of the Leaf, this is what may have led the first shamans to steep tea so long ago. The currents of energy within us are the flow of atoms that began long ago, and every bit of our experience of them is within that great current, starting with the explosion in which the very stars themselves were strewn across the sky. We connect and become that flow.

Cha Qi is therefore at the very core of an understanding of Cha Tao, and without it I think tea would never have been recognized by all the sages and seers throughout time, and never inspired a book such as this. By learning to become sensitive to the way that tea affects the Qi in our bodies, we develop self-awareness through introversion, Quietude, peace, tranquility, and equanimity. Beyond just the simplicity and Zen-like Clarity of being present, absorbed, and aware of a moment of tea—beyond that, the Qi connects us to the energy and movement of the entire Universe.

CHAPTER NINE

Completion

Searching for the Hermit in Vain
I asked the boy beneath the pines.
He said, "The master's gone alone
Herb-picking somewhere on the mount,
Cloud-hidden, whereabouts unknown.

—CHIA DAO (777-841), Translated by LIN YU TANG,
as quoted in ALAN WATTS CLOUD-HIDDEN WHEREABOUTS UNKNOWN

As your Quietude deepens into Presence, and you develop more and more sensitivity and Clarity, you will also find that so many more of your tea sessions flow in harmony with your inner nature. You begin to feel a connection to the environment, to Nature and the Universe. This Completion satisfies like nothing else. You feel that the present moment is perfect and whole, nothing needed or wanting. In that way, acceptance and wisdom, renunciation and true freedom are available. The comfort and depth of experience in tea can be a doorway through which we connect to the Tao.

The Way of Tea is so much more than any leaves, water, or the most elegant of teaware could ever be. While all that can be an art, which captures and expresses the aesthetic of living tea, they aren't the essence of it all. Cha Tao is about so much more—more than just tea, more even than just finding solace from the trials and tribulations of life: Cha Tao is about finding and creating a space within which we can find harmony with the Universe, the Tao. And perhaps beyond that it is a way for us to share some time and space with others, in our true natures, as One.

There is in every ordinary moment a sense of connection with the Universe, whether we are aware of it or not. Even when we are distracted, even at the height of impurity, all that we do still takes place within the Tao, an inseparable part. Tea is therefore, not the only means we have of aligning our lives with the Tao, but it can create that space if all the elements are correct: if the intention and reverence is there, the peace and quiet, as well as the desire to share and express the Tao.

Approach the tea ceremony with some intention, unaffected, and establish some peace and quiet in your day. Eventually, somewhere down the Road, all the elements will just fall into place, and perhaps when it is least expected, your true nature—whether expressed as the virtues of Quietude, Presence, Clarity, and Completion or not—will shine forth, ringing your liquor in gold.

Transcendence

There is a common Taoist saying that the "Recluse's heart rests in stillness like a serene lake, unruffled by the winds of circumstance." And there is no concept as all pervading in all Eastern literature, from Taoism, Buddhism to Hinduism, as stillness. In fact, all religions in all times promote quiet, unmoving reflection, for a truly healthy human being must have periods of stillness interspersed amongst those of activity. Without introversion our lives are incomplete.

Most of us have closed our accounts with Reality, separating ourselves from the world, to use William James' metaphor. He also said that, "our normal waking consciousness is but one special type of consciousness, whilst all about it, parted from it by the filmiest of screens, there lie potential forms of consciousness entirely different. We may go through life without suspecting their existence, but apply the requisite stimulus, and at a touch they are there in all their completeness." For me, and many others, the "stimulus" we needed to experience such varied and higher states of consciousness was but a quiet cup of tea.

Beyond all the Quietude, and some space in the day to meditate, I think there is more to tea drinking, for it can at times lift the veil

covering the statue of the divine, and give us a life-changing glimpse of what harmony with the Tao means. In fact, I find tea to be analogous to the two main interpretations of early Taoist thought, sometimes called "Lao Chuang" in honor of Lao Tzu and Chuang Tzu. Many scholars past and present have read their teachings and found them to be espousing quietism: a withdrawal from the world and acceptance of all the changes that come; actionless-action (*wu wei*) with equanimity towards all events so that they live a carefree life in the wilderness, enjoying the simple joys in life, like the moon, hills and trees, as well as the stillness in their beings. Other scholars and practitioners alike have read more deeply into their teachings, plunging the dipper far deeper into the placid lake for colder and more ethereal draughts. They claim that these ancient sages espoused nothing short of mysticism, transcendence of the world, and complete union with the Ultimate, the Tao.

I truly believe that there is no argument, and all such debates have been so much wasted words, as the Tao has always been understood as applicable to all endeavors, worldly or spiritual, which has accounted for the great diversity of understanding and approach, including even folk religion and the worship of a huge pantheon of gods, fairies, and demons. In other words, if you seek a quiet space withdrawn from the World, accepting and gratefully still—the life of a quietist like Thoreau—then living the Way will achieve this; yet if you seek mystical transcendence, higher truth, and wisdom, enlightenment, then that is available as well. And what's more, as I mentioned, I think this applies equally to the Way of Tea. If you wish but a time and space to live in quiet, not necessarily renouncing the World, but rather accepting it as it is—free and at complete peace—tea may be drunk as a toast to such Quietude. If one seeks higher insight and potentially even mystical transcendence, the stillness and the experience of drinking life, this is to be had at times as well. It would seem incredulous if I hadn't seen it happen so many times: people changed, deeply so, by drinking tea in the right setting. However you interpret it, when all the water, tea, teaware, and people mix in the right way, changes happen.

One of the most amazing experiences of my life happened when my whole family came to visit me in Taiwan, including my very

aged grandfather and great uncle. I took the whole group to see a tea master. The eight of them sat around the table chit-chatting about how exotic the tearoom was, with its walls and walls of tea, waterfalls, and bonsai trees. Eventually, my teacher passed me a sly grin and reached behind him to a jar of very old Puerh tea. Brewing the deep and dark liquor—leaves ancient and wise, connected to the spirit of Nature— changed the entire atmosphere of the room. Within minutes, it was enshrouded in a deep and peaceful silence, only the waterfall singing in the background. For the next two hours, I sat with my entire family in complete quiet, connected to one another as never before. Never in my entire life prior to that day had my family and I ever sat in quiet; never had we been so close. My mother wept in joy, my grandfather cried too, saying later that he felt the presence of my then recently departed grandmother. The power that a tea session steeped in Tao can have—the life-changing presence and connection to the spirit of the Universe that they offer—became clearer to me than ever before. I share this experience, so personal, to show that one need not be a saint, a meditator, or even a tea lover to experience Completion.

To many it may seem like a fairy tale that those Taoist mystics cloudwalking around ancient China were able to find a sense of oneness, transcendence, and connection to the universal energy when today people all over the world drink tea all the time and never get close to those sensations. Though we may have more to overcome by way of distraction, the virtues in a life of tea are still being steeped and poured freely every day around the world.

The Virtues of Tea

There are many virtues found in living a life of tea. We have here discussed these virtues as they were handed down to me by my master. None of them need refer to anything I have discussed, for you may interpret them how you wish. Living them is far more important than understanding them anyway. After all, any intellectual understanding of Tao I help you find is hypocritically absurd, since a life of Tao is beyond words, just as the Tao itself. And yet I write—mostly because

that is my way in the same way it is in a lark's nature to sing.

In drinking tea quietly you will find that the Quietude more and more becomes internal, so that there are deep and peaceful pauses even when you're drinking tea socially. Then you will find yourself more and more Present to the tea. This leads to a greater Clarity, and you'll uncover new flavors, aromas, and sensations in the very same teas you've been drinking for so long. Then, if you haven't already, one day the sensation of Completion will come over you: this isn't so much an intellectual concept or idea as it is an actual emotion. It feels as if the present moment is absolutely and completely perfect. You aren't missing anything. You don't need anything or wish anything away. This kind of acceptance and joy brings a deep connection to Nature as it is in this moment—the flowing stream of the Tao. Slowly, this current will then begin to flow through more aspects of your life and you'll realize that there's no longer any distinction between your "tea time" and the rest of your day.

Master Rikyu said, "imagine your life without tea, and if it's any different than it is now, you don't understand tea." That is a very deep level: one in which the tea life doesn't even need tea anymore. At that point, the drinking of tea is just a natural expression, like my writing, the lark's song, or the soughing of the wind through the pines.

May you find all the Calm Joy, Quietude, Presence,
Clarity, and Completion inherent in tea.
May a thousand other virtues line the shelves of your tearoom.
May they be a part of your journey, every turn of every road;
And spread,
Cup by cup,
To those whose paths you cross along the Way.

Ceremony

It is called a tea ceremony, not tea drinking. It is not a teashop or a café, it is a temple. Here, ceremonies happen. This is only symbolic. In the whole of life, around the clock, you have to remember that wherever you are it is a holy land and whatever you are doing it is divine.

—OSHO

Every morning as soon as I am finished meditating, I go into my tearoom and spend a quiet hour with my tea. I brew my teas *gong fu*, using a kettle full of mountain spring water and some scattered leaves. I quietly sip my tea, cup after cup, diving into the flavors, aroma, and sensations of the moment. The warmth of the charcoal fire, the hum of the kettle, and the birds singing outside all inspire reverie of the near and distant past, walking on moonlit paths amongst the smell of pine, the splashing and creaking of a bamboo fountain near my home in Japan…Soon these memories also begin to fade, the worries of the day before and the plans of what I'll do later all slip away, and there is only tea—leaves and water. I take my time between steepings, enjoying the quiet at the beginning of the day when most of the world still hasn't awakened. I try to let go of myself and just be, letting all the parts of the ceremony—the water preparation, the washing of my cups, the dance of leaves into the steaming pot, the steepings and pourings—I let it all happen naturally, interfering as little as possible. The tea leaves, the water, and the old cups and pots come together of their own accord. And when it is all really aligned and everything is still, there is a kind of magical perfection there, a ceremony.

Why use the word "ceremony," then? Are we following some kind of formal rights and rituals established by some ancient authority on tea? Actually, nothing could be further from the truth. Tea is a "ceremony" in the sense that it is a sacrament, a celebration of life as it is lived in the ordinary moment. It is a promotion of awareness to the level of Presence, a connection to the Tao, and also a means for people to associate with one another in Calm Joy. And while it has formalized weddings, soothed the meetings of dignitaries and enemies, and regulated the transmission of information—none of these are the tea ceremony itself, but merely examples of the many malleable forms it can take; for the true tea ceremony is loose and free, like the Tao itself, adaptive to the needs of the situation. There need be no specific ritual at all. In fact, the best tea ceremonies follow no guidelines. There is no recipe for peace. The serenity of having a daily tea ceremony isn't in the formalization; it isn't a list of dos and don'ts or guidelines to the preparation of tea. The purest tea ceremony comes from within, following the intuition of the one brewing and the spirit of the present moment.

If I were to illustrate the tea ceremony with photos or a "1,2,3" list for how to brew tea, I would be doing you a great disservice. For there can be no right or wrong way to make tea—the right way is dependent upon who, where, and when you are. You might say that the question is not which method of tea preparation is right, but which is right for you. The Way to make tea an expression of the greater energy of the universe is all in the relaxation of any of the impositions you usually put on some parts of your life; it is, in essence, a letting go of the mind—approaching the moment unaffected and pure, allowing it to flow through us. Rather than attempting to observe it from the outside, we try to participate and connect to the moment mindfully. All the greatest joys in life always come from such a sense of connection, letting go of our inhibition. Whether dancing, eating, making love, or meditating, the highest wisdom and bliss always involve a transcendence of the mind and ego, and never, ever come with a list of proscriptions or a handbook on techniques. They are natural, fluid, and intuitive, like the Tao.

Furthermore, it is the nature of that unity which all people—sages and farmers alike—have always sought. Less developed souls have always confused unity with some *part* for that which can be attained in communion with the *Whole*; but eventually realization that it was never the object of beauty we sought, rather the completion and connection itself, will dawn and our outlook will be transformed. As such, real peace is a transcendent one, not really found in the outer gloss of the tea ceremony, but only achieved through letting go and reaching the center of the moment, beyond the tea and quiet, beyond the water and leaves to ourselves.

Most of what makes the tea ceremony transcendent is in the approach of the people at its center. In the Way of Tea, we take out our utensils and prepare our water with reverence—not as devotion to anything other than the act itself, its ordinary poise and our own inner serenity. So many enlightened beings past and present have taught that all meditation and prayer is a "practice," a method for approaching life. We are, in effect, learning how to live; how to use our lives as meditation. By refining, perfecting, and purifying every aspect of our tea preparation, we are seeking the essence of something ordinary and alive. If we find the Tao of Tea, we will have found the Tao. It's that simple. "As by knowing one lump of clay all that is made of clay is known, the difference being only in name, but the truth being that all is clay—so, my child, is that knowledge, knowing which we know all," say the Upanishads, and substituting the word "clay" for "tea" wouldn't harm the insight either.

As a living art, this expression of peace is powerful. But intention is the key; it unlocks all the Tao in Cha. The Way of Tea is all about intention: the intention to find the best leaves, the best water, and to bring them together in harmony and grace, quietly serene. The idea is simple enough to be mundane, yet difficult in application. And not because we can't find leaves good enough or because the water near us is polluted, nor because our teaware isn't high quality—for these galaxies all orbit the one at the center of the ceremony, the one creating it and then experiencing it. After all, "best" doesn't mean highest quality; it means the most suitable for the moment at hand. Each person, and

every tea, in each situation requires intuition, Tao, and then a unique expression of that energy. Lu Yu reminds us to "always sip tea as if it were life itself," and I would go a step further and say that it *is* life itself.

The various material aspects of tea preparation can be influential, but are ultimately secondary to our intention. Why do some find great peace and presence in daily tea drinking—learning ideals that are applicable to all life—like kindness, sharing, Presence, Completion, and connection? Why do others find only a beverage, refreshment on a hot day? And what about the hobbyist that is attracted to tea as some kind of intellectual curio to discuss, debate, and scrutinize on and off the shelf? Intention.

Some people won't like to think of their tea as a "ceremony." Must it always be drunk in silence, with a kind of Zen-mind, empty and pure? Of course not! That is the beauty of the tea ceremony: it must remain fluid, finding space to function in whatever Here and Now it occurs within. In fact, that is what *gong fu* tea is: finding the best leaves, water, and harmony to coincide with the situation at hand. And that, ultimately, is also precisely what is meant by a "Zen-mind." Sometimes the liquor needs warmth, soothing a group of people, so that in comfort they find a joy and sociability in each other not otherwise possible. The greatest Taoist and Buddhist monks I've met always had great senses of humor, and I have had several tea sessions filled with great joy and laughter—also within the Tao. Other times, the liquor need be deep and transcendent, carrying the participants beyond themselves to merge into the universal Tao; while other mornings, the tea ceremony is but a simple gesture, bringing awareness to the beauty in all simple things: a slant of sunlight through the window, the variations in the ferns just outside, or the rim of gold that highlights the liquor itself.

For these reasons, the tea ceremony can never be formalized. If it becomes a performance, it loses all its presence and power, like so many other sacraments hollowed out by years of repetition. Even those only interested as a hobbyist often fail to understand that the tea brewed by the master didn't taste better because he knew some secret about water temperature or had better cups—it was better because he was present, connected to the Tao of the moment. For those that are really

connected, the tea ceremony then becomes an artistic expression of that ineffable energy, a way of sharing and transmitting it to the others, and a way of celebrating its beauty hand-in-hand with the Universe. Reverence is the key. Whenever I ask my master why his tea is better than others, he always responds, "I just love tea."

We find in tea an ability to connect to the world and others. Tea changes our perception, simplifying and sanctifying moments we might have otherwise ignored. For that reason, it may be called a "ceremony."

Is the moon really so large,
In the Autumn sky,
Or is it merely a reflection
Of my empty cup?

CHAPTER ELEVEN

Teaware

For hundreds of years teaware has been the principal method and media through which the art of tea is expressed. The vast array of cups, pots, decanters, kettles, and utensils has spawned thousands of artists, small and large, using many different media to capture their understanding of tea. From calligraphy to painting, ceramics to metallurgy, artists have found ways to enhance the beauty of the tea ceremony. This vast tradition need not be at odds with Cha Tao, either. In fact, the art of tea can and does capture the essence of the Tao and express what could otherwise not be said, even in its more physical aspect as teaware.

And if teaware be true teaware, in this pure sense of art as transcendence, beyond form, then the viewer finds within the piece symbols that help him or her connect to, interpret, or even transcend the ordinary world. In that way, our teaware and the way we arrange it might be thought of as a Mandala, which the Hindus and later Tibetans define as any kind of geometric pattern that expresses an aspect of the totality of the cosmos itself, a symbolic meditation of transcendence. They also taught that objects of beauty could be great encouragement for spiritual development as long as they were used and appreciated without desire and craving. Perhaps this is what Lu Yu meant by devoting so much time to the proper creation, organization and expression of one's tea set; what the Buddhists in China and Japan later formed into the tea ceremony: its tea houses, paintings and flowers; and even what we may achieve today with the organization of our own tea sets, as expressions of our own inner nature.

The ancient Taoist sages lived simple, clean, and pure lives. In their forest hermitages they practiced meditation, *Qi Gong*, and other methods of connecting to the Tao, including tea. In such an environment, the simplicity of bowls and hot water is enough—the pure mountain water and the essence of the Leaf were sufficient for people as sensitive as they were. Many tea sages and tea ceremonies in the modern world could be equally simple, though for some of us calming down and finding that connection to Nature beyond ourselves is difficult. Beyond just satisfying the collector's passion in us, teaware can improve our ability to relax, and help inspire our connection to our own personal tea ceremonies. When we are in a beautiful setting that inspires calm, it will be easier to find the quiet place that Cha Tao flourishes in.

Some might argue that the simplicity of the ancient tea sages better exemplifies ideals like renunciation and purity of mind, but I think that like all ideals, these take place on the inside. One can be attached and affected as much by a worthless stone as one can by a solid gold throne. The simplicity, renunciation, and even unaffectedness must all take place within the breast of the person walking the road. If calmness, presence, or renunciation are only external symbols, they are as hollow as a rich man's outer garbs meant to distinguish him from others. There is an ancient Chinese proverb that says "it is easy to be a sage in the peace of the mountains, more difficult in the city; while the deepest of saints can live unaffected in the palace."

Finding teaware that improves the sensations, flavors, and aromas of our teas will help inspire you to delve deeper into the world of tea and tea culture. Many of our cups and pots will become like brothers, supporting us as we journey through tea. Our love for them can help connect us to the ceremony, igniting the understanding, connection, and even transcendence of the ordinary moment just as well as the leaves themselves can. My most prized possessions are my different teaware, and just by looking on them I find an expression of the Calm Joy I am sometimes able to find in my tea. They are a representation of the silence and peace I find each day in my tea room, and sometimes just in handling one of my pots I can catch a glimpse of that energy.

As I discussed elsewhere, I believe that the worlds of art and spirit have always been aligned, and though art is capable of expressing a terrific variety of meanings, within that list is the articulation of spiritual principles and experiences that are otherwise ineffable. And though the art, even at its best, can never be equal to the experience of being with tea, it can help those who have had such experiences to rekindle them, not only by inspiring them to have more and varied tea sessions, but also by relaxing and connecting their spirits to the ceremony itself. Grasping in pleasure a beautiful cup—knowing its energy is stronger, the flavors of the liquor within more effervescent and joyous—this all helps increase the degree to which one participates in the tea ceremony, and that is what Cha Tao is all about. The more we participate and involve ourselves in our tea, the more it consumes the moment. We find ourselves emptied, lost in a blissful stillness. Through that, transcendental wisdom is possible.

The Aesthetics of Tea Equipage

Most tea lovers find that as their experience, discrimination, and understanding of tea grow, they invariably start leaning more towards simplicity and function. Teaware becomes a matter of which cup, pot, kettle, etc. can enhance the flavor, texture, or aroma of their teas—which are also becoming more refined, rare, and often expensive. Of course no amount of function can outshine the skill and focus of the person through which the ceremony flows. Tea brewed ever-so-simply by a master will still be more delicious than that brewed by a beginner with the best of teaware. The conduit through which the water is held, poured, steeped, poured again, and served is the most important part of the ceremony in every possible way. After all, it isn't the cup experiencing the tea; the pot doesn't pour itself; and no amount of silver can gather and carry the mountain water that will be heated in its kettle. Understanding the human role in the Way of Tea is important if one is to progress, and in order to do so there must be a balance between the aesthetic and functional sophistication of the ceremony and the teaware we use in it.

The role aesthetics play in the enhancement of tea, both in flavor and in the experience as a whole, should not be underestimated. Even if one's taste remains simple, one shouldn't ignore the influence beauty has on the most important element of the tea ceremony, which contrary to the obvious is not the Leaf, but the person.

Arranging the tea sink, teaware, flowers, cushions, and artwork of the tea space are all aspects of the expression that has ever made tea an art form. Not only do they allow for creativity and intuition, they create an environment of comfort and calm, relaxation. The best tea houses, tearooms or even tea spaces in a house are the ones that immediately relax one as soon as he or she arrives. Before the tea is even served, one already feels outside the busy flow of the ordinary world, comfortable and ready to enjoy. This will directly affect the experience of the tea itself.

It is a well-known fact that different people are all bound to taste, smell, and feel a variety of different experiences when drinking the same tea—as any cursory survey of tea reviews will demonstrate—but even our own experiences change over time and space. Why then is the same book so much better when read on a vacation at the beach? Why do restaurants devote as much attention to ambience as they do to the menu?

Learning about the various roles that teaware plays in the creation of the best cup is exciting and adds to the passion of tea. Tasting the water heated in different kettles, for example, is so insightful and often improves the way tea is made thereafter. It is, nonetheless, important to maintain a balance between the teaware that will improve the ceremony functionally and that which will inspire the one making the tea aesthetically.

The process of creating the tea space and ceremony are very personal and the aesthetic design need not follow any other pattern than the one that will motivate the person who brews the tea—he or she is the master in that space and unless it is a tea house with a steady stream of guests, then his or her feelings and intuitions are the only ones that really matter. A teapot with excellent function that doesn't at all inspire one may not be as good of a choice as one that functions

a little bit worse but is gorgeous. Again, balance and harmony are the ideals of tea.

Achieving harmony without helps foster harmony with, but we must never lose touch with the *beings* at the center of the tea session. Even within the preparation of tea itself, so much is dependent upon the energy of the one doing the brewing. If they are cheap and focused on getting a lot for a little, if they are a businessman focused on selling tea, or if they are rich and trying to show off their Ming Dynasty teapot, all of these factors will show in the tea ceremony, resulting in a different cup. There is no scientific objectivity in the world of art, only taste.

There are those that write books on form and function, conduct experiments on water temperature, and get busy recording notebooks full of tea reviews, but as such they will never progress to the level of artist or master—a level based not on the intellect but on intuition. Measuring, analysis, and recording data play no part in experiential growth. One cannot record data and fully experience at the same time. Anyone who has experienced trying to review a tea, with written notes and all they incur, has already recognized the difference between these sessions and the more relaxing, personal ones. And anyone who has ever meditated or sought connection through calm knows the importance of shutting off the mind, and its internal dialogue.

True enjoyment must be just that. This is why tea is made "gong fu," because it is a skill, an intuitive mastery. Cha Tao must be free and loose, open to exploration and responsive to the idiosyncrasy of every beautiful moment. And there is much to be said about brewing with a clay kettle rather than a plastic one, a beautiful Qing Dynasty cup rather than a cheap one; and not just the ware itself, but also the fact that the one brewing isn't reading a digital temperature on his or her kettle, analyzing the ratio of leaves to pot size, etc.—he or she is intuitively dancing a flutter of leaves from the scoop to the pot, gauging the water temperature with a gentle touch, and steeping with all the relaxation of the timer built in his or her heart. Does that sound corny? Perhaps it is, but after enough tea houses, shops, teachers, and enough sessions, most people would agree that the best cups they ever

had were poured by people such as this. In the hands of an artist, even the simplest lump of charcoal and torn cardboard can become a masterpiece; likewise, a cup of tea brewed by the hands of a master can hold worlds of flavor, aroma, and even peace just over the cusp of its rim.

Remember the Soul, Forget the Bowl

Master Rikyu once attended a tea party where several rich samurai and lords were showing each other expensive teaware and antiques and discussing how much they were worth. One of the lords then noticed that throughout their entire conversation the teacher had remained silent. He asked the master for his opinion and Rikyu humbly begged to be excused. The samurai, however, pressed him to offer some insight. "You all seem to have missed the point," he began, "the value of a piece of teaware is reflecting in the tea it makes and the state of mind it brings about, not whether it is expensive or cheap, new or old." Perhaps none of the lords understood the rebuke, though there surely responded politely; or maybe one or two of them realized and ceased collecting for its own sake, achieving a higher level of understanding on that day.

It might sound hypocritical given the detailed discussion above about why nice teaware is great, but one must be careful not to get too attached to the date, name, or price of any piece of teaware, as this only leads away from the Tao. There must be balance. Rikyu himself owned several precious antiques, and his teacher Master Joo often said that those who expressed poverty without ever owning a treasure were merely justifying their lack, rather than expressing real renunciation. In other words, they wanted antiques and nice teaware but perhaps couldn't afford them, so they feigned disinterest and said that their simpler teaware was a better representation of *wabi*. Real renunciation takes place on the inside. St. John of the Cross often commented that several of the monks and nuns in the church were more attached and hindered by their single possession, rosaries, than any duke or king he'd ever seen.

I think there is a way to use great teaware and explore the subtleties it offers, as these only serve to increase our sensitivity and enhance the overall experience. Also, as we'll discuss in detail shortly, it shows reverence when we serve our tea in precious teaware and surroundings. Nevertheless, we must be careful that we don't get caught up in covetousness and worldly craving. When teaware becomes too much about which famous person made it, how old it is, or how much it costs then we are no better than museum curators or curio dealers. "We should be kings rather than curators," as one of my teachers always says.

It is important that we stay open-minded with regards to any piece of teaware, develop sensitivity and learn to evaluate it in terms of the tea it creates, and more importantly the state of mind that it inspires. By following our hearts, as well as our own burgeoning sensitivity as it develops from the gross to the subtle, we will choose teaware that is aesthetically pleasing and makes good tea. Many antiques or masterpieces are worth a fortune, but make poor tea. As such, they hold little interest to the true *chajin*.

All the Ways Teaware can Help

True art has always meant more than entertainment or decoration. Art is that special place in us where we meet the world around us without any intermediate, nothing to confuse or cloud our communication with Existence. Through an artist, the world is channeled and pulled back out onto itself, carrying some of the artist with it on its way. Like water running through a wet cloth, our experiences flow through us and come out dyed the reds, yellows, and blues of our soul.

I often think of acting from our inner selves—and the quiet, equanimous stillness that rules that kingdom—in terms of my own practice of making Chinese ink paintings: years of meditation and focus have allowed me the ability to quiet my mind, not always but at times. And it is only when my mind is balanced on that equanimity, like a poised crane effortlessly circling above an ocean of silence, that I ever even pick up my brush. This is what the ancient sages meant by

"Wu Wei," or "not obstructing," as we discussed earlier. Such actions are the ripples on the surface of an ocean that is ever so calm, endlessly so, just beneath its thin surface. And that's why I always sign my paintings "Wu Wei Hai (無為海)" (Ocean of Nothingness), for that stillness is the real artist, not me. And the same can be said about tea as well. We may prepare and *drink the moment* with a basis in that same stillness, sharing that time and space with the tea—becoming tea as it becomes us. And if we are together with other beings, we might also share our lives and hearts, passing our intuitive wisdom on to others.

Lu Yu spoke of nine ways that man must invest himself completely in tea, which were:

> *He must manufacture it.*
> *He must develop a sense of selectivity and discrimination about it.*
> *He must provide the proper implements.*
> *He must prepare the right kind of fire.*
> *He must select a suitable water.*
> *He must roast the tea to a turn.*
> *He must grind it well.*
> *He must brew it to its ultimate perfection.*
> *He must, finally, drink it.*

(These Quotes are from the FRANCIS ROSS CARPENTER translation)

He then went on to admonish that, "There are no short cuts. Merely to pick tea in the shade and dry it in the cool of evening is not to manufacture it. To nibble it for flavor and sniff at it for fragrance is not to be discriminating. To bring along a musty tripod or a bowl charged with nose-insulting odors is not to provide the proper implements. Resinous firewood and old kitchen charcoal are not the stuff for a seemly fire. Water from turbulent rapids or dammed-up flood water is not a suitable water. Tea cannot be said to be roasted when it is heated on the outside and left raw underneath... Manipulating the instruments awkwardly and transitions from instrument to instrument that attract attention are not brewing tea." And if we but change some of these inferior approaches to tea, like "old kitchen charcoal"

or "flood water," for their modern equivalents—a cheap electric kettle, the "Amazing Tea-Doodad" that brews your tea for you at the push of a button, or some convenience store bottled water—the suggestion is as poignant today as it was when Lu Yu put brush to paper so long ago. To love tea is to appreciate it and complete it in a way that reflects its nature.

By using better teaware, one is focusing on the fact that one reveres the tea ceremony, and creating an attitude and approach to tea with devotion—a precursor for the experience of being with tea in the Tao. It would, of course, be impossible for one to experience deeper aspects of the tea ceremony if one never took it seriously.

Why does any "ceremony" allow for a connection to the transcendent? At the temple, the church, or any other place that humans have sought to experience the peace and joy beyond their transient selves, it was always the intention/approach/method of the participant that made or broke the experience. A nonbeliever wouldn't feel anything in a temple, no matter how beautiful the art—some people go to Rome and are moved to tears, others buy some popcorn and snap a few photos. Without reverence, the most holy words would be but sound; the deepest prayer meaningless.

We don't adorn our sacred images and arts with plastic and paper; we frame them in gold, surround them with flowers and incense and an ambience of reverence. The art of tea, if it is to be a Way, should be in a similar vein, lest it express baser intentions. If we are to make of it a Way, we must respect every aspect, from the Leaf to the water, and even the vessels within which they seek each other out.

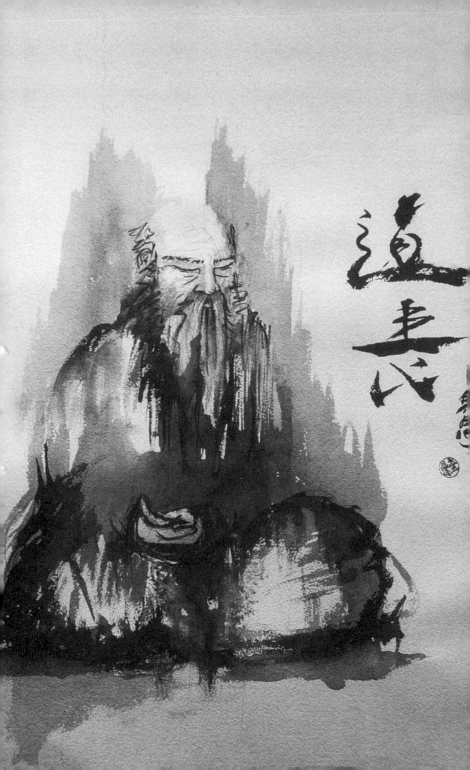

CHAPTER TWELVE

The Tea Space

Drink tea, make friends.

—CHINESE ADAGE

A s we drink tea quietly in the same place each day, the space will get "charged" with the energy of quiet. And beyond the teaware, decorations, or music we will find that visitors start remarking how pleasant and peaceful they feel upon entering our tea space. And that is one of the greatest aspects of all tea, everywhere—no matter if it be quiet Cha Tao, social friendship at a boisterous tea house, or even scholarly study of tea—and that great quality in tea is its ability to connect people to each other, as well as the Tao. The beauty of the tea space is that no matter who we are and how unclear our minds are, we can find connection, comfort, and cheer in that environment.

In the tea space, we share ourselves, our hearts, and connect to the Tao not only through the tea but through others, especially the one who is doing the brewing. We may come to the tea space troubled, guilty, or fraught with physical or emotional turmoil, but in that space we are all free to show our true natures, as one great being and mind. There is life-changing power in such a sharing. The greater, deeper experiences to be had through tea are also possible if the environment and participants are committed to expressing such ideals. After all, the congregation of spiritual beings, no matter what they are doing as an expression of their inner selves will result in Spirit. And this can affect great changes in us—novice or veteran.

All One in Here

A great Japanese Zen master, Joshu, greeted an arriving layman who had come to the temple to meditate. He asked, "Welcome, kind sir. Have you ever been here before?" When the man replied that he had never come to this temple before, the master said "Have a cup of tea." A second man arrived and bowed and the master greeted him in the same way, "Welcome, kind sir. Have you ever been here before?" When the man replied that yes, he often came to this temple to meditate in the evenings, the master responded "Have a cup of tea." The master's attendant was puzzled by this and asked the master, "Why, when one of the laymen said he had never been here you told him to have a cup of tea, and then when the second said he often comes to meditate you also said 'have a cup of tea' the same?"

"Attendant," shouted the master.

"Yes, master?"

"Have a cup of tea."

Master Rikyu invented the small door that we crawl through to get into the tearoom, the *nijiriguchi*, to express the humility and effacement of entering the tea space. Swords are also left outside with rank and title, for in the tea space prince and pauper are alike. In the moment when the poor farmer drinks deeply from his cup, sighs, and lets go in Completion, he's attained the same state of consciousness as the emperor drinking tea in his palace. What's more, if they met in that space, they'd have no problem sharing a second cup with one another.

The best tea spaces are ones in which we are free to set down all our differences; and even the things we don't like about ourselves or others are all rinsed off clean. In this space, we're free to be one.

Cleanliness in Space as an Expression of Inner Purity

Rikyu's son once spent all morning sweeping up the dewy path (*roji*), plucking all the weeds and pruning all the trees and bushes. Satisfied that not one stray plant or leaf was evident, he summoned his father to inspect his work. Rikyu just clucked his tongue to show his son that

he had failed. Thinking that he missed some spots, the boy returned to his work with a greater verve than before, noticing even smaller weeds and the occasional stray leaf. After some time, he again summoned the old master. Rikyu sighed, "You obviously haven't understood why you failed before, and the hour is getting late. The guests will arrive soon. Therefore, let me show you how to clean the *roji.*" And the master promptly grabbed the thickest branch of an autumn tree and gave it three brisk shakes, scattering fallen leaves over the path in a rain of graceful, unpretentious life.

The art of Zen gardening is not based on the idea that the artist enter the garden and form it according to the image in her mind, but that she guide it along natural, spontaneous expressions that appear as artless as any wild scenery—in fact, suggesting such mountains, beaches, and cliff trees in miniature. Nor does the artist attempt to hide their influence, which would be shallow and ineffectively contrived. The idea is that the gardener herself is also a part of that same natural world; a living being that expresses Nature as profoundly as any animal, bird, or tree. When a person is free of ego, growing out of one's spontaneous inner-self— flowing with the Tao—one acts in the same way a wild tree grows, according to an inner flow of unprompted, unplanned movements. In that way, the gardener is as much a part of the garden as any shrub or bush. The same could be said for all of the arts, if they are to be Zen arts—painting, poetry, theater, archery, and even tea.

While a greatly-skilled artist could potentially copy the great Zen masters to such an extent that even experts would be fooled, to do so would be to miss the point: for the Tao is a journey, not a destination. The affect of the painting is in its creation, not the result. The enjoyment and transcendence found in the sharing of tea, with each other or with oneself, is in the time spent with the tea itself, not the parting words when the gathering is over. While the imitation painting, poem, or even tea session may have the "same," or relatively similar substance, the journey getting there is lost; and that was the whole point.

A person could, consequently, study tea for many years, learning a lot about its processing, history, and even how to brew a proper cup. But without the inner, spiritual growth the resulting cup is bland in

an indescribable way—only apparent when one drinks another, deeper cup poured by the hands of one who has walked the Tao, rather than imitated it. The greatest tea, in other words, isn't about the brewing parameters, the teaware, the leaves, etc. It is about the journey itself, and its transformative power. Most of us swim against the current of the River Tao, though it still carries us with it no matter how hard we swim, but if we turn and let it carry us, we have all its power flowing through all that we do. There are many small aspects of the art of tea that are often overlooked, even though they are important factors in learning how to brew the Tao, rather than brew tea. Tea lovers often spend time learning about the externals, like the "six kinds of tea" or "where to buy a teapot" while ignoring the small things like how to clean the tea space properly. "God is in the details," as they say.

Many of the principles of living a tea life have been proven through aeons of monastic practice and its marriage to tea. As we discussed in an earlier chapter, Rikyu defined the four characteristics of a tea life as: Harmony, Respect, Purity, and Tranquility. Of course, each one of these is deep enough to fill volumes, difficult enough to last a lifetime of practice; and even then, ultimately, ineffable qualities that are best articulated through the tea one brews, not parroted words. Nonetheless, let us again return to one of them, Purity, and some simple, real ways we can apply it to our tea. We might, for instance, view Rikyu's "Purity" as, in part, the cleanliness of the tea space and all that inhabits it.

Long ago in Japan, one's ability to host a tea gathering was in part judged by the cleanliness of the tearoom. Every corner was swept, the dust removed; even the garden was cleaned and sprayed with water, suggesting Nature's own refreshing hand. This cleanliness is not about a tidying up of unwanted refuse. In fact, the spontaneity of all Zen art, as we mentioned above, means that the creator should be a part of the natural creation, rather than molding an inanimate medium to his or her will. The cleanliness, like all of the tea life, is within. The sweeping of the tearoom is the sweeping of the mind; the wiping of the dust like polishing the "mind mirror"—until one reaches the state of realization that there is no dust and nothing for it to cling to.

It may seem silly at first, but cleaning the tea space will take as many decades to master as learning how to pour the kettle, gauge the amount of leaves or any other skill one normally associates with tea preparation. This is because cleaning isn't just about sweeping, mopping, and washing the tea towels—cleaning also involves removing unnecessary furniture and decoration so that the tea space is uncluttered, for example; and ultimately, like all principles that lead to a concordance with the Tao, cleaning is a mental and spiritual exercise. As the above story showed, the real master cleans without any distinction between what is "dirty" and "clean," allowing Nature's own inner-purity to shine; and sometimes this purity might be demonstrated, paradoxically, in a pile of "dirt." For example the morning dew dripping from a *camellia* bush onto the dark, loamy earth that now smells of things growing. The very image inspires purity of mind and cleanliness. Consequently, cleaning is an art form, especially when it comes to Zen, tea, and Zen Tea.

Beyond the preparatory cleaning of the tearoom and garden, there is also the quasi-symbolic washing of the hands and feet of the guests before they enter the tea space. Halfway down the *roji*, there is a stone basin filled with water (*tsukubai*)—cool in summer, warm in winter—and a dipper that the guests use to clean their hands, face and/or feet. Then when the guests finally enter the tearoom, the utensils are all thoroughly cleaned before their eyes. This has its equivalent in the Chinese *gong fu* tea ceremony, which also suggests that the host rinse all the teaware, and tea, before the guests. The fact that this cleaning is not done before the guests arrive is more than just a gesture to show them that the utensils are hygienic. After all, the thorough cleaning of the tea space and garden occurs long before they arrive. There is a much deeper aspect to the rinsing of the teaware, and even the tea leaves themselves.

The washing of the hands and face, the rinsing of all the teaware and tea is about washing off the "Dust of the World." The idea is that the tea space is otherworldly, beyond the realm of the ordinary. In fact, the gate and dewy path (*roji*) are also designed to impart the feeling of traveling away from the ordinary world, perhaps hiking up to the

abode of the ancient hermits: lost up among the cliff trails, wandering above the clouds. Ancient Taoist mendicants called the life of laypeople below the "World of Dust," and leaving it behind "shaking off the Dust." The metaphor was more literal back then, before the invention of paved roads when Chinese towns were actually quite often dusty. The rinsing of the teaware and tea isn't just a symbol of this leaving the world behind, though it can be viewed that way, but a literal practice of it. Until we can learn to clean our minds, we instead clean the space within which we practice. Eventually the purity inside and outside dissolves, the discipline becomes natural and the whole relativity of pure versus impure vanishes; after which there is still cleaning, but only for its own sake; and that then sometimes means shaking leaves over the path, as Rikyu taught his son.

Washing off all the cups, pots, pitchers, and then rinsing the tea itself is further a practice of purifying the tea space of all ego. It is, in effect, saying to your guests that here we are free to be ourselves. We don't need to carry on with any of the pretension or competition that is going on in our ordinary, business lives. Sometimes in the West this kind of "escapism" is viewed as unhealthy, but traditional Buddhist and Taoist culture viewed it as something quite natural: taking a break from the doldrums of ordinary life to, even for an hour, be like the Taoist monk who wanders about "like a cloud" with nothing more pressing to do than listen to the birds or the song of a river—all this is viewed as something necessary and healthy to a living being. Nature also alternates periods of release with those of stillness, and the idea that even a businessman needs some time to wash off the dust of the world and relax into the deep repose of an old, gnarly tree is something the West is finding a taste for, coming to understand how this very lack of stillness has harmed our health.

Furthermore, the cleaning of your tea utensils also serves to wash away all the previous tea sessions you have had. This is central to the idea that each tea session is a unique gathering of unique individuals that will never meet again. The Japanese tea masters expressed this in the words "one encounter, one chance (*ichie go ichie*)." According to Buddhist and Taoist philosophy, even if you and I share tea every day

(and it is the same tea) each encounter will still be unique in every possible way, including the fact that you and I will be changed—completely different people, actually. This forces us to remain present, to focus on the matchless, irreplaceable chance that is here before us: to connect to each other, to ourselves and to the Tao. By washing off your teaware, carefully rinsing each cup, saucer, and utensil, you are washing away all the other lost sessions and refreshing this one, further exclaiming its distinctness. For this same reason, you might want to practice washing off all the teaware at the end of the session as well, showing not only a care for your teaware, but also as an expression of the fact that the tea gathering we have shared now echoes in eternity, singular and complete forever.

Some Tips for Realizing Purity Through the Cleanliness of the Tea Space

Zen art has always faced the criticism of absurdity. On the one hand, there is no "pure" or "impure," no need to distinguish them, and many times what is ordinarily considered "impure" can be pure, like Rikyu's leaves scattered about the garden. At the same time, one is asked to clean, to focus one's attention on cleaning up the tea space. Though paradoxical, the experience itself is meant to go beyond logic, and as a result the more absurd it is, the more it works—confusing the rational mind. The idea is that you just clean. In the beginning there is a distinction between that which is "clean" and that which is "unclean," but over time the duality vanishes and there is just cleaning. And that is when mastery can be achieved; when you too can scatter leaves around your tea table without making it look contrived—when your unaffected, spontaneous cleaning is as natural as if the wind had scattered the leaves, for you are as much a part of Nature as the wind is. Though there are masters that can have a kind of messy clean (a mess that is pure in other words) this is not an excuse to be lazy and not clean; just as the idea that we are all already enlightened—already flowing within the Tao whether we recognize it or not—this truth is not a license to throw caution to the wind and do whatever one wishes.

The difference between Rikyu's messy garden and his neighbors which is simply unkempt is a profoundly real difference.

So much of modern life is cluttered. We have cluttered minds, so it is no wonder our space is also muddled: with images, things, and even garbage. So much of our inability to relax and find repose in our lives is caught up in the fact that our lives, our space, and our minds are disorderly. Anyone who has ever done a meditation retreat can testify to just how cluttered our minds are, as thoughts, ideas, memories, and words arise in bubbling torrents of nonsense the moment one seeks to let the mind settle. Our lives are like turbid waters, and the remedy for turbidity is of course just to let the water alone so that it will settle to Clarity. But in order to do that, we'll need a space that allows the water to settle; one in which we are free from the steady thrashing that further upsets it. For that reason, cleaning the tea space should start with the removal of all unnecessary objects, decoration, and furniture.

Try creating a space for tea that is simple, purified. A cluttered tea space only furthers all the messiness of our ordinary lives. One of the reasons that a great tearoom relaxes us the moment we walk in, is that it is simple and empty. The best tea houses are always designed in this way. If there are too many things in the room, the mind is just distracted, looking around and never letting the water calm down to transparency. I am acutely aware of the difference, as I myself have two tearooms: one is a more "social" room with a table and benches. I keep my tea and teaware in this room, and it is also decorated. My other tearoom is very simple and empty. When serving tea in the former, guests rarely ever settle down—looking about at all the tea, teaware, and decorations, and sometimes even getting up repeatedly to examine this or that. In such environs, how can the murky waters of the mind ever settle to purity?

However big your tea space—whether a tearoom or just the corner of a room—try starting the cleaning process by removing as many decorations, tea, teaware, and furniture as possible. If you only have the corner of a room, you may want to think about separating it, perhaps with an Asian changing screen. Try using a low table and sitting on the floor, which removes the need for chairs. You can decorate the space

later, recognizing that before an artist can begin painting, he or she requires an empty canvas. Actually, the use of space is one of the most difficult techniques for an artist to master, and often it is the space of the ink painting, the empty suggestion of the theater stage, that say more than the parts that are painted. At this stage, take out everything you can—in fact, go beyond what you feel comfortable removing. Extend the emptiness as far as possible to start—it is always easier to add than to take away. Try keeping your tea and teaware in another place, and bringing it into the tea space as you serve it. In purifying your space in this way, you will find the emptiness immediately contrasts this area with the rest of your house and life, which makes it feel relieving. Indeed, it is amazing how much of a relief it is to enter an empty space, where our mind is free to settle down. In such a cluttered world, a bit of empty space is a rare find.

Once your tea space is emptied of all clutter, you can scour it. The more you clean, the more the act of cleaning becomes part of your tea practice. Don't leave any detail undone. It doesn't matter if your guests notice that the underside of the *tatami* is clean, or that the windowsills are recently dusted. As I mentioned before, you aren't cleaning for the end result anyway. Cleaning is like breathing, as soon as you breath in, you must breathe out. In other words, you clean the tea space spotlessly, but the tea gathering only spoils it again. The practice is the journey, not the contrast between "clean" and "dirty." Still, it is a good idea to clean the tea space before and after every session, every time. Even if you are having tea alone, don't neglect this practice. Many of our defilements revolve around a lack of discipline: laziness. Slouching, for example is always a sign of mental impurities. Just as we must sit up straight to meditate properly (or make tea for that matter), we mustn't neglect the cleaning of our tea space just because we are too lazy to do it. The tea space is a reflection of our minds. If our space is a mess, so are our lives. So much can be read in the way a person organizes their home. If the tea space isn't cleaned, neither are we. In meditation, one cannot leave a single speck of dust anywhere in the mind. Use the cleaning of the tea space as an expression of that same wisdom.

The art of decorating the tea space will also take decades to master.

Mostly we are here discussing the "purity" of the tea space, which for most of us is a negation of unwanted things in our lives. While it is possible for purity, of space and of mind, to be an affirmative action, in this modern world purity is mostly about removing obstacles, abstaining from unhealthy practices, and allowing all the turmoil in our minds to settle down so that the water is pure and fresh, which others will then also wish to drink from. Try decorating as minimally as possible in the beginning. Arrange some flowers or hang a single scroll painting. These are good places to start. One important thing to note is that, generally, more lasting, permanent decorations go against the aesthetic of tea, which is why flowers are always great. The fleeting spirit of flowers have always lent them a special place in the poetry and practice of Eastern spirituality, and of course in tea as well. By changing the decorations repeatedly, one is recognizing the exclusiveness of the tea session, unlike any other in all eternity. Changing the decorations also makes the guests feel as if you care for them all that much more. They will recognize that care has been taken to enhance their experience of the tea. It will also refresh the tea space, rewarding your own sessions as well.

During tea preparation, rinse all the teaware and even the tea. Similarly, if you are alone, this washing of the tea things is useful. Many of us don't have a tea garden, a dewy path (*roji*) or a washbasin (*tsukubai*). There are simple ways around this, though. One way is to simply wash your hands and face before entering the tea space. At my house, we serve guests a moist towel—cool in summer, warm in winter—to wash off their face and hands before tea. As the pours of the skin open up, one feels more relaxed, clean, and open-hearted: the mud has already started to settle down. I slowly rinse each cup in a circular motion, being sure to clean it thoroughly, so that all past tea sessions are rinsed away—leaving only this present tea mind.

After finishing a tea session, I also clean up my teaware thoroughly. One of the biggest problems with this modern world is that we have lost all respect for the "objects" we take into our lives. Even the creation of simple things was radically transformed by the industrial revolution. One reason antique teaware works so much better is that it was made

with pride. In our great-grandfather's day, adults bought one pair of shoes to last them their lives. These shoes were handmade, with pride, and repaired by equally skilled craftsman whenever they were damaged. All of our environmental problems stem from a lack of respect for objects, which we use and cast aside at an amazing pace. If your tea is drank in a similar fashion, as you work on the computer—or other "multi-tasking," which is only a synonym for clutter—it only furthers the very worldly stress and dilemma you are trying to relieve. Take care of your teaware. It is a precious companion on your tea journey. Don't leave your teaware dirty, staining it with neglect. Wash, dry, and replace it with care each time you use it, so that it may find in you a friendship equal to that which it gives.

After your guests leave, or after you finish your session, clean up the tea space and teaware thoroughly. Ancient masters suggested that we use this time to sit in the tea space for a few minutes and quietly reflect on the tea session that just occurred: the ways it changed us and our guests, fondly remembering its grace and wishing the guests who have come and gone a pleasant journey through life, hopefully cheered by the company and tea.

At first you may find these exercises tedious. Discipline is always thus. You will soon find that cleaning is not something dreary, boring, or wearisome. It will become a part of your tea, as much as selecting the leaves or pot to use that day. And, what's more, you will find your tea all the more delicious, not to mention spiritually rewarding, for the very reason that it was enjoyed in a clean, empty, and pure space. And as your mind purifies, your tea space will begin to take on a natural sheen of Clarity that extends beyond just the simple, obvious fact that it is clean. And it will be at this moment, when your tea space is sparkling, that you too will smile, reach up, and scatter a mess of leaves over it.

You will have created a tea space that has the power to lead to transcendence, affecting all those who come to it. In such a place, each cup will be steeped in the Tao, and people will go home feeling as if they have left the world and returned refreshed, as if Spring herself had come in unawares and spread dewdrops over their lives, each one reflecting the moon.

The Daily Tea Space

These are just some of the ways that I have learned to use my tea space to enhance the way that I enjoy my tea. There are several others. You may wish to build or buy a cabinet to display your teaware, hang calligraphy on the wall of the tearoom, learn *Ikebana* and bring flower arrangements into the space; the list goes on and on. Of course, some people won't want to invest in the more expensive ways of improving their tea ceremony, like antiques or silver—others will find it's worth saving the money. The creation of a tea space need not be expensive in order to promote calm, connection, and artistic inspiration. Some of the best cups of tea I've ever had were in incredibly simple surroundings. The point being made here is not which part of your tearoom or tea ceremony should be changed; the suggestion is that you continue or begin participating in the creative inspiration of tea and see enjoyment in the creation of the space, and ambience, where you enjoy tea.

Masters like Rikyu could completely change the environment of a tearoom by placing a single, beautiful blossom in a vessel of water, finding an interesting stone to use as a lid-rest, or even carving something out of wood or bamboo. Just by bringing artistic energy into your tea, and life, you will find your tea so much more enjoyable, and that participation is what can make a life of Cha into a Tao.

Many tea lovers, including myself, take great joy in expressing themselves each day when they set up their tea. First I choose the right tea mat (*cha bu*); then I decide on the tea and teaware, arranging it all in a different way each and every time—"one encounter, one chance." I may then add a flower from the garden, a vase, or hang a piece of calligraphy in the tea room. In that way, each and every tea session is a unique expression of that day, and subtly captures my mood and conveys it to my guests, or at least reflects it back for me to see. And many of the variations I choose aren't about collecting teaware, vases, art, or anything: I could paint something myself, get a unique stone from the river and use it, find an interesting twig and use it as a spout-cleaner, or maybe even scatter a few leaves or blossoms in a bowl of water or on the tea mat itself. Each choice is from the heart and soul, and therefore beautiful.

Ancient saints, sages, and seers told us in so many ways that once you truly understand a thing, you understand all things. It isn't really about what you buy—even an unappreciated silver kettle would be useless—it's about the attitude you convey to the ceremony. Instead of brewing tea ultra-casually on the kitchen counter, carry the tea sink to a coffee table and arrange some flowers there. This motivation itself will open all kinds of doors; and that creative energy will make your tea into an art rather than a beverage.

The fact is that we don't live in such a clean pure way, simply and spiritually like those sages on their mountains long ago—at least I don't—and we don't come into our tea space as unpolluted and ready for calmness; our approach and connection with the Tao is more spurious, and many of us can benefit from an environment that inspires tranquility, as well as teaware that not only is beautiful and motivates us to participate and enjoy our tea, but also enhances its flavors and aromas, bringing us more into our bodies. Most of us need the help of such places and things, methods and practices, to let go of our daily affairs and find the serenity that forms the basis of harmony with the Tao. I have found that for many people, especially when you begin to really appreciate tea, having more beautiful pots, cups, utensils, tea sinks, etc. actually improves your ability to experience the subtleties of the tea. This may be in part because of the reverence or ambience inspired by taking the whole event seriously and constructing an environment that reflects that devotion. And that was the same energy behind the Japanese flower arranging or calligraphy that they brought into the tearoom.

In this way we sanctify our tea space and our tea lives.

CHAPTER THIRTEEN

A Life of Tea

These few leaves in my hand are all man could ever teach in words,
But the Truth is like the forest behind me.

—Said the BUDDHA.

So I answered, *then put them in this bowl and lets have a drink.*

Much of the understanding Cha Tao brings will come when we make enough room for it to grow. There are no words to teach one how to be with tea; you simply must start making some quiet time each day to drink some. One of my teachers always says that our meditation is like a tea tree itself: In the beginning, it is a fragile sprout—we must water it, care for it, nurture and protect it. But eventually, it will grow stronger and stronger, providing shade, leaves, and seeds for others to use. As we make space to allow a bit of quiet interaction with our tea and ourselves each day, we will quickly find that it wasn't as difficult as we thought. We weren't as busy as we thought. Sooner than later we will even find that we miss a quiet tea session when we can't afford the time—that those days seem "off" somehow. And then some day, when you least expect it, you will reach the amazing moment in your journey when it is you sliding a cup of tea across the table, just as it was once passed to you.

The greatest truths and changes in our lives are not so many words, and neither are the greatest teachings or teachers, who instead guide as living examples. The greatest teas are drunk, not stored in glass cases or read about in books or magazines.

Te (Virtue)

One of the most important concepts in Taoist thought is "Te," often translated as "virtue." The Chinese word, however, is used more in the sense of the virtues of a certain medicine, rather than simply to be good. In fact, Lao Tzu says that the one who knows he is virtuous expresses a very inferior form of virtue, while true virtue is unaware of itself.

The real master doesn't need to practice peace, he or she *is* peace; the teacher doesn't practice compassion, reflecting on how compassionate she is being, but manifests it naturally and unaffectedly. Similarly, my tea master makes better tea because he *is* more, not because he knows more.

For many years I mistakenly thought better tea was in the technique. I read as much as I could and learned all the brewing parameters from as many teachers as I could—studying and studying in vain. But, like life itself, tea isn't an intellectual problem to be solved. You can't read your way to better tea—the kind that makes everyone in the room feel relaxed and peaceful. You have to live it. Like spirituality, too many of us try to approach tea as some kind of science project—something to wrap our brains around; and if we only read and study more, we'll get it down. But this is like reading books about art in an attempt to create a masterpiece. You can't learn art, it has to be felt and lived.

Te could be viewed as skillful living. Understanding how to follow your inner Way, in accord with the greater current of the Tao. As you progress in tea you will realize—if you haven't already—how much the mind of the one brewing and drinking affects the tea. Tea is, after all, the interaction between a beverage and a human body, so at least half— you must admit—of the process is within the body and perception of the individual. As you come to this understanding, you more and more firmly cement the idea that everything you do affects your tea. Like Takeno Joo taught, tea doesn't end at the door to the tearoom: all that you eat and are digesting affects your discrimination and tea, all that you think and all your emotions—everything you are in fact steeps along with the leaves.

At that point, tea becomes a Way of life. The cup becomes the mirror we gaze into each day to learn how to live with *Te*. We learn to be sensitive to all the changes in our lives day to day, and if we listen to the Leaf as it whispers its nature, we'll hear the movement of the Tao—a bit like hearing the ocean in a seashell or the proverbial word of God beneath the river stones.

I imagine myself as a novice in some ancient monastery up in the mountains. I imagine being summoned to the quarters of the abbot for my last lesson before I am to be ordained. I am nervous all morning, expecting some kind of test on the "Eight Noble Truths" or the "Wings to Awakening," and I spend most of the early hours pacing. In his room, though, he merely smiles, reaches behind him to a silver tin and pulls out some wizened leaves. He brews the deep liquor and we spend the morning meditating together. At the end, he looks me over and sends me away. Did I fail? What was the lesson? Worried, I spend a sleepless night in the garden. But my master is kind; he gives me more chances. Each morning, I am again called to his room and again he brews tea for me—only this time I notice a slight bitterness I hadn't before. I realize that the tea also coats my throat. On the third day, in the middle of the tea session, I imagine that understanding dawned on me. I knew what it was my master was teaching—my last lesson. As he slid the cup across the table, as I drank the deep liquor and felt its warmth course through me, I understood. It was time for me to be ordained.

Living Reflections on the Way of Tea

They say that when you find the path you were always destined to walk, every road you have ever trodden—even for just a mile—every way you've meandered through your journey is within that greater road. And yet, standing here at the crossroads, it sometimes doesn't seem so simple. I wish it were. Our energies are so scattered, and not just through a lifetime, but through most of the days we walk this Earth. I am sometimes a gorgeous soul, and other times ugly. I have trembled in rage and the ecstasy of a deep love both. There are times when I am spiritual, and my years of meditation shine, while during other seasons it seems as if those tides have receded beyond the horizon even, replaced instead by all the baser emotions of the "World." Like Shiva, I too seem to spend half my time dancing to the beat of the World, all its greed, ego, and joy, and the other half contemplating higher truths— the person I sometimes wish I was. With such confused minds, and wandering desires it is rare to find a true path, a Way to approach this mess of living a human life with a bit of depth and understanding.

For more than a decade, I have tried so many kinds of meditation, yoga, *tai chi*, etc. and some of them have indeed made deep and lasting changes in my being, but looking back on my long journey literally around the world and through the spirit, I have come to find that there was always one aspect of my life that remained constant throughout: No matter where I was in the world, what I was practicing—what beliefs or dreams I had surrounded myself with—there was always tea. Whether in love with a woman or God, I drank tea. When I meditated in India for a few years, I still had a travel tea set and did my ceremony each morning. When the tides of spiritual verdure would wane and I would go forth into the world, motivated by the same materialism

as anybody, I still had my tea; even more so with the myriad levels of collecting tea and teaware. Tea...

The more I embraced the idea that something so ordinary, so simple as some leaves and water, has been my best friend and companion along the way, the more insights into living all the ordinary moments of life with a bit more virtue (*Te*) I've realized. After all, the object of our devotion and meditation isn't really important. There is no aspect of the world that isn't divine. These leaves have in them the sky, the rain—the Earth, Man, and Heaven.

For each of us, I believe, the way we focus our scattered selves and find peace and meaning is different (or so it seems from the lowly perspective we have here on Earth.) For me, finding a Way to achieve some harmony, channeling all my energies in a more healthy Way, can really brighten my living self. And the more I work with this simplicity, the farther I go—farther than any meditation or book ever took me. I meditate with tea. My body uses tea for its own health and longevity. I also find great sensual joy in tea; there are so many aspects of drinking great teas that are intoxicating. Using tea, I have reached great heights of meditative bliss and wisdom. I have been at peace with the moment, completely present and connected to my environment. On the other hand, all my greed, ego, and worldly desires all revolve around tea, as do my possessions. I even offer my creative energies up to the goddess of herbs: I paint pictures and write articles and books about the Leaf. I share time with friends and family through tea... The list is as long as there are moments and ways that I approach each day.

If you were to focus on the more conventional aspects of my relationship with tea you might say I am possessed, addicted, or in some other way compulsively chasing something trite enough to be comical. At times this may be true, but at others I honestly find harmony with myself, others, and the universal Tao through just simply sitting quietly enjoying tea. Yes, I sometimes crave tea, feeling the pangs of greed—I'm a human—but I always seem to find myself giving in the end, sharing even when my ego suggests I do otherwise. It would seem that the moments when tea drinking is transcendent are bright enough to illuminate all the others. Another way of looking

at it might be to admit that I am obsessed with tea, but would that sound as strange if I had said I was obsessed with meditation, religion, compassion, generosity, or even love? To me, the ideals of Cha Tao are in harmony with these principals, and though I may falter along the Way, the moments when I am aligned with the Tao, through tea or any other expression, also encapsulate these virtues as well.

I'm not saying that tea is the only way I approach the Spirit, but it is definitely a part of *the* Way. I still meditate everyday. However, the more I allow the Way of Tea to occupy a central place in my life, the more the quietude of the cushion seems to permeate my quotidian life. Before, I always felt that peace was available at the meditation center, yet fleeting in many of the situations and people we must meet out in the stream of life. Tea unlocks the Quietude, Presence, Clarity and Completion I use to face the other ordinary moments in my life, bringing the peace and power of my meditations into my everyday consciousness. Through tea, I found a reverence for the ordinary that can and does translate to the steering wheel of my car, my clothes, food, and even the keyboard I stroke now.

I really do believe in the power seemingly ordinary moments can effect in our lives. I try to worship the slanting rays of sunlight that are coming through my window now. I revere the quiet of my tearoom, my Qing Dynasty cup, and the dark liquor that steams gently in it. I hope to find a transcendental peace in all my moments, not just those spent in the company of higher ideals, people, or places.

To live tea is to live in the Tao. This means that we practice doing whatever it is we are doing with awareness, and without the interference of the ego. Without any thought, in harmony with my inner self, I achieve what is perfectly necessary in this moment in time.

Some of you may scoff at these ideas, "It's just tea already!" you'll exclaim. And that is the very point I'm making: you start ticking off all the moments of your life that are *just*—just eating, just brushing teeth, just working—and soon enough the largest percentage of your experience on this Earth is "just." But what if those moments aren't "just," what if they are everything? What if every bit of experience is precious and true, meaningful and connected? Would tea then be "*just*

tea?" And then why not use any old object if tea is as good as another? For some this may be a very valid point, though I have seen enough people changed by a tea session steeped in the Tao to believe otherwise. Though other trees and plants might be equally connected to Nature, few have the ability to connect us to Nature and our fellow humans as well as the Leaf.

And I now know there are others like me, those that understand what it means to live a life of Tao through Cha. I have written this book to share my experience, strength, hope with those of you. I am also writing with the wish that maybe some other gentle reader was just waiting to brush up against the right current and find his or her own Tao—his or her own Way to meaning and brightness.

As I have said so many times throughout this book, Cha Tao is not words about Cha Tao, which is why I subtitled this book as some "reflections," not the Way itself. There is so much that just cannot be said, though it can be shared in a cup of tea. I would love to have that quiet cup with you some day. However, if I never find you, my reader and friend, in this life and share that cup of tea with you, don't worry: for when you find the still center beyond yourself—when you too are just tea pouring, steeping, sipping…When you, too, are calm and complete, we will be one: One in the occasional moments when I also find my true self. One as the sky, the tree, the leaves, the water— one cup of tea.

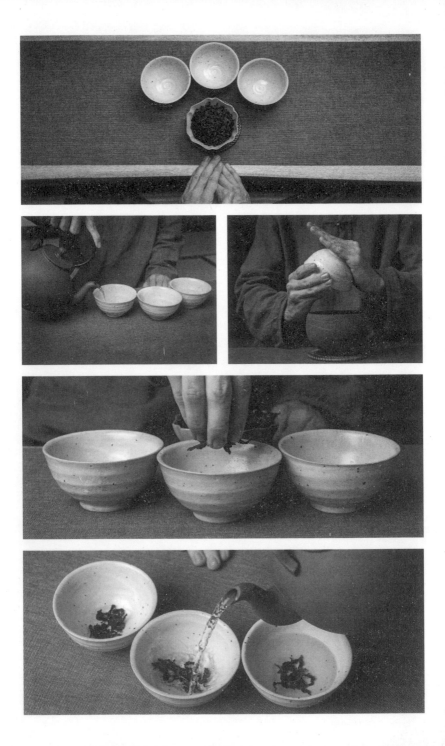

Leaves in a Bowl of Tea

The journey of tea is not linear; it is not a progression through stages. There are no levels in Cha Dao—no higher or lower seats around the tea table. The beginning and ending are but points on a circle. And at that table, a tea master is not a beginner filled up with knowledge, but one with a deeper and more open connection between hand, heart and tea, empowered by a skill born of repetitive practice. One of the constellations in our tea sky, Sen no Rikyū, wrote a famous poem that is sometimes shortened in calligraphic scrolls hung in tea rooms: "One to ten, ten to one," celebrating that the movement up is followed by a return to the beginning, over and over again. The "ten" here represents "everything." It is hard to describe what is different with each revolution from one to everything and then back again, but if anything, the change is more of a subtraction, a letting go, than it is an addition of anything. The signal path grows clearer and purer as distractions are surrendered, while the movements become more polished. As we grow, our form is cultivated and our sensitivity is honed to experience microdynamics of what was once gross to us, but nothing is abandoned along the way. Like the journey of an artist, from simple drawings to masterpieces, the whole is always there at every step of the way. The final painting contains the earliest sketches, it is just more refined. Thus, advanced techniques are naught but basic techniques mastered.

Years ago, I learned one of the most powerful ways of brewing tea I've known, and my tea journey has never been the same. It is a brewing technique for beginners and masters alike. There are many convenient, simple and inexpensive ways to teach a beginner to brew tea, but many of them then need to be put aside as one progresses in skill and develops a palate. But I try to never teach anything that will later be abandoned. As I said, the end should contain the beginning in

its entirety. I thought I would share this wonderful brewing technique with you as well, whether for the first time or as a pleasant review, and along with it explore some of the many ways that it is useful in a tea journey. There really isn't much to it, you just put a few leaves of tea in a bowl and add hot water. *Bowl, leaves, heat and water...* That is the essence of Cha Dao.

Even after decades of tea, many masters I respect still continue to drink tea in this way at least once or twice a week—a tradition I have carried on in my own way. There are many reasons why drinking tea in a bowl is so beautiful, some of which we I can introduce here, others are for you to discover on your own, while the very best insights are those that lie beyond the silent gate where words can never intrude.

One of the most important reasons to drink tea this way is to remember our humility. (I say "remember" because humility is not something we can cultivate—it is not something we increase, but rather our natural state when we let go of self-importance.) We drink bowl tea to reduce all the human parts of tea brewing to almost nothing. There are no or very few parameters: Simply adjust the amount of leaves and water temperature—or don't and enjoy the tea however it turns out! In this way, we let go of all pretensions. There is no longer any quality in the tea brewing, no comparative mind—no better or worse. A lot of skill and mastery often leads to snobbery. Then we miss the chance to connect with Nature, ourselves and each other through tea. In drinking bowl tea, and minimalizing the human role in tea, we can return to just leaves and water, where the true dialogue begins and ends.

The Sanskrit word for wisdom is "*prajna*," derived from "*pra*," which means "before" and "*jna*," which is "knowledge," so wisdom is that which is literally "before knowledge." In Zen, this is often translated as "beginner's mind." The beginner's mind is the end, the wisdom, as much as it is the beginning. A beginner's mind is open, humble, curious and usually full of wonder. Such a mind is light and supple, easily changed and, ultimately, free. Such receptivity isn't the starting point in tea, but a constant companion throughout our journey. The bowls aren't empty, waiting to be filled, but rather moving through emptiness and fullness throughout their lifespans.

Putting a handful of leaves in a bowl and adding hot water is one of the oldest of tea brewing methods, dating back thousands and thousands of years. In antediluvian forests, pristine in verdure, sages exchanged wisdom over such steaming bowls. They would find wild tea trees and process the tea on the spot, withering, roasting and drying it as they talked or sat in silent meditation. No doubt they also had pouches and jars of aged teas lying around for special occasions, when distant masters chanced to visit, when certain astrological and cosmological conjunctions happened making the time ideal for powerful tea and deeper meditation or even to celebrate seasonal changes... Using crystal mountain water, boiled simply over charcoal, they would cover the leaves in water and in energy from their Qigong and meditation— passing more than just tea and water to the traveler or student, but a part of themselves. Tea has always been a communication of the Dao precisely because it goes beyond words and the concepts they engender, and there is a truer representation of a person's wisdom in the tea they serve you than in a thousand books or lectures. Bowl tea can cut through to the heart, bypassing the intellect on its way to the present moment.

It is important that we don't get caught up in all the pretension that can accumulate as we learn about tea. Unfortunately, some people become snobby about their tea and lose the ability to enjoy the tea without all the perfect accouterments—expensive pots, kettles and jars. Over the centuries, many types of tea ceremonies were criticized by monks and spiritualists alike, since the practitioners lost the true spirit of tea over time and turned it into a chauvinistic obsession based on collecting expensive teaware and tea and showing off their wares or skills to others. One great tea master, Sen no Rikyū tried to right this by incorporating local, simple raku pottery and natural decorations in a simple aesthetic. Today also many people use tea to promote themselves and get lost knowing more or having more than others. We use bowl tea to overcome this: a formal ceremony rooted in simple rice bowl-shaped tea bowls, with naught but the simplest of leaves and surrounded in a spirit of humility conducted with as few movements and guidelines as possible, distilling method into clarity.

By returning to the simplest of tea brewing parameters a few times a week, we can effectively wipe the slate clean. All of our affectation is gone. There are no better cups, jars or pots; no need to pour in certain directions or from certain heights, no better or worse—just leaves in water. The discriminating mind can often ruin tea, analyzing and criticizing what should be enjoyed, embraced and absorbed into the body and spirit. There is a time for working towards bringing the best out of teas through skill, and a time of returning to softness when the human element and all our posturing is put aside in favor of the simplicity of Nature, which since ancient times has attracted people of spirit to tea.

I always suggest that beginners follow this method for the first months that they are learning about tea, so that when they move on to studying all the different kinds of teaware and tea, skills and techniques, they do so from a strong and humble foundation, rooted deeply in tea's essence. And returning to that foundation each week, they never forget their home base in the "beginner's mind," free of all the ego that ruins more tea than any bad water ever could.

These days, a greater and more empathetic dialogue between humanity and Nature is needed above all else. All of our personal and social problems stem, in essence, from the fact that we have ignored this conversation—a subtle whisper still heard if you quiet the mind or walk in the forest where the noises of the city are far away and the river's voice more audible. Over centuries, our analytic, rational mind has been developed to an extraordinary degree, bringing with it such wonderful advancements in technology and science, like this very computer I now type on. But this exclusive focus on the rational mind has also meant the loss of another, more ancient kind of intelligence: *the feeling of being a part of this world.* This innate intelligence sees patterns instead of pieces, understands relationships instead of causes and also attunes to the unfolding dynamic of our world as opposed to watching it from a mindmade "outside."

Lost in the rational voice that narrates our lives, many people feel completely disassociated from each other, Nature and the world. An intelligence and wisdom born of a connection with Nature was self-

evident to ancient peoples, our ancestors. Through this connection, they understood inarticulate aspects of Nature that are completely lost to us today—the names and ways of the star constellations, the role of the seasons, rivers and mountains in our lives—the way a lifespan was measured in "winters" for example—and all the communication between Spirit, animal and our nature that we no longer understand... We've lost the ability to read water signs, track the forest, follow the animals, read the stars or smell the toxins versus healthy plants. And in our solipsism, ignoring Nature to explore our own desires and satisfaction, we have polluted the Earth; and only now that the warning voice has reached a cataclysmic volume is humankind once again beginning to hear and understand what has been sacrificed in the name of technological development.

Obviously, our social problems aren't about a lack of science or information. We have so much information that huge computers can't store it all, and you couldn't learn even a fraction of it in a lifetime. Wisdom is what is needed. It isn't new technology or information, but the proper application of the sciences and awakened, aware living that is the key to our prosperity, both personally and as a species. In other words, we need guidance to steer our research and the resulting technological innovation. And that should supersede the decision to create more or bigger, newer versions of the same.

When you drink tea from a bowl, there is an even greater connection to the Nature within the leaves. Lighter brews often reveal the deepest qualities of a tea, connecting you to the sun, moon and mountain that all worked in conjunction to form these leaves. Another common tea scroll we contemplate is "True taste is only found in the light and simple (真味只是淡)." When you cover these simple leaves in clear, clean mountain spring water and surround your drinking with calm, the overall effect is powerful indeed. If you stop all other activity and focus on the bowl before you, the voice of Nature often returns, louder than ever before. You find yourself connected and complete, a part of the process that began with a seedling gathering sun, water and mountain to it as it grew into a tree, sprouted a crown of glorious leaves, which are now culminating in this very warmth and energy

coursing through you as you drink... Nothing is missing from such a moment—no better or worse, no striving for something other than this. Bliss is written in steam across such moments.

Brewing tea simply in a bowl allows for a kind of clarity of the senses. Between sips, you can hold the bowl and close your eyes, allowing the warmth to flow through your arms, just as the inner warmth spreads through your chest. With all the room in the world the leaves open up gloriously in the bowl and are a delight to behold. There is a sense of openness to the bowl and leaves other brewing methods cannot compare to, connecting the tea more clearly to the room and people around it.

When you drink tea this way there is no question of quality, or evaluation of any kind. There is no need to record your impressions internally or communicate them externally. The tea is stripped down to its most basic elements: leaves, water and heat. In such a space, you are free to be your self (or no-self). Sharing such tea with others, you may find that the conversation naturally winds down, and you and your guests smile at each other one last time, before drifting off into contention, contemplation or meditation. There is a powerful and lasting connection found through sitting together in calm joy, silently together in a space beyond all the words and ideas that usually distance us from one another.

This quietude is also paramount in living a healthy life in accord with the Dao, balancing stillness and activity and acting from depth and with meaning, when the time is right. After all, what is important cannot be expressed as well in words as it can in the direct transmission of something so intimate as liquor we ingest into our bodies, prepared by the hands of the master—not I (I haven't mastered anything yet), but the true master who lies enshrouded behind your face.

The essence of a tea is beyond its flavor or aroma to the energy deep within the veins of the leaf, just as the essence of the tea ceremony is beyond the tea or teaware. Master Rikyu is said to have once told a student, "imagine your life without tea and if it is any different than it is now, you have yet to truly understand Cha Dao." If tea becomes pretentious and snobby, the essence is lost. Anyone can learn about

tea, reading and traveling to tea-growing regions. It is the Dao that is the more powerful and lasting part of a tea session, not the tea. And actually, though it may sound paradoxical (or even downright zany-Zenny illogical), transcending the tea is the true tea. So, it's either all about the tea or not at all, depending on how you look at it.

The tea bowl before you is a gateway to yourself, and beyond that the Nature and the flow of energy through this universe. And it is often easier to transcend the tea when the process is simpler and close to the essential Nature that produced the tea in the first place.

You can simply put leaves in a bowl and skip all the parameters, approach and method, keeping things simple, or you can learn a traditional ceremonial method. In this guide, I will introduce one such form for those of you interested in advancing your tea practice. Such forms do have a lot of value: they connect us to lineage, increase mindfulness and focus, help keep us connected to the present moment and also contain a spirit of hospitality and oneness with our guests. However, the spirit of bowl tea is simple, so feel free to surrender the form if you wish to practice on your own. This method is more important in the sharing than in the receiving.

Our journey must begin with at least a handful of tea leaves. But where to start? The modern world of tea isn't anything like ages past—we must create our mountain hermitages in spirit alone, and finding our ways to those forests, even metaphorically, is harder than ever. Today, any one genre of tea offers a baffling array of choices, quality and information. Even in the later periods of Chinese history—by the time tea had spread all over the kingdom, offering people a huge selection of leaves—even then, the choice of which tea to drink wasn't nearly as important as it is today.

Not only has the number of different teas available reached heights never seen before, but the success of the market has created space for unwholesome tea production, sales and misinformation. Deciding on a tea, these days, can mean the difference between healthy or not, flavorful or not, and of course with spirit or not. For that reason, it is important that one does some research, and if possible, seek out a teacher and ask for help in finding the right tea to begin one's practice.

Still, I don't think any tea sage can save you from a bit of wear and tear along the way. It is important that one approaches tea open-mindedly, knowing that eventually you will encounter poorer teas, and sometimes they will become the basis for your standards; while at other times you will find that you later enjoy some of the teas that you initially didn't. One should just keep in mind that choosing some natural, healthy teas with spirit (Qi)—and at other times bland and lifeless beverages that taste nice at best and leave one disappointed at worst—this is all part and parcel of drinking tea in the modern world. Unlike our ancient predecessors, with their simple bowls and leaves, these are all too often aspects of a life spent drinking tea in a world out of touch with Nature.

To prepare tea leaves in a bowl, you don't need much. Tea basically comes in three shapes: striped, ball-shaped and compressed. For this kind of ceremony, large striped teas are best since they don't get stuck in the mouth, are less likely to float and are beautiful to watch open. (Sometimes a few balls can also work, especially if they are hand-picked and open up into bud-leaf sets.) You can actually find tea suitable for bow tea in all the seven genres (green, white, yellow, black, red, oolong and puerh), though some genres have more examples. I suggest starting with striped tea, and finding one that is healthy, chemical-free and produced sustainably, meaning good for you, for the farmer and for the Earth!

As for teaware, you will need some kind of dish for the tea, bowls for each of your guests (rice bowls will do if you don't have tea bowls yet, but make sure they have a foot on the bottom so that they aren't too hot to handle), and if you like, some *chaxi* supplies (茶席, "tea stage" is the decorative environment of a ceremony, discussed in more detail in this guide) like a runner, flowers or other decorations and a waste-water container (*jen shui*, 建水).

Guide to A Simple Ceremony

I. Preparation

For a Chajin, there really is no beginning to a tea session. Master Lin often says, "I have devoted fifty years of my life for the sake of this cup of tea." We put all of ourselves into the service of tea, and as a result this practice transforms us. For a formal session, you may want to spend as much time as possible planning the occasion, time and place to host your tea. You may even want to send out themed invitations and create small gifts for your guests to take home based on that theme (maybe a small packet of the tea you're sharing). The more time you spend planning and creating the event, the more special it will be for your guests. There is no need to acknowledge this effort, as it will be in the heart of the event itself and your guests will feel that honor and love whether they recognize the particulars or not.

On the day of a ceremony, even a more casual one, you should spend time cleaning. We honor our guests by cleaning and decorating. In this way, we also honor the occasion itself, taking the time to make a session special is actually what does set it apart! Clean everywhere, even the places your guests will never see, as the purity of the space is a real energy and not just a show. After you have cleaned sufficiently, you can start on the *chaxi*.

A *chaxi* is a mandala: a work of art that connects this occasion with the cosmos. The main function of this art is to honor your guests and the tea served. For that reason, it is important to choose your tea and brewing method *before* starting on your *chaxi*. After you've chosen a tea and brewing method, remember that the subject of any chaxi should be the tea itself. Arranging flowers for tea (*chabana*), for example, follows a very different aesthetic to ordinary flower arranging (*ikebana*), because the flowers cannot draw attention away from the tea and therefore

need to be much simpler and understated. In fact, simplicity is one of the main principles that should guide a well-designed *chaxi*. There are rarely neutral elements in art, and this is even truer of *chaxi*. If you aren't sure about how any element is enhancing the space, take it out. Less is truly more.

One of the great tea sayings in the legacy of wisdom that has been handed down over generations is "*ichigo ichie*," which is Japanese for "one encounter, one chance." (The Chinese is 一期一會.) Any discussion of *chaxi* would be remiss without an exploration of this poignant expression, as it speaks to the underlying spirit of a great chaxi and the session that will take place upon it. Before the session begins, this expression asks us to remember that this tea session we are preparing for is unique, pregnant with possibilities. It reminds us to treat it with the same respect and attention we would give to a once-in-a-lifetime meeting with someone very important, *which it surely is.* This intention and the state of mind with which we carry it out are just as important as our intention and state of mind when the session begins. Don't rush to set up a tea session in order to get to the point where the tea-drinking begins! After all, if the instruments are not in tune or the stage improperly set, it doesn't matter one bit how well the music is played later on, it's going to be disharmonious.

Once the session has begun, ichigo ichie reminds us to cherish this moment, taking nothing for granted. Even if (*especially if!*) you and I drink tea together every day, even if it's the "same" room, the "same" time, the "same" tea, this saying reminds us that, in fact, nothing and nobody are ever the same. We are always sitting down to tea for the first and last time together. The whole Universe is changing every second, and so are we.

Anything at all that instills in us a sense of the uniqueness of this moment in time is worth contemplating. Nothing is guaranteed in this life. It's all a gift. We have no rights to it, we didn't earn it and we don't get to keep it as long as we want to. We don't even get to know when our lease is up. It has been granted us through some extraordinary fate, and everything can change in a flash. We just never know. We may not live out this very day. Such contemplations may sound dreary at first,

but it is actually quite glorious, as it reminds us to celebrate and savor the experience we have left. And nothing helps you learn to appreciate each occasion like a tea practice, especially with a bit of *one encounter, one chance* heating up the water!

Method: Work towards a theme (perhaps pre-planned). The more obvious themes are related to the event itself, like honoring a birthday or other life event; or you can always resort to basing your *chaxi* on Nature, connecting this occasion to what's happening around, like using autumn leaves on the table. More subtle themes can also be implied, like a sutra under the tea boat suggesting that the tea is digesting lineage wisdom. There is no need to explain themes to your guests, though you can do so if you wish, especially if you are sending invitations beforehand. Most times, however, it is better to let them read into the session in whatever way resonates with them. Like any art, there are infinite insights and reflections available.

The art of making *chaxi* and preparing for a ceremony is a huge part of the respect that makes tea drinking into a ceremony, and you can continue this process into whatever depths you have a capacity for or your schedule allows. You can include the shirt of the brewer, which will also be a big part of what the guests see when they sit down. (Does it match the tea runner, for example?) You can decide whether or not to play music, whether to offer gifts, are the decorations just at the tea space or throughout the house, etc. The more we put into the session, the more special the occasion will be and the more honored our guests will feel.

This shouldn't make us feel like all tea sessions have to be formal—doing so when the occasion calls for casual tea would be forced and ugly. But neither does that mean that casual sessions must necessarily be sloppy. You can celebrate the chance to have a casual gathering with friends as much as any formal occasion. It is, after all, a wonderful opportunity to have some time to chat with friends over tea! Why not celebrate that and make a *chaxi* that acknowledges, accentuates and encourages that type of tea? A skilled master of *chaxi* creates the perfect environment to support whatever tea and energy the session is trying to evoke—from formal ceremony to nice, down-home conversation.

II. Washing the Teaware

We could wash the teaware before our guests arrive, but doing so in front of them is meant as a gesture of respect. It shows hospitality and cleanliness, offering them intimacy into as much of our tea preparation as possible. The respect the host has for the guests, as well as a desire to invite the guests into our practice and space, are the overt reason for cleaning the teaware in front of them, but there are also deeper internal reasons as well. There is not a need to express these internal reasons to your guests, though it is important for you to understand them, hold them in your heart and then let the gestures of cleaning the teaware express them without words.

Firstly, the washing of the teaware is a "temporary ordination," an idea that most modern cultures have lost. In the East, it was common for young people to spend time in the monastery finding themselves before making big life decisions, like who to marry and what to study. (I'm sure we could all have used more of that!) Beyond that, temporary ordination also meant that even wealthy businessmen could build a tea hut and garden in their back yard, and for a few hours a week live just as the hermit-monks in the mountains do. Many arts were born of this aesthetic, like bonsai, for example. Scholars would retreat to mountain temples when they had vacation time, writing poetry and living simply the way monks do. The tea ceremony is also one such space. In tea, we are all monks or nuns: social class, gender and our ego stories are all left outside with our shoes. We are all equal here—one heart sharing tea and wisdom together.

Most every tea tradition has some version of this temporary ordination. In Japan, tea huts often have very small doors called "*nijiri-guchi*," or "crawling-through door," that people have to kneel through, leaving behind status and ultimately all ego. Other Chajin have used ordination scepters in their *chaxi* to symbolize a metaphorical shaving of the head, leaving the world of dust. In China, cities had unpaved roads and were dusty, whereas in the mountains, where holy men roamed and temple roofs made winged gestures at Heaven, the air was clear and clean. Consequently, it quickly became custom to discuss worldly matters in terms of "dust," especially "red dust" since the

capital cities in the North often had red soil. We therefore wash the teaware in service of washing away all our ego-stuff, so that we can set down our background and show up equally pure and clean, resting in our highest beings for tea.

Washing the teaware is a purification ritual like any done throughout ceremonies since the dawn of time—creating a purified space to host the guest of honor: *Tea Herself.* We wash the teaware and rinse away the world. As such, purification is an important preparatory step in any ceremony. Finally, we also wash the teaware and rinse the tea to wash off all our past sessions. Oftentimes, we forget to be present and miss out on the life that is passing us by all too quickly. By learning to honor this occasion, we learn to honor our very own lives. Sometimes people take a sip of a nice puerh, for example, and exclaim: "This puerh is wonderful... You know, I had another wonderful puerh two weeks ago at John's house..." And then three bowls of the puerh they themselves just said was "wonderful" go by unappreciated because they are talking about a puerh that no longer exists—lost in the past and missing the present. We are all prone to this. None of us celebrates the treasure of this life as much as we should. By washing the teaware and rinsing the tea, we are staying present to this very occasion and moment, which will never happen again—*this* "one encounter, one chance." There is no other tea in our lives other than this very bowl! Even if you buy several cakes of this puerh and take it home to brew over and over again it will never, ever taste like *this* again!

Method: We wash the bowls by holding the bowl in the offhand. Make the offhand into a bicycle fork, with the thumb forming one side and the four fingers held together forming the other side of the fork. This hand *does not move.* (This will be very important if you are to rinse the bowls properly.) The bowl spins through this hand much like the wheel of the bicycle spins through the fork. The strong hand then grips the ring of the bowl and spins it *towards yourself* (you don't want to pass unclean water towards your guests). Hold the bowl at a forty-five degree angle. The ideal is to have the water clean the inside of the bowl as well as the outside of the rim where your guests' mouths will be

touching. In order to achieve this effect, you will have to master the right angle and speed. The speed will be more difficult than it sounds, so you may want to practice at first with cooler water. If you go too slow, the water will run over the edge and down to your hand, burning you; and if you go too fast, it will shoot out and won't clean the outside rim. Like most things, you have to do it just right. You will know when you have cleaned the entire way around the bowl because you will feel the wetness return to the thumb part of your forked offhand. At that point, put the palm of your offhand into the curve of the bowl, much like a martial art attack, while holding on with the strong hand and shake the bowl up and down to flush out the last of the excess water. Then, repeat this for every bowl, cleaning your own last.

III. Adding Leaves and Water

Once you have washed all the bowls, you can add the leaves. When we prepare leaves in a bowl, we often include the leaves themselves in the *chaxi*—often in a large bowl at the center of the table. Use a large open bowl that makes it easy to grab the leaves. Teas with long, striped leaves are ideal for leaves in a bowl tea, as they won't get caught in your guests' mouths and are more beautiful opening in the bowl. As your guests are sitting down, you can invite them to appreciate the leaves if you like, which they often enjoy. They may have questions, which you can then get out of the way at that time or politely postpone until after the ceremony.

Since the brewing starts here, this is a good place to review the Five Basics of Tea Brewing, which will help you throughout your entire tea journey. We will post some articles that go into each in greater depth in the "Further Readings" section of our blog this month (there is also a nice video on our YouTube channel). In summary, they are to divide the space in half and do everything on the right side with the right hand and vice versa, all circular motions move towards the center, always keep the kettle in your offhand, never (ever X10) pick up the kettle until you've stilled your heart-mind and, finally, stay focused and concentrated on tea preparation until handing the tea to your guests.

Once you are ready to start the tea brewing, we like to bow to our

guests. More than the obvious show of respect, this bow is also a kind of apology, as you will be excusing yourself from the role of host to focus completely on the tea. You are asking them to allow you to ignore them, so that you can honor them by making the best possible tea you can, which will, of course, demand all your heart and attention. If you are serving guests who are new to tea ceremony, you may want to mention out loud that you will be sharing some tea together in silence, with time to talk and ask questions afterwards. For especially agitated guests, it is also helpful to tell them *how many* bowls, as indeterminate silence can be uncomfortable for some people. By saying out loud that you'll share three bowls in quiet, for example, can make the space much more comfortable.

We need hot water to help open the leaves in this style of brewing. However, since the water is going directly into the bowls, you may want to experiment with taking the kettle off the stove for several seconds, or even a couple minutes depending on the kettle, to make sure the water is cool enough that the bowls can be held comfortably. After the first steeping, you can use cooler water. You may also want to let the tea steep for a minute or two each round before handing the bowls out.

Method: There are two useful skills in adding the leaves to the bowl and steeping them. The first is to use your thumb and fingers and pinch the leaves upward from the bowl and release them. This separates the small bits, which fall to the bottom of the dish. This will make it easier to choose large, beautiful leaves for each bowl. How much you add depends on the kind of tea: for sheng, we like to add one large leaf and one budset, if possible. Red tea, on the other hand, is nice when it is a bit stronger, so you may want to add five to seven leaves if you're making this month's tea.

The second skill that is useful is to make the leaves spin when you pour the water. In the first steeping, this helps pull the leaves under the water so that they start steeping right away, instead of floating for a long time. In later steepings, the leaves will be stuck to the bottom of the bowl, so this technique is helpful to lift them off so that every leaf steeps evenly. To do this you will have to get to know your kettle and

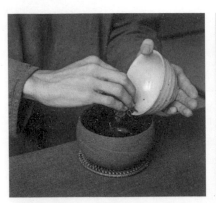

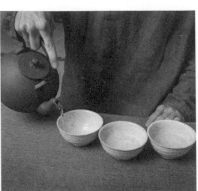

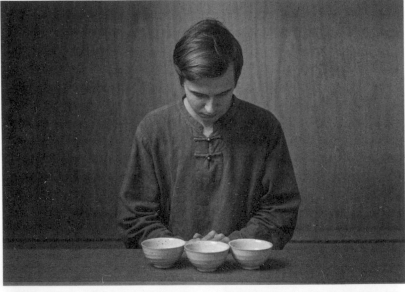

bowls. We want the spin to move around at a slightly downward angle as opposed to just going in flat, horizontal circles, which wouldn't pull the leaves under in the first steeping. Try starting with a thinner pour from the kettle and move along the side of the bowl furthest from you until you find the place where the leaves start to spin, at which point you can increase the flow of water—"turn on the gas," as Wu De often says. After some time, you will get to know your kettle/bowls and be able to do this rapidly without hunting for the right spot.

IV. Acknowledge the Guests on the First Round

Sometimes when people come into ceremonial space, they may find it heavy. They may not know that when you bowed before serving that you were excusing yourself and wonder why you are ignoring them. The intent look on yourself, as you focus all your heart and soul on tea brewing, may feel intimidating. And, let's face it, not everyone is comfortable with silence, as it shifts the whole world inward and we all fear looking inwards to some extent. Whether beginner or seasoned tea drinker, it helps to show that a session is not heavy and that all our energy is bent on perfect hospitality. There will be plenty of time to move inward and rest in peace or take a journey, but it helps to connect to all your guests in the beginning of each and every tea ceremony.

Before serving the first bowl, we like to make eye contact with each of our guests one by one. Bring their bowl to your heart and look at each of your guests in turn. You can smile at them or bow. Whatever you do, make sure that you communicate welcome and warmth, hospitality and love. This one gesture goes a long way towards making the silence of a tea ceremony into a *joyful silence*, rather than something heavy and/or intimidating. Feelings that this space is unapproachable or uncomfortable will be deflated and everyone can then spend the rest of the session focusing on the tea. We only do this for the first bowl.

Method: When bringing the bowl to your heart each time, be sure to switch hands halfway round the table, so that the guide hand holding the bowl from the top will switch from the right hand for the right side to the left hand on the left side. This allows you to place the bowl before each guest with the proper hand. Once the bowl is by the heart,

you can place your open palm over it and fill it with all your heart and hospitality as you make deep and meaningful eye contact with each guest—an exercise that can be challenging for some, forcing us to confront others openly and honestly.

V. Serve the Tea and Change the World, Bowl by Bowl

The coming and going of the bowls or cups is the breath of the tea ceremony. We are separate individuals and we are also one—one gathering resting in one heart space. The tides of together and apart mark the pace of a tea ceremony, and if you have defined a limit to the silence, it will also determine when you can start conversation again. Always try to bow and initiate the conversation yourself. As the host, it will be your job to steer any conversation towards meaningful, heart-centered topics.

Each round, wait for your guests to finish their tea, being sure not to rush them in any way. If you are a guest and want to pass on a round of tea, you are always free to do so. We must listen to our bodies when it comes to taking plant medicine. Simply place your hand palm down over your bowl on the table as the host is gathering the bowls and he or she will know that you want to skip this round.

When serving, make sure you keep the same order every time. This is usually achieved by putting your own bowl to the far side of your strong hand. Also, always be sure to fill your own bowl last.

Method: When we hand each bowl out with one hand (depending on the side of the table), we open the wrist outward, which is the one exception to the second basic that all circular movements are towards the center. This turning of the bowl outward offers the guest to drink from the part of the bowl that your hand was not on. It is also a gesture that heralds back to a simpler time when everyone in the community shared from a single bowl and turned it to offer the next person the part of the bowl where their lips had *not* been. The revolution of a single bowl in circles, and in orbit around the gathering, connected the tea ceremony to the celestial movements of the Earth. It is nice to share a single bowl between you and your guests if you want, but even with many bowls, this turn of the bowl is to represent that though we all

drink from separate bowls, we share in the same Tea spirit. Tea connects, bringing people together. This gesture symbolizes drinking from one bowl together, and not just those who are present, but all the bowls that have ever been through time, starting with old Shen Nong himself!

VI. Ending the Ceremony & Cleaning Up

When a ceremony doesn't end, guests are left with an incomplete feeling. It is always worth ending what you've started. One of the best ways to end a leaves in a bowl ceremony is with a bowl of water. There is an old Chinese saying that "friendship between the noble is like clear spring water—it leaves no trace."

Simply, quickly and deftly scoop the leaves from each bowl and place them in the wastewater dish. Then, rinse the bowls one by one again in the same way you did at the start of the ceremony. Finally, add some water to each bowl. You may want to leave the kettle off the stove in anticipation of this, since you don't want the water to be too hot. After serving water, bow to your guests one more time to complete the ceremony, show respect to them and to excuse yourself for breaking the noble silence.

Always leave ample time to clean up a tea ceremony, as it too should "leave no trace." Honoring the session, tea and teaware means cleaning up completely. By taking the time to always clean up, we honor this practice. If this is my means of cultivation, it should be tight, clean and clear. After all, a cluttered altar means a sloppy relationship to the Divine, and, in this case, to Nature and the spirit of Tea as well.

It is also a wonderful practice to sit in the tea space after your guests have left and spend ten or fifteen minutes cleaning and drying the bowls, while at the same time celebrating the wonderful occasion you just had the fortune to be a part of, acknowledging with gratitude the time and heart to honor such a space. Then, you may want to wish each of your guests a fare-thee-well in turn, hoping that the ceremony which has just occurred carries them to fortune and happiness. Contemplate each of their faces in turn, filling your heart with loving-kindness. Be grateful for the occasion and for their company as you clean up your teaware and put it away, clean off the chaxi and wipe the table or floor down, leaving no trace of the "one encounter, one chance" that has just occurred.

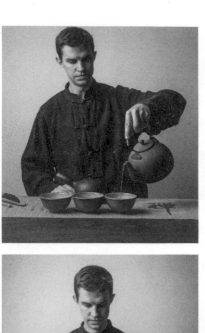

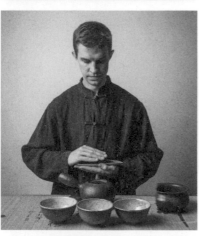

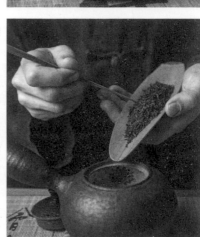

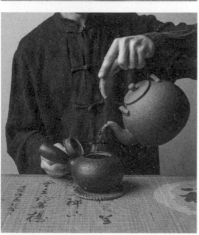

A Side-Handled Teapot Ceremony

The sidehandle pot ceremony is an extension of leaves in a bowl, providing the opportunity to prepare more kinds of tea with the ceremonial, meditative ambience of leaves in a bowl. Long ago, all tea was processed simply, and therefore suitable to leaves in a bowl or boiling. But the last few centuries have seen a wonderful explosion in tea varietals, cultivars and processing methods. And not all these teas are suitable for leaves in a bowl or boiling: Some are compressed and would expand too much in the bowl, are made of small leaves that would be difficult to drink without getting small buds and/or bits in your mouth and others are too astringent or fresh, requiring flash steepings (quick decantation, in other words). The sidehandle ceremony is an addition to leaves in a bowl that allows us to prepare all the varieties of tea in a bowl with ceremonial force. With these two brewing methods alone, a Chajin can host ceremonies that suit all occasions.

It is important to remember, however, that the sidehandle is not meant to complicate leaves in a bowl. It is not "higher" or "better." One should not think of this ceremony as more advanced than leaves in a bowl. Sidehandle tea should be prepared with the same simple philosophy of focusing on meditational space, ceremonial celebration of Nature and tea drinking and not on the quality of the tea. We chose the sidehandle as a vessel because it is the oldest and most rustic vessel, and is therefore conducive to the spirit of bowl tea: leaves, water and heat in its purist form. We prepare sidehandle tea without an evaluative mind. Each bowl is complete in and of itself. Consequently, we learn to set down the discriminating mind and rest in a harmony with this moment, this very bowl exactly as it is. We try to let go of "too hot" or

"too bitter" and just be in the present moment fully, feeling the tea as it is. Sidehandles don't add anything at all to a bowl tea ceremony other than the practical and down-to-earth ability to prepare more kinds of tea in this spirit.

Ceremonies teach us to remember to remember. All too often we forget what is most important to us: to spend time with our friends and loved ones, to connect on a deeper level, to discuss what's important and to honor this beautiful day. We must learn again to honor life and our bodies. Our respect-muscles have grown weak, so we must hone them to strength. Ceremonies turn attention into intention, creating energy that connects us to Nature, to our own hearts and to each other. In such a heart space, we remember that deep down in the most spacious part of our hearts, we are all one Heart: one with all of Nature, with spirit and with each other. Many of the steps in this ceremony are similar to the leaves in a bowl ceremony we learned in the previous section.

Chaxi

All tea ceremonies start with the "stage" or "*chaxi* (茶席)." The truth is that the output of any system is determined by its input. Tea grown in a healthy environment without agrochemicals and lots of biodiversity makes beautiful, healthy leaves. Similarly, the more you put into a tea ceremony, the more you get out of it. The more we prepare, the more we honor the occasion and our guests and the more special our session will be. This includes cleaning, decoration and also the practical elements of a session, like which teaware to choose, gathering spring water when possible, charcoal and heat, music if you wish to play some, incense and every other detail of the environment the tea will be prepared within.

Chaxi practice always begins with cleaning. Cleaning is, in fact, eighty percent of Cha Dao! We clean inside our hearts to be pure channels of tea spirit and we clean our tea space to celebrate the occasion and our guests. We all know how to host guests: we clean and decorate. And we all know what it feels like to enter a space that has been cleaned and decorated in our honor. This helps remind us

of the spirit of tea, which is based on "one encounter, one chance (一茶一會)." This means that if we gather here everyday and prepare the same kind of tea with the same teaware it will never, ever be *this tea* again. In fact, each bowl is a whole and complete moment in and of itself. And this moment will never exist again; it is all of our reality, here and now. This is our only chance to be present and to experience our tea. Making a *chaxi* for each ceremony teaches us to celebrate the occasion. It is precious to have a human body, to be relatively free of discomfort—not to mention to find the time in this busy world to pursue something so aimless as a bowl of tea!

Chaxi is focused mostly on honoring the occasion, one's guests and the tea of choice. There can be a theme that facilitates this, like a full moon or congratulations for one of your guests. Most often, on a day-to-day basis, we practice honoring the occasion by connecting Nature to our tea session. This is easy outdoors, since Nature surrounds us and is, therefore, our *chaxi*, but indoor sessions often strive to bring Nature inside, reminding us that this session is a part of a bigger world. This means autumn leaves in the fall, spring flowers in the spring, and so on.

A *chaxi* is a mandala: a temporary work of art that connects a moment to Eternity. We create them to honor this precious time and space and to welcome our guests. We also prepare a *chaxi* to honor the tea we are preparing, and the hard work of the only true tea masters in the world: *farmers*.

Purification

All ceremonies start with purification. If you wish, you may light some aloeswood incense to purify the space, yourself and your guests. We like to keep the bowls to our side and bring them out after everyone is seated for sidehandle tea. This is different from bowl tea, in which the leaves and bowl are often out already as part of the *chaxi*. (You can make an exception for sidehandle and put the bowls out, or for leaves in a bowl and have them to the side for certain occasions, but most sessions will follow this general pattern).

Bring each bowl to your heart and then place them one by one in front of your pot. Be as mindful as possible. Remember, a ceremony

is to turn attention into intention. We should use every fiber of our being to prepare tea, filling our heart with this moment, this time and place, this gathering and this tea. The most important element in any tea ceremony is the heart of the brewer—same tea and teaware, but change the brewer and the tea will be completely different, like giving a guitar and sheet music to different musicians, which results in a very different song. If your heart is still and very present, your tea will be steeped in this presence and your guests will drink of it, guiding them to that same presence and stillness in their own hearts.

After all the bowls are place out, you can take a breath, lift the kettle and place some water in each bowl. Then, pour some hot water into the sidehandle pot itself to purify it. At this point, we gently bring out the wastewater container (*jen shui*, 建水). We keep this to our side or behind us to honor the space and our guests. As you go to wash the bowl, bring each bowl to the heart and then to the *jian shui*. This is done for a few reasons: First of all, bringing the bowls to and from the center means that you carry them around the sidehandle pot, preventing any chance of knocking the pot with your hand or arm. Secondly, bringing the bowls to the center makes it easy to switch hands so that you can rinse the bowls properly.

To rinse the bowls, you follow the same method as in a leaves in a bowl ceremony, which we discussed in the previous section. The offhand is like the fork of a bicycle wheel. It is extended straight and *does not move* (this is important as your washing will be fumbling and awkward if you try to coordinate the movement of both hands). Extend the offhand with the fingers straight and unbent to allow free circular rotation of the bowl. Hold the bowl over the *jen shui* at a forty-five degree angle and rotate it towards yourself with the strong hand (we also expel waste water towards ourselves to honor our guests). The aim of this circular movement is to rinse off/purify the inside and outer rim of the bowl, where your guests' mouths will touch. You will have to practice the angle and speed of the rotation—if you move too fast the water will spill out without rolling over the lip of the bowl and purifying the outer rim, and if you go too slow, the water will roll down the side of the bowl and burn your hand. You will know

when you have rinsed the bowl all around completely, as you will feel a wetness on the inside of your thumb. At this point, put the palm of the offhand into the curve of the bowl and use the strong hand to shake the bowl three times, removing any access water.

At this point, it is a good idea to reach down and wipe your hands of with a tea cloth (*cha jing*, 茶巾) before grabbing the handle of the pot. Then, decant the rinse water from the pot into the *jian shui* and set the pot back down gently.

Next we add the tea to the pot using a scoop or "*cha he* (茶荷)." Take a moment to place your hand over the tea and "whisper" your good intentions from your heart through your hand to the tea. Silently ask that this tea remind us of Nature, of the preciousness of this occasion and of our love for one another. Then place the tea gently in the pot. At this time, shower the leaves with some water, filling the pot only just above the leaves. This is to purify the Tea Herself. She also has journeyed by plane and truck to get to us, and we all know that a shower is good after a journey—washing off the dust of commoditization and other negativities She has passed through to reach us. This also wakes the tea up, readying her for the session. At this point, replace the *jian shui* to your side, as you won't need it anymore. Then, start to absorb the peace...

Steeping & Offering

...Take a breath and calm yourself. Lift the lid and pour into the pot. Pour in circular motions at least until the water is above the leaves, so as to not scald any one leaf too much. When the pot is full replace the lid and as the water steeps the tea, allow your heart to steep in peace.

Those of you who have attended our ceremonies before will maybe have seen some of us putting our index finger on the button/pearl of the pot and our other three fingers flat against the side. This is *not* a ceremonial gesture and should not be done for this reason. We do this to listen to the tea to know when it is steeped to the proper degree. Learning to communicate with the tea leaves, water and liquor and feel the proper time to decant is a necessary skill in tea brewing. Practice listening in this way. Can you "hear" the frequency of the tea changing

as the water becomes more and more infused with tea? Feel through your hand. All great art is performed with such sensitivity and feeling for the medium, and from painting to photography, artists will describe the intuitive sensations that went into their works. Tea is no different. Try to avoid using the mind, and instead listen with the heart. This gesture can help you to become more sensitive to the changes in the liquor in the pot and decant at the proper time.

Take another breath before lifting the pot to decant the tea for your guests. Move in circular movements around the edges of the bowl. Bubbles make tea astringent and rough. We should pour smoothly in figure-eights around the row of bowls back and forth until all the tea is decanted. Then gently replace the pot. Sometimes, with some sidehandle pots, you may have to rotate the handle around to make sure it isn't in your way after you set it down.

The first bowl is an important one. For this first bowl, we bring each bowl to our heart, cover it with one hand and make eye contact with the guest it is for, offering them a warm smile of welcome. Do this for each guest, one at a time as you hand them their bowls. For a lot of people, a silent tea ceremony can be intense and heavy. They resist the silence and connection with presence as it goes against the grain of their busy lives and active minds. They grow bored and feel that the situation is overbearing. By connecting to each guest at the beginning with a heartfelt smile, we have found that the silence of a tea session is magically alchemized into *joyful silence*. We aren't sure of all the mysteries of why this happens, but it certainly works. The rest of the session will flow much smoother and happier for you and your guests due to this one simple gesture of love!

When you hand out each bowl, rotate the wrist outward—offering the part of the bowl your hand is not touching to each of your guests. We do this for every steeping. It is another of the many ways we honor our guests, opening the Universe that they can touch in each and every bowl!

After each bowl, return the bowls to the center. It helps to keep your bowl on the far side of your strong hand and place each consecutive bowl in order so you don't lose touch of whose bowls are whose. The

bowls then come and go, steeping after steeping. This is the breath of a tea ceremony, and the essence of its spirit: we are one (one gathering, one heart and one moment) and we are also apart (individuals with unique journeys).

Completion

A proper ceremony must have a completion. Without it, your guests will still feel like they are in ceremonial space even after they leave, which will make it hard for them to go about their day and concentrate on whatever comes next. The oldest and simplest way to end a tea ceremony of any kind is with a bowl or cup of clear water, which represents a washing away of the ceremony—celebrating the precious impermanence of the occasion. At this point, we feel comfortable breaking silence and engaging in some conversation with our guests, usually about important matters or tea. (They often have questions.)

After your guests leave, take a few minutes to sit in the space. Tea ceremonies are very intimate and getting up immediately does not honor the grace that has just happened. Cultivate gratitude for the occasion and love for the warmth of the space. We also like to think of each of our guests one by one, wishing them well on their journeys and hoping that the ceremony we just shared in brightens their day.

Finally, *always* leave time to clean up. Just as we clean before a session, failing to do so afterwards dishonors the occasion and our teaware—the instruments of our Dao and of our Tea-Joy. If you have somewhere to be, make sure you always leave adequate time to clean up your tea session, leaving no trace of what just happened. This is a part of learning to honor the occasion and rest in a graceful and loving relationship with impermanence. This is the moment at which the ceremony circles in on itself, returning the empty stillness from which it came.

The Five Basics of Tea

The five basics of all tea brewing inform every kind of tea ceremony, including the leaves in a bowl ceremony we discussed in the previous section and this sidehandle pot brewing, as well as gongfu tea and

whisked tea should you choose to explore those roads at a later time. For this reason, they for a useful basis for all ceremonial tea.

1. Separate the space in half and do everything on the right side with the right hand and everything on the left with the left hand. This protects one's teaware from accident and centers the body in a much more graceful and fluent way.

2. All circular movements are towards the center. This means the right hand moves counter-clockwise and the left moves clockwise. This is in harmony with the makeup of our bodies and creates harmony with the tea ceremony and environment around us.

3. The kettle always rests on the side of the offhand, and is used by the offhand. Doing everything with one hand reduces fluency and grace, creating a stop and start motion to your brewing. It also leans the whole ceremony towards the strong hand. This practice will center everything and make steeping and pouring much more graceful, fluent and smooth. Harmony within and without is the fulcrum of all movement in tea.

4. Never, ever (X 10 "evers") pick up the kettle until your heart is still. The lifting of the kettle starts the brewing process. Nothing good will come from an unsettled heart preparing tea. Remember the heart of the brewer is more important than anything else. Take a few breaths before each steeping and calm yourself. The time the kettle takes to boil has always been a time for meditation. Relax, slow down, pause and breathe so that movement comes out of stillness.

5. Stay with the tea. This means that after you calm yourself and pick up the kettle, do every movement with all the concentration you can muster, cultivating mindfulness (*Samadhi*) in every aspect of tea brewing. Invest all of your heart, in other words.